PERSPECTIVE SKETCHING

I dedicate this book to my parents Alvaro and Luisa, who taught me how to be creative and see the world under a different set of eyes. And to my sons, Thomas and Simon, for showing me the wonders of play.

ROCKPAPERINK

branding · typography · logos · color · design management · design for change · posters · fashion
www.RockPaperInk.com

© 2015 by Rockport Publishers
Text © 2015 Jorge Paricio

First published in the United States of America in 2015 by Rockport Publishers, a member of Quarto Publishing Group USA Inc.
100 Cummings Center
Suite 406-L
Beverly, Massachusetts 01915-6101
Telephone: (978) 282-9590
Fax: (978) 283-2742
www.rockpub.com
Visit RockPaperInk.com to share your opinions, creations, and passion for design.

10 9 8 7 6 5 4 3 2 1

ISBN: 978-1-63159-032-0

Digital edition published in 2015
eISBN: 978-1-62788-365-8

Library of Congress Cataloging-in-Publication Data available

Cover and book design: Traffic Design Consultants
Illustrations: Jorge Paricio, except those noted in the Contributor Directory, on page 218.

Printed in China

PERSPECTIVE SKETCHING

Freehand and Digital Drawing Techniques for Artists & Designers

Jorge Paricio

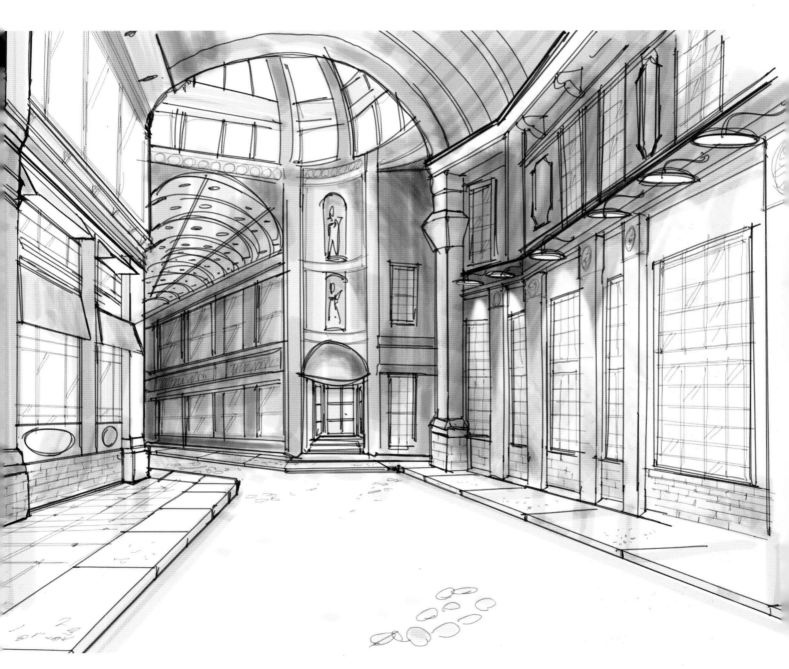

Rockport Publishers
100 Cummings Center, Suite 406L
Beverly, MA 01915

rockpub.com • rockpaperink.com

PREFACE

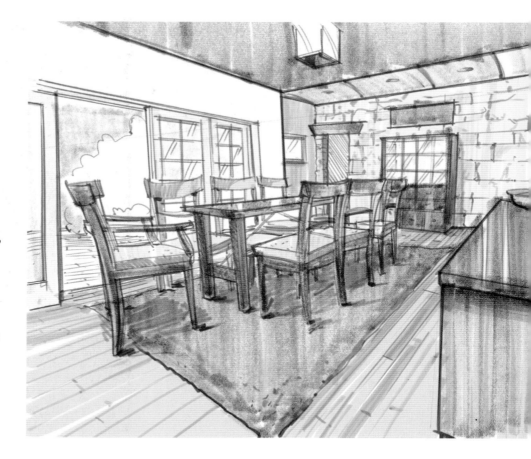

I have drawn for as long as I can remember. I grew up in a family of artists where any drawing and painting medium was always handy, and where experimentation was always encouraged.

While in art school I would visit the Prado Museum, in Madrid, to admire the works of Velazquez, Greco, and the early Renaissance pieces, and I fell in love with the use of line weight and color. Back in my father's printmaking class I still remember perusing through the school's collection of prints and grabbing a magnifying glass to admire up-close the line work of Hokusai, Piranessi, Rembrandt, Dürer, or Goya.

I started thinking about a book like this one when I prepared my Ph.D. dissertation back in 2004, titled "Freehand Drawing in Industrial Design," and I am grateful for the good advice and direction I got from my thesis advisor Manuel Alvarez Junco. Ten years later, I find that much of what I had written in those pages still holds true: drawing and perspective sketching is a core skill that artists and designers have to nurture constantly.

Finally, I am indebted to so many talented students that wanted to share their work in this publication.

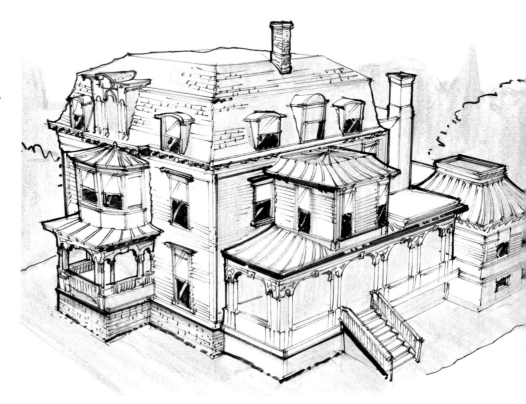

The future is here

This is Photoshop's version of Lorem Ipsum. Proin gravida nibh vel velit auctor aliquet. Aenean sollicitudin, lorem quis bibendum auctor, nisi elit consequat ipsum, nec sagittis sem nibh id elit. Duis sed odio sit amet nibh vulputate cursus a sit amet mauris. Morbi accumsan ipsum velit. Nam nec tellus a odio

CONTENTS

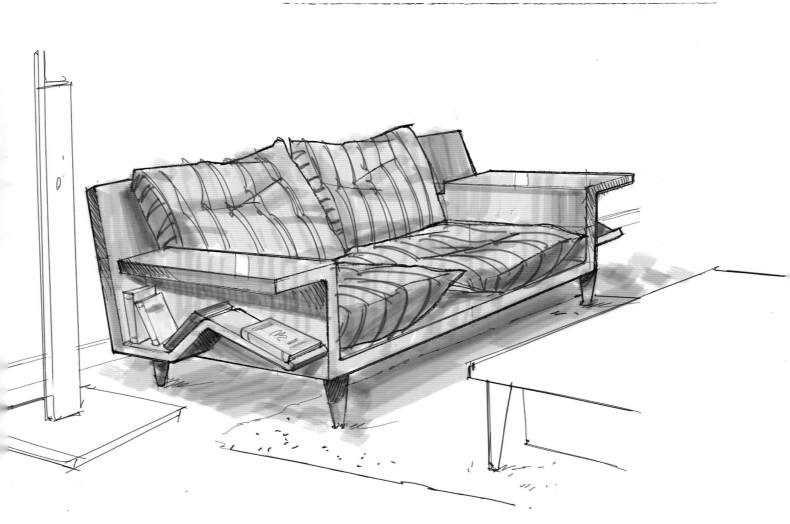

INTRODUCTION

This book is a tool for designers, artists, students, and anybody interested in the visual arts to improve their sketching. It can be read from beginning to end, as the content is revealed progressively, or you can dip in and out of chapters to find a particular area of interest.

You will not find a collection of polished drawings elegantly displayed but rather sketches and renderings that are carefully explained step by step, making sure every major milestone is covered. The same way that a good cookbook explains every step of a recipe, this book analyzes all the necessary stages that are required to complete a sketch or a rendering, broken into a series of small topics.

Knowing how to sketch can provide designers with the necessary confidence to evolve an idea progressively in stages and gives them the muscle to "see" their creation quickly on paper, without having to invest in three-dimensional models or computer models. Sketching is often done on the fly, allowing the designer to capture her initial thoughts and concepts before actually executing a plan. They are kept as proof of the evolution of a concept or shown only to other designers in the office.

Sketching is not a linear process. It is a journey that can have good and bad results. For that reason, sketching needs to be done with confidence and with a sense of freedom. Failing and succeeding in sketching go hand in hand, and just like anything else in life, sketching will get progressively better with practice. It is a skill that needs constant honing. The more we practice it, the better we become at it, but it requires time and dedication. The exercises provided in these pages will help you hone your drawing skills by practicing the basics of composition and scale.

CHAPTER 1
SCALE DRAWING

When we are ready to draw in perspective, it is important that we figure out the best method to use, according to the type of design we are developing. In this example, we see a finished rendering of a forklift that is done in a two-point perspective, which is one of the most common types of perspective drawing. In the following pages we will discuss the advantages and disadvantages of using different perspectives, focusing mainly on analyzing the differences between axonometric, two-point, and three-point perspective drawing.

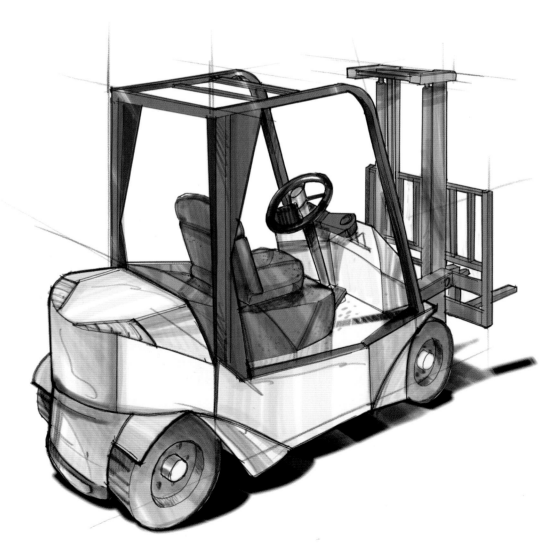

If we eliminate all color on the forklift, we get a clear vision of how a two-perspective drawing works. All vertical elements remain vertical (as seen in the drawing in red), so the lines do not converge toward any vanishing point. There are two main vanishing points: the left vanishing point (marked in green) and the right vanishing point (marked in blue).

As long as lines are parallel, they should converge in a vanishing point. The cube on the top left corner shows a simplified version of this method.

A: *In a two-point perspective, our vertical lines remain vertical.*

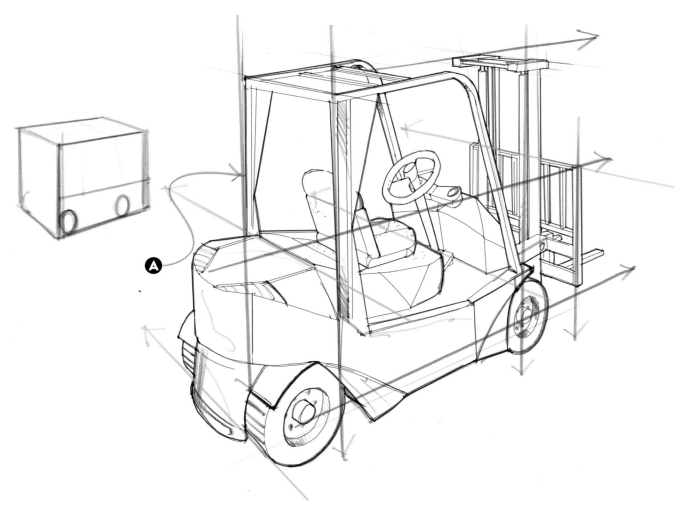

In the next drawing, we see how an axonometric view works. An axonometric view is the generic term to describe a drawing in which all lines are parallel, whether they point toward the left, the right, or remain vertical.

The cube on the top left shows how the lines marked in green, blue, and red create a 120-degree grid. In this situation, the axonometric perspective would be called an isometric perspective—this is favored by architects and interior designers in many cases, as objects and spaces tend to favor 90-degree relationships.

On the other hand, industrial designers would rather use a two-point or even a three-point perspective if their object will have angles or curved surfaces.

A: *In an axonometric drawing,
 all lines are parallel to each other.
 Parallel lines do not converge into
 a vanishing point.*

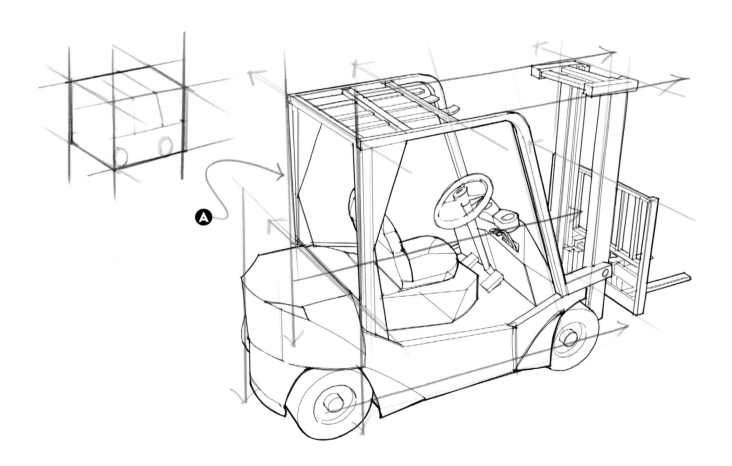

The next drawing points out the advantages of using a three-point perspective. The view looks more natural and closer to what the human eye would appreciate. Note how the vertical lines now converge toward a vanishing point, which could be aiming up or down depending on the point of view (imagine drawing a tower while standing at the base or hovering over the top level, looking down).

A: In a three-point perspective drawing, the vertical lines also converge into a vanishing point.

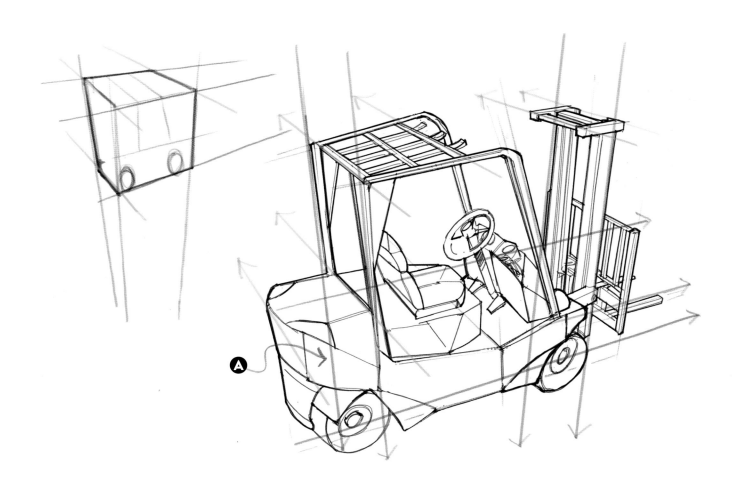

The use of a three-point perspective drawing can dramatically alter our perception of an object if the vanishing points are too close to each other. If we go back and examine each of the forklifts, we see that our blue and green lines converge into vanishing points that are far from the object and each other.

This has an obvious advantage, which is avoiding distortion or acute foreshortening. Seasoned rendering artists and designers tend to separate their vanishing points from each other to avoid this. In the example, the forklift appears to be strangely built, not because of the design itself but because of the relative closeness of the vanishing points. This is even more apparent on the box drawn on the top left corner.

A: In a forced three-point perspective, our object appears distorted and lacks a sense of reality.

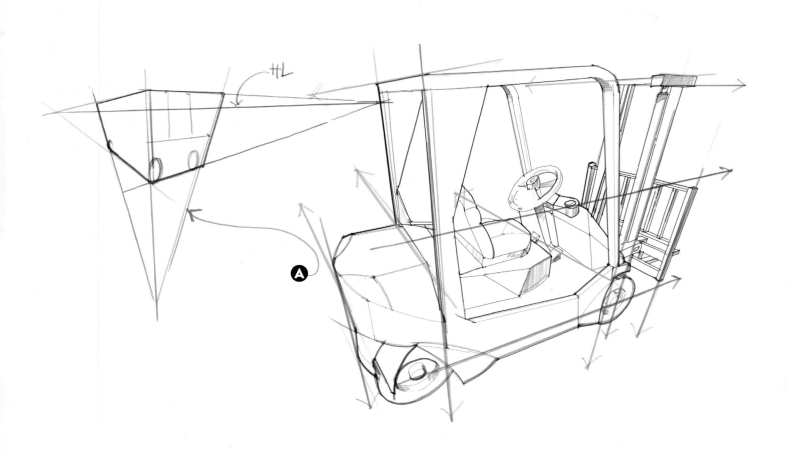

Designers often need to show the design they are producing in such a way that it could be measured and understood unequivocally, from different angles. However, in a perspective view, it would be difficult to show a measurement without confusion (from where to where are we measuring exactly?).

In an orthographic projection, the confusion is gone entirely. If we imagine that we can fit our design snugly in a transparent box and we project all dimensions onto the six sides, we would get six different views: front, top, bottom, left, right, and back.

A: *Top view*

B: *Left view*

C: *The front view is usually chosen to be the one with the most relevant and iconic information.*

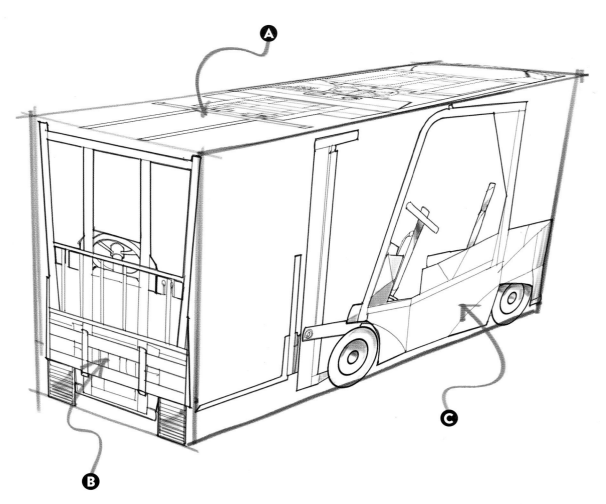

Depending on the type of design we are dealing with, we would show four views or all six. In our example, since the forklift is symmetrical, the front and the back views are the same, and the bottom view is not that relevant for design purposes. So it makes sense to only show the front, left, right, and top views.

A: All views get organized from the front view, which is located in the center of the page.

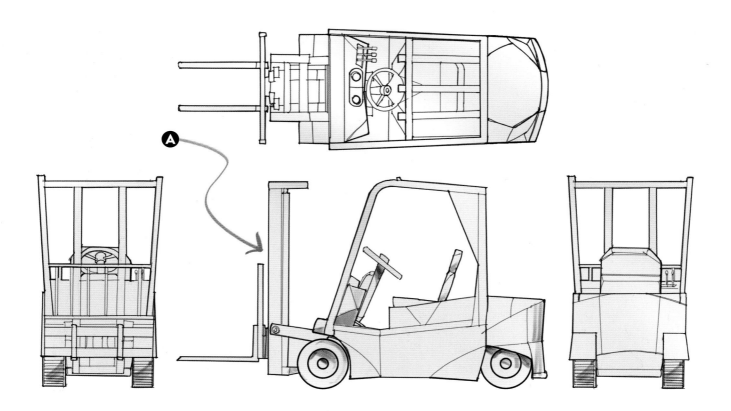

In this sketch done by footwear designer Joe Napurano, we see how he combines different orthographic views to accurately represent a concept from different angles. Starting from the bottom left corner, we see the front view, labeled as such because it is the orthographic projection that best defines our design. Starting from this view, all other views are defined.

To the left we appreciate the right view, and to the top of our front view we see the top view. It is important to note how these three views are aligned: the height for the front and right view are matching, and the widths for the front and top views match too.

The same goes for all other details—they are aligned horizontally and vertically. Notice in the empty space on the top right corner of the board Napurano has filled it with two ideas for the sole design, but at a different scale so that they would fit. He used a background line work using a non-photo blue pencil, followed by pencil work. It is a simple but effective approach for quick sketching.

A: *Geometric cut*

B: *Vented quarter over mold*

C: *Heavy articulation*

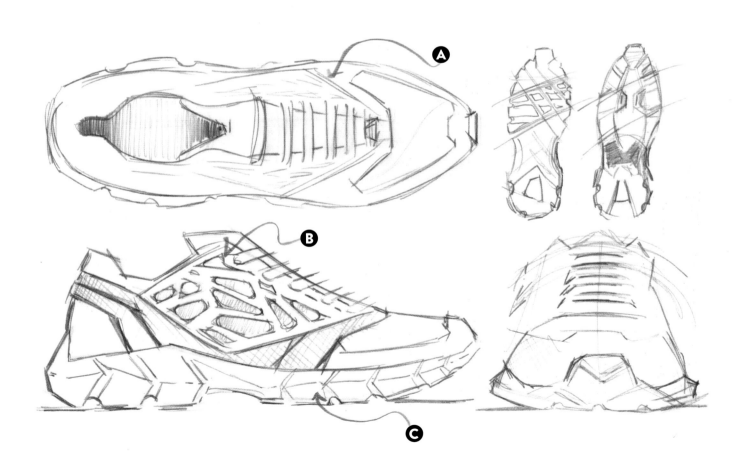

Once we have the orthographic views laid out in our page, we are ready to add our dimensions with accuracy. The process always starts with the addition of three dimensions: width, depth, and height. Notice, for example, the width for the forklift of 11 feet 6 inches (3.5 m) was added on the Top View, but it also could have been added to the Front View, right below the Front View title.

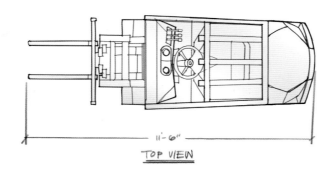

TOP VIEW

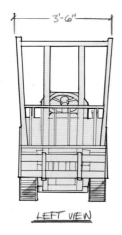

LEFT VIEW

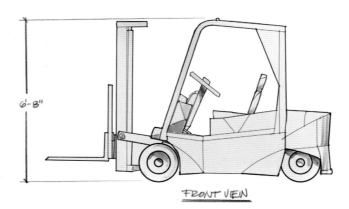

FRONT VIEW

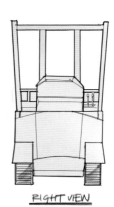

RIGHT VIEW

Adding dimensions depends largely on what they are needed for. In most cases, they represent the main proportions. If every single dimension needs to be recorded, we might need to represent every part separately. In this drawing, it shows how to locate the dimensions in the page.

A: Symbol for a center line.

B: These are called dimension lines and need to have tick marks, dots or arrow heads, on top of having a dimension (angular, linear, etc.).

C: These are called leader lines and can be overlapped but minimally.

D: Two or more dimensions can share the same leader lines.

E: Sometimes we need to add a special dimension, such as this one, from center to center.

F: Examples of dimensioned angles.

G: A curve can be dimensioned as a radius or a diameter (the diameter symbol is noted by a circle crossed by a diagonal line).

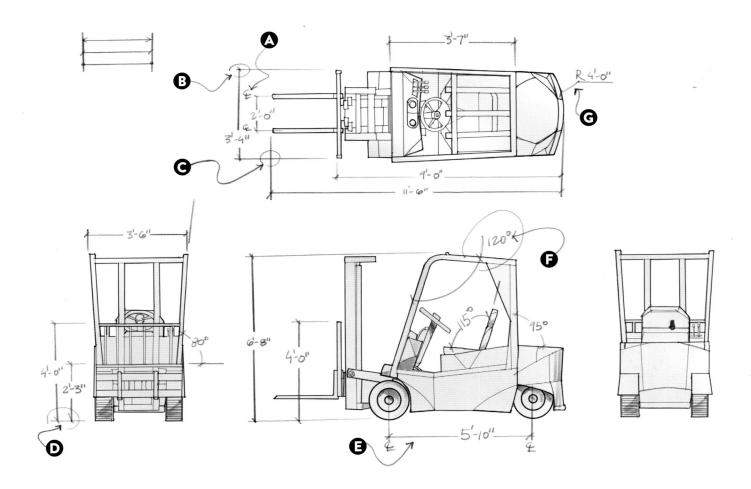

To create crisper lines and record the dimensions of the different orthographic views, Napurano, used Illustrator. The varying line weights and textures represent different materials, and callouts and notations record a detail or a manufacturing process.

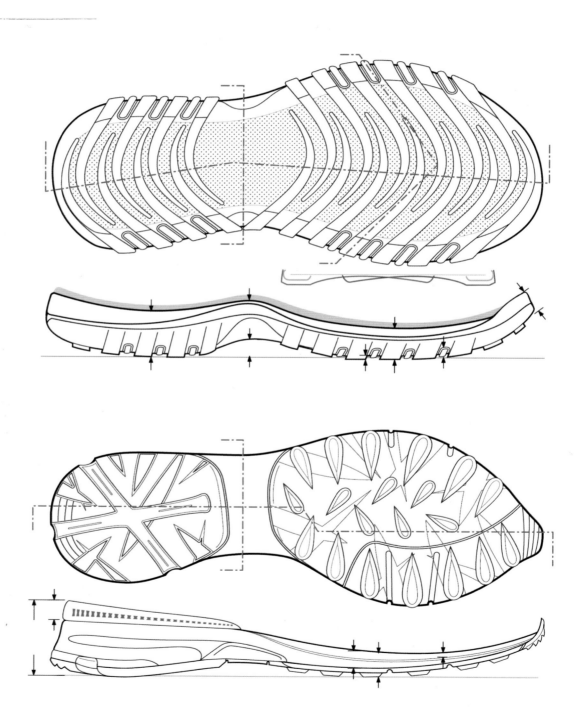

In this illustration, we see graphically how a perspective drawing happens. First, we have a person, standing straight and without changing his position. His location is called a station point or point of view (POV), and this position is key to determining the perspective. From the station point, we can determine if we are looking straight at the subject (the sofa), how high from the floor we are looking at the sofa, and the range of vision this person has. The range of vision, typically called the cone of vision, roughly covers from 60 to 90 degrees.

In front of the station point, there is an easel holding a drawing surface, called a picture plane. If the line is connected from the viewer to point A and marked with a dot where that line intersects the picture plane, it shows the first point of the viewer's perspective. This process is called *projecting the points from the subject.* The process can be repeated for each of the points that describe the sofa.

A: *Picture plane.*

B: *Station point (point of view).*

C: *This is the cone of vision (roughly 60 to 90 degrees).*

D: *This is the horizon line (the eye level).*

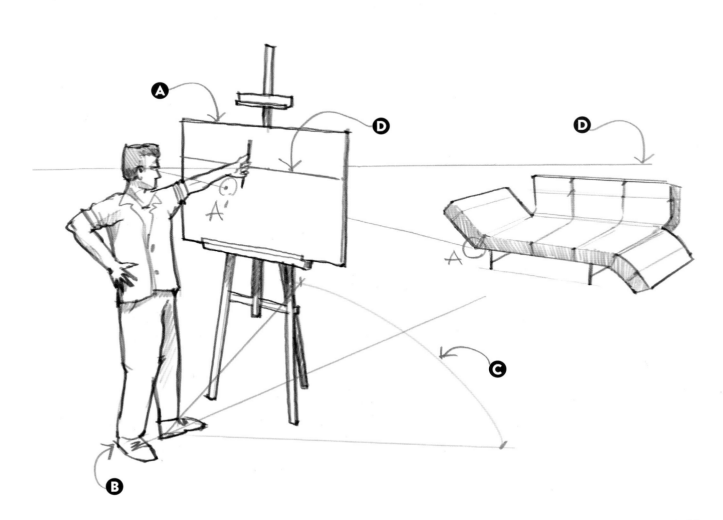

THEORY OF LINEAR PERSPECTIVE

In any perspective drawing, always keep an eye on the vanishing points, and how they relate to the horizon line (HL). The most common type is a two-point perspective, which showcases a vanishing point (VP) on the left and another one on the right. The vertical lines are kept as such and do not converge toward a third VP.

In the furniture sketch shown here, we took special care of making sure that our lines A–A' to F–F' would converge toward our left VP. A closer inspection intuitively reveals that the lines C–C' and D–D' aim toward the left VP. On the other hand, the remaining lines are harder to grasp, as they are imaginary.

For example, the B–B' line that defines the top of the finial is drawn just so that both bronze decorative elements are placed at the same height. Also, the imaginary lines F–F' help us place the four legs resting on top of a horizontal surface.

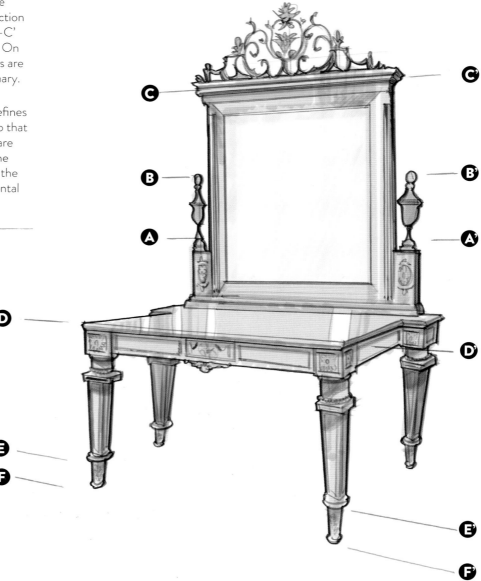

Often when we draw, objects (or parts of objects) are repeated in the perspective. Those repeated objects diminish as they recede into the drawing. Objects that are closer to us appear bigger, whereas objects that are further away appear smaller. In this particular example, we can see two different subjects in the scene—a bus stop and a bus. The bus stop has a series of glass panes. It is interesting to see how they get progressively smaller on the side. By the same token, the windows and luggage compartments get progressively smaller on the side of the bus. If we were going to draw a cell phone with buttons that are the same size or a large building with lots of windows, the same situation would occur.

A: These side panels get progressively smaller as they go deeper into the drawing.

B: These windows and luggage compartments also get smaller as they go deeper into the drawing.

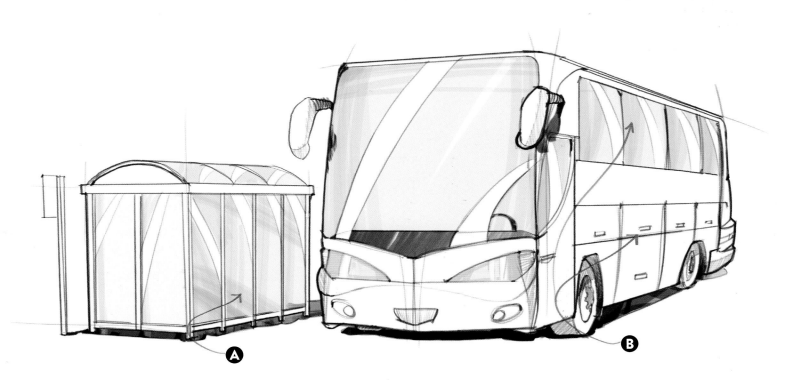

SET UP A VIEW; COMPOSE A SCENE;
FINDING THE EYE LEVEL

When coming up with the preliminary sketches to design, let's say, a sofa, we have to concentrate on the three most important dimensions: width, depth, and height. This notion would be true regardless if we design a sofa, a coffee mug, a vacuum cleaner, or even a vehicle. In any case, we have to make sure we get these dimensions correct before we go any further.

Once that's clear, we have to figure out which point of view is the best one. In this particular case, there are many possibilities, ranging from a normal point of view (first sketch), to a slightly high point of view, a low point of view, and the very low point of view as if we were lying on the ground looking up.

If the lines that define each of these four sketches are extended, we will be able to find the left and the right vanishing points. In a two-point perspective setting, each box should have two vanishing points: one for the left and one for the right. If we join those two points, that would give us the horizon line (HL). Each object that we sketch on paper will have a HL no matter how big or small the object is.

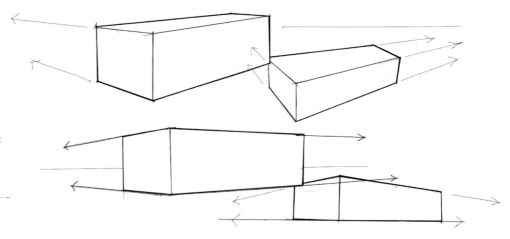

Once figures are added to the scenes, it's easy to see the implications of drawing the design with a high or low point of view. In this particular case, the sketch on the top left corner has the best point of view to define the object with a slightly lower than normal point of view, as if crouching down to look at it. The other three sketches didn't give the right perspective. That first sketch also provides the best balance between the top, front, and side profiles.

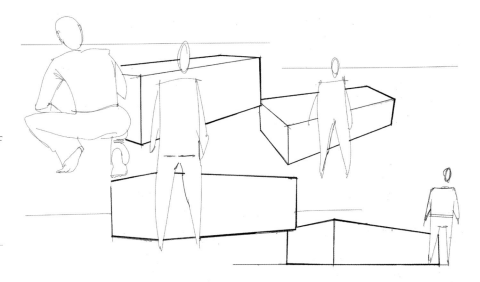

In this example, the sofa is shown from two perspectives to get an industrial designer's point of view. As you can see, the designer is more interested in showing the full shape of the sofa without any distractions coming from surrounding objects. The back view shows the client how this design works from different angles. The rectangular background unifies these two drawings, making them belong to each other. Notice as well how the designer decided to place the back view of the sofa at 90 degrees against the first view.

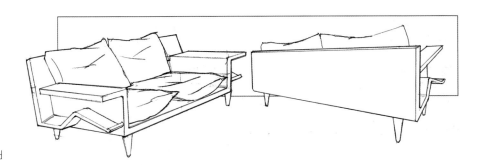

Once the three basic dimensions are figured out, as well as the correct point of view, it's a good time to start adding detail to define the design. In this case, the first task is to draw the lines that define the hard surfaces. Pay special attention to mark the thicknesses of the materials.

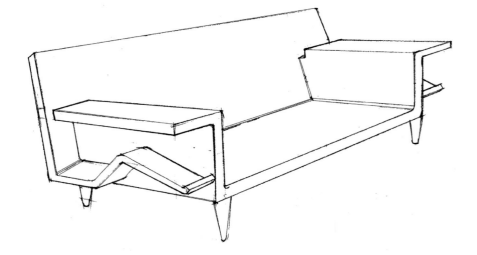

Once this is done, start adding soft materials, such as pillows (in this case) that define the back and the seats. It's important to add the right details, like the crisscrossing lines that define wrinkles that would appear naturally in the pillows. Also notice how the outside perimeter of the pillows is treated with a slightly thicker line compared with the thickness of the wrinkles drawn inside.

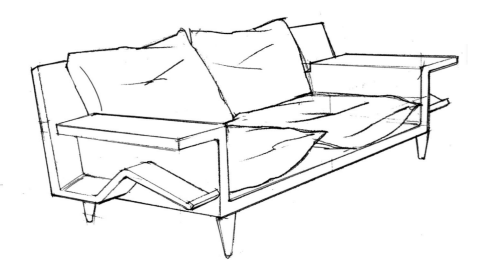

At this point, we could have stopped the sketch, but it is important to situate our objects in a better context of use. In this particular example, we have defined other objects that would come along with the sofa, in addition to adding some books on the wooden side wings. After all, those side wings were designed so that the person sitting in the sofa would be able to access his favorite books easily.

Pay attention to how loosely the additional elements are drawn in the scene. We need to make sure that the primary focal point still remains on the sofa, and not so much on the side lamp or the coffee table placed in front. This type of drawing would appeal better to the interior designer or architect, because he would be showing the sofa in a context of use.

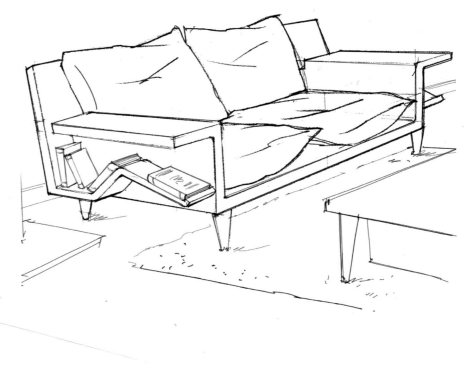

When you are ready to apply color, the best choice on most applications is color markers. Any brand will do, as long as you work with a marker paper. In this example, I used a light brown marker applying parallel, vertical strokes. This is the most commonly used method of filling out a surface with color, as it allows some white reserves when the space is filled with color (those are highlighted with two red circles).

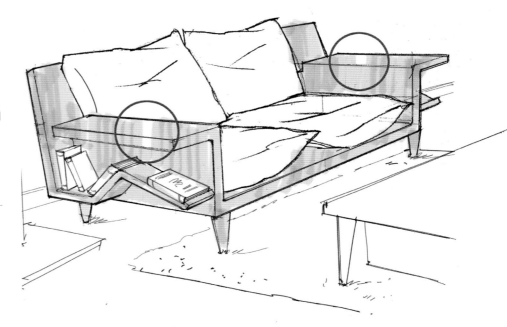

In consecutive layers, a slightly darker tone was used to create shade on the object, and a mid-gray marker tone implies a shadow under the sofa. As you can see, I tested my colors on the side of the sheet before I applied them to the drawing.

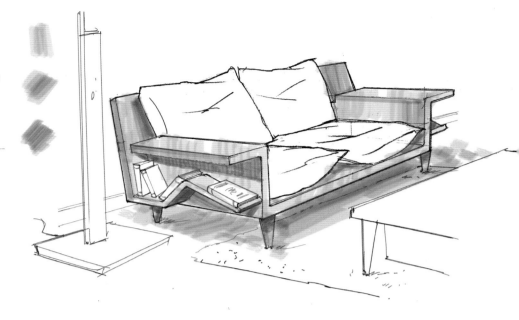

After I finished the wood tones, I chose two marker tones for the soft materials; the light tone will be used for the main body of the pillows, while the darker tone will be used to create volume on the wrinkles and on one side and on the bottom. The lighter red can also be used for a second pass, to add depth on some of the lighter wrinkles too.

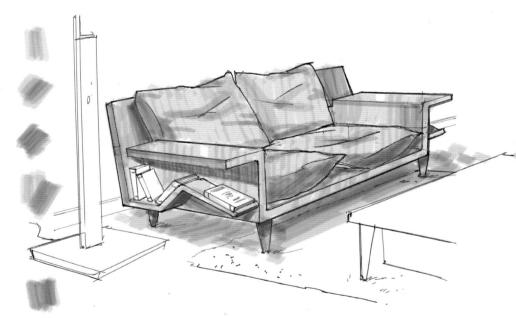

More details were added in the final drawing. In this case, we used a red pen for the upholstery details on the pillows for the seat and back. Notice how the red lines follow the folds and wrinkles of the upholstery material. The books on the side of the sofa have also been shaded to detail the built-in shelf.

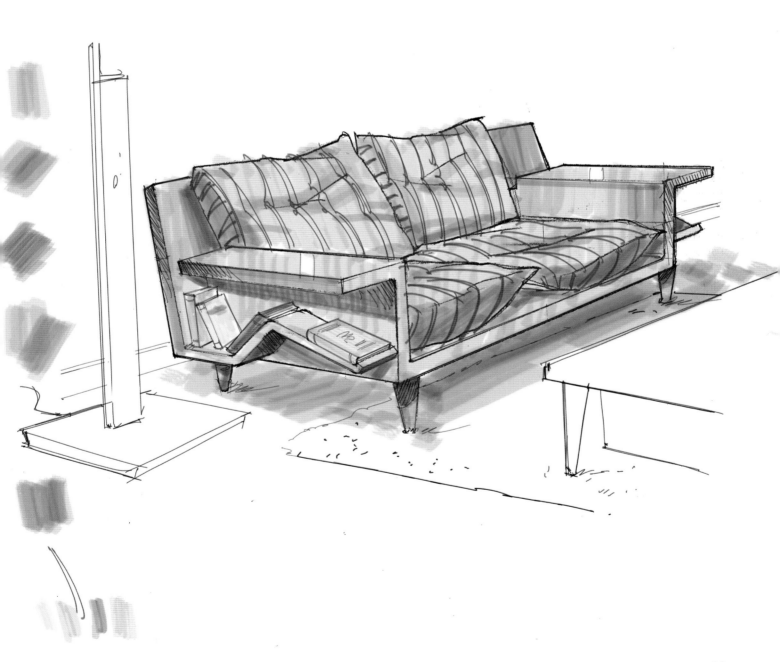

In the following example, we are going to describe how to set up the center of vision and how to draw the models with the right proportions. In this case, there is a Hepplewhite chair and a Chippendale chair, right next to each other. Let's first imagine that we have agreed on a height at which they will be drawn, not too high and not too low.

That height will allow us to see a bit of the seat, approximately at a 3 feet (1 m) mark. Then, imagine that they are set up on top of a rotating surface and that we orbit them to find the right angle or center of vision. I have drawn three possibilities, but just the three basic dimensions of the chairs: the width, the depth, and the height.

A: Option 1. The short chair on the front works well. Both angles seem to work just fine.

B: Option 2. Chair on the left does not have a good angle; both chairs appear too far from each other.

C: Option 3. Short chair placed in the background appears too short, although both chairs have good angles.

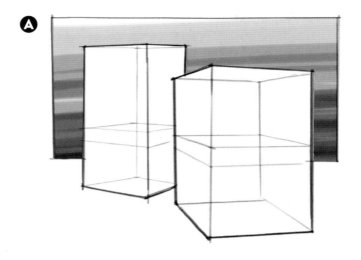

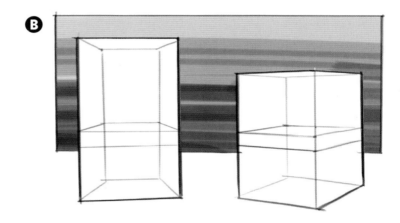

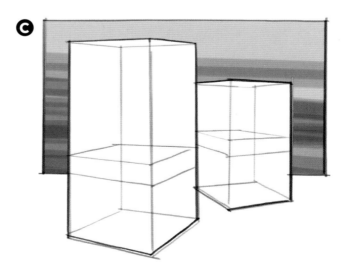

Once we have figured out the center of vision and have drawn a prism that contains our shapes (a prism with the correct width, depth, and height), we can establish the rest of the proportions for our chairs. In this case, I established my "unit of measure" to give me the starting point for the proportions of the chairs. After a quick visual analysis of both chairs, I realized that both had the same seat thickness so that was my unit of measure. The second and more obvious similarity is the height of the seat, four units on both cases.

With that proportion in mind, figuring out the rest got easier. The tallest chair is roughly 9 units tall, by 4 units wide, and 4 units deep. The shortest chair is roughly 7 units tall, by 4.5 units wide, and 4.5 units deep.

Once the main proportions are drawn with horizontal and vertical lines, I added some other simplified shapes for the legs and backrest.

A: To figure out our proportions, I considered my unit of measure: the seat thickness. From there, I guessed all other proportions as best as I could.

B: Once we have the main proportions, all the other details are drawn first using simplified geometric shapes.

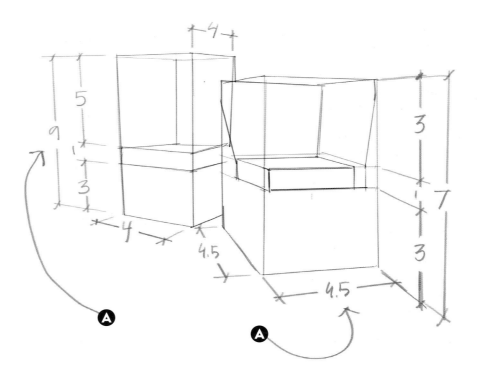

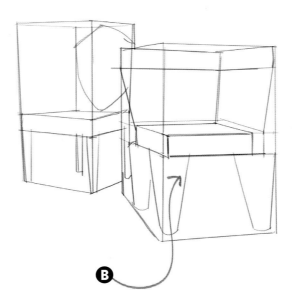

The final two steps got much easier, as I was confident that the main proportions provided my drawings the necessary foundation. At this stage I erased some of the original straight lines to give room to more curvilinear shapes that defined the cabriole legs with the ball and foot ending and the double splat for the corner Chippendale chair.

I also brought some curved lines to define the shield-shaped backrest on the Hepplewhite chair, and starting working with a pencil on some shading to add depth.

The final step involved the use of soft-colored markers in one or two passes, mainly to separate upholstery from wood.

A: And once we have the main volumes, we can start erasing our construction details to make room for detail.

B: The final step involves adding some light marker tones to differentiate the materials, and adding some shadows under the legs.

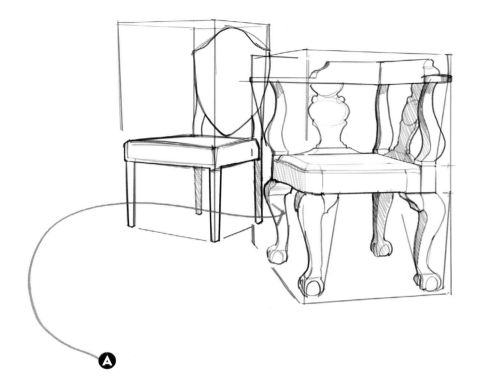

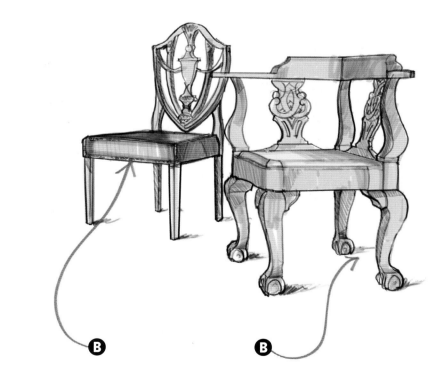

In this example, we see an interior perspective of a living room and almost all of the lines converge toward a single vanishing point (VP) in the center of the page, with the only exception of the angled lines of the staircase.

In most scenarios, though, objects are not always situated parallel to the edges of a wall, at 90 degrees, or products might have an angled face. In that case, we will have to establish other vanishing points in the drawing. In the next pages we will analyze where they can be found.

In this second iteration we made a few changes to play with different angled surfaces and marked exactly where the different VPs are located. We have a VP half-opened window blind, a tiled floor that is placed at 45 degrees, an angled wall on the right, and a halfway opened door on the right. For every angled surface, there is a different vanishing point.

A: Window shutter on the left has VP-C.

B: Angled wall on the right has VP-A.

C: Checker pattern on the floor has two VPs: VP-B and VP-E.

D: This outline marks the location of a sofa.

E: Half opened door on the right has VP-D.

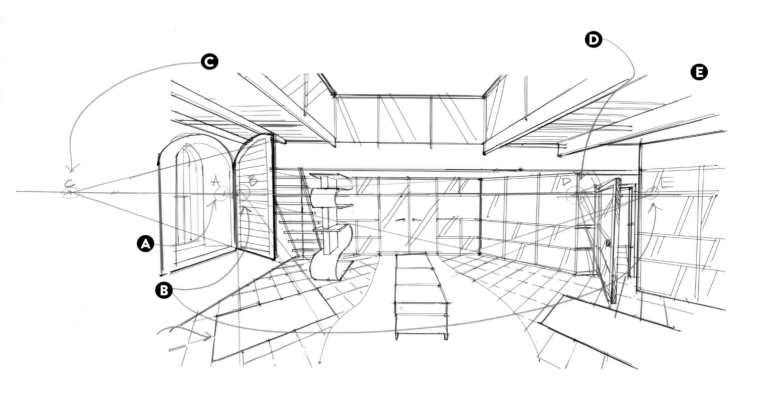

In this third and final iteration, changes were made to show a 45-degree grid on the floor that can be used to place two sofas at the same 45 degrees. Also, the ceiling can be angled to discover two more VPs: F and G.

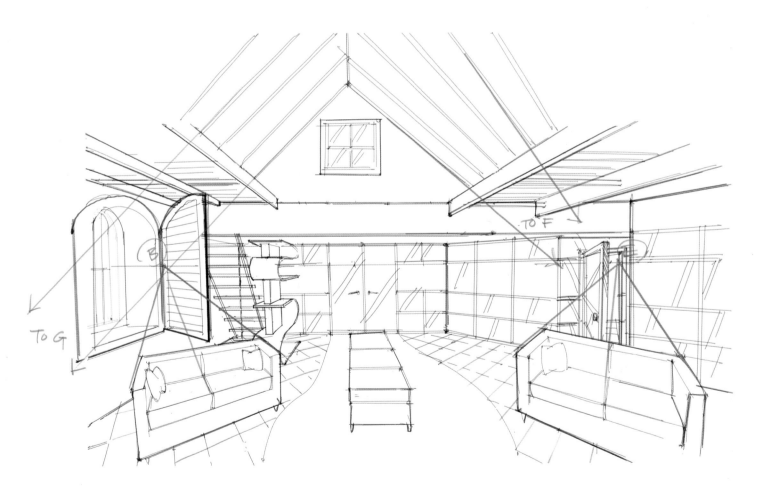

In this project we need to find the point of view for a park design, for the city of Providence in Rhode Island, done for the non-profit Partnership for Providence Parks and under the guidance of designer Jonathan Montalbano, founder of Parkour Rhode Island. While many concepts can be developed quickly, in the design process it is important to first sketch out a floor plan and locate a variety of points of view from different angles that could potentially be used.

In this image, we see four different quick sketches; while sketches 1, 2, and 4 are from a normal point of view roughly at the sweet spot of 5 feet 6 inches (1.7 m), the third one is done from a much higher point of view, just to test what the whole park would look like from above. The creation of preliminary ideations or thumbnails is an effective way for designers to rough out a concept without having to spend a lot of time on it. The focus is on speed and establishing a quick idea.

Before committing to a good perspective, often designers do a variety of quick sketches (thumbnails), to explore the best angle for their rendering. Notice the four marker points of view on the floor plan.

A: Sketch 1

B: Sketch 2

C: Sketch 3

D: Sketch 4

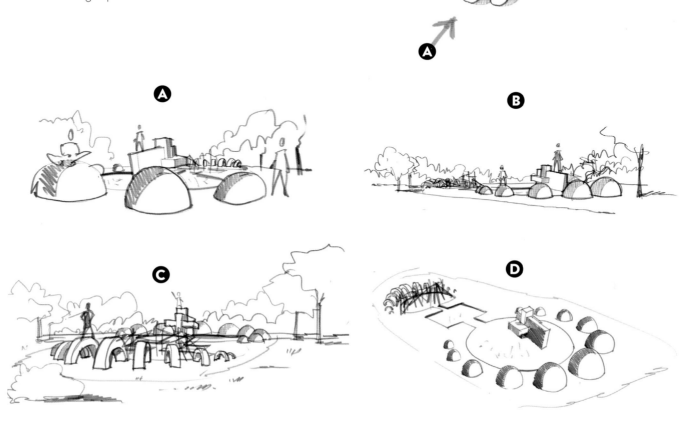

For this particular project, the first concept proved to be the most successful as it provided a good focal point (the focal point here is the collection of our concrete half-spheres in one end of the park), while still hinting how the other areas would be used.

While this presentation consisted of many pages that describe each of the areas, it was important to visually catch the potential and the essence of the concept by creating an engaging single rendering of the park. In the first step, we added more detail to our perspective and made sure we had enough detail, but still using a single line weight.

A: *In this first stage we worked on establishing the main elements, using two line weights exclusively.*

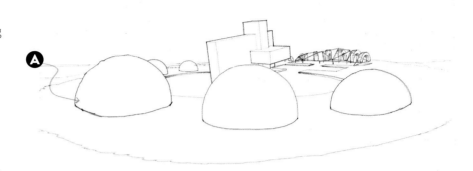

It is interesting to note that the moment we add people in our perspective, the concept suddenly becomes closer to being real, like taking a peek into the future, as we can imagine it being used. The figures also help us establish depth, as we can separate foreground, mid-ground, and background elements in the perspective.

Notice, the figures in the foreground have more detail such as facial features, wrinkles in their clothing, and a two-line weight treatment: thin for the inside lines and thick for the outlines. This technique also helps us bring the figures closer to the front.

A: *The moment we add figures to our design, it becomes "real," as we can start relating to it at a human scale. The abstract concept becomes a believable option.*

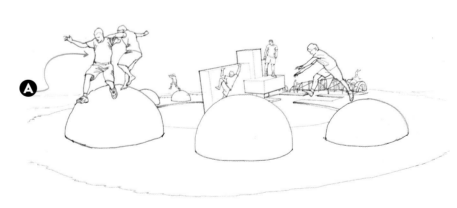

In this next step, surrounding elements were added to the park, such as outlines for grassy areas and tree trunks at various depths and foliage. It is interesting to see how the foliage was deliberately made larger on both ends of the perspective to the left and right, to help us better frame the view and make the park design the primary focal point.

A: The addition of foliage provides a better understanding of the context of use.

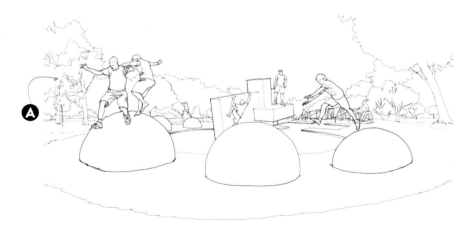

In this next step, we added even more surrounding elements to the park, to bring depth to our rendering. First, we added some outlines of buildings to the background to make the perspective be a city view. Second, we added textural notes to the background, such as mulch for the park area, grass blades outside the perimeter of the park, and circles and dots to suggest cast concrete on the half-spheres in the park.

A: Adding shadows to these figures on the foreground makes them belong fully to the environment.

B: A few textural notes on the foreground allow us to differentiate our materials.

C: Adding buildings on the background makes it believable that this is a city park.

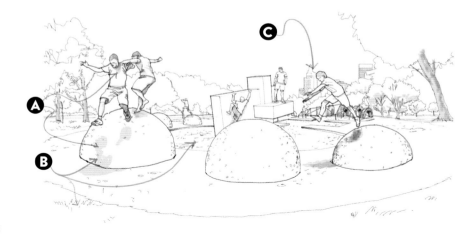

Sometimes adding an extra thick outline to the objects in the foreground and mid-ground elements makes the perspective appear even more three-dimensional. In this particular example, we paid special notice to adding it just on the objects that would help us in this task: the horizon line, the tree trunk to the right, the climbing sculpture, and the half-spheres in the foreground. After this, we added some gray marker tones on the mulched area in the park, and extra shadows on our half-spheres to complete the work in the foreground.

A: Extra shadows on the half-spheres make them appear even more three-dimensional.

B: Extra-thick outlines on the foreground elements for added visual impact.

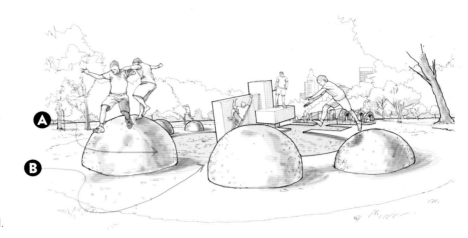

In this final stage, we added color to complete the rendering process. While our previous stage already proved successful in communicating our idea to the client, the inclusion of some color often brings the rendering to the next level. In this case, we concentrated on working with two shades of green and brown trees, grass and foliage, some simple strokes for the sky, and some more intense color tones for the objects in the park and the figures.

Note: We need to be careful when applying color, especially if we added some textural notes on the previous stage. If we happened to saturate our rendering with intense textural work done with thin black pens, then we should be gentle with our color application, as they can collide visually.

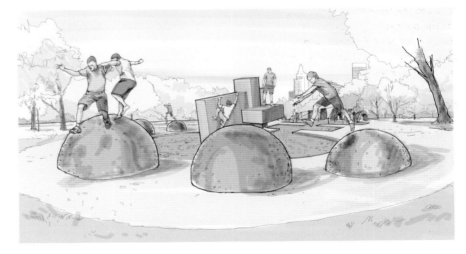

In this second example, we see one more time how designers use their floor plans to mark different points of view before they start the rendering process. Designer Laurie Cogle marked three possible shots, and after only one line drawing (POV1), she realized that starting a perspective with a large furniture piece in front was not a good idea. She then settled for an intermediate solution, which is the mid point between POV1 and POV2, as it lets her see beyond the two sofas in red.

In this plan view the designer marked three possible points of view (POVs), and ended up using POV3 as the best possible solution.

A: Floor plan

B: Point of view 2

C: Point of view 3

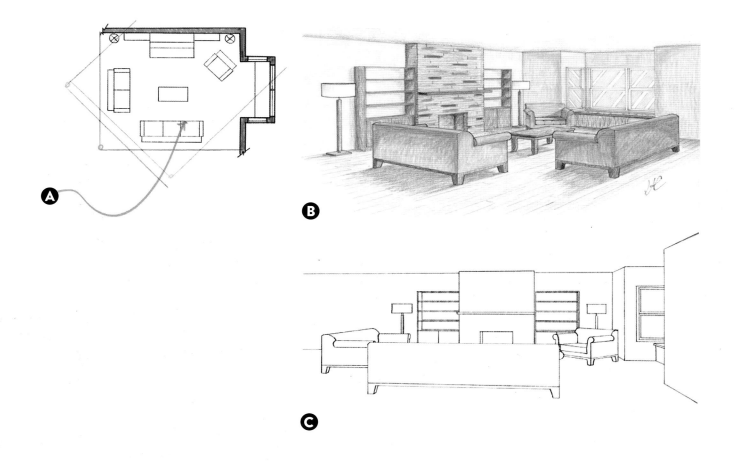

As a final assignment in the storytelling for industrial design class, student Elliott Ouchterlony crafted a series of drawings for a cargo plane with a vertical lift. On these drawings he explored the overall style of the plane, thinking of different turbine designs that would allow the plane to take off while carrying a metal shipping container.

These drawings are done using an underline of non-photo blue pencil strokes to get the main shapes, followed by some black pencil lines. As a final step, black lines are applied to enhance the main volumes and some minor shading is applied with light cool gray marker tones.

The drawing on the top was the first one to be completed. Elliot further evolved this idea with a second concept on the bottom, changing the shape of the propellers and focusing on developing a narrative that would give the viewer a sense of scale. The figures are ready to board the plane, with the cockpit visible at such an angle that we would see the pilot's seat, his access ladder, and finally the shipping container it would eventually be lifting (shown in light blue).

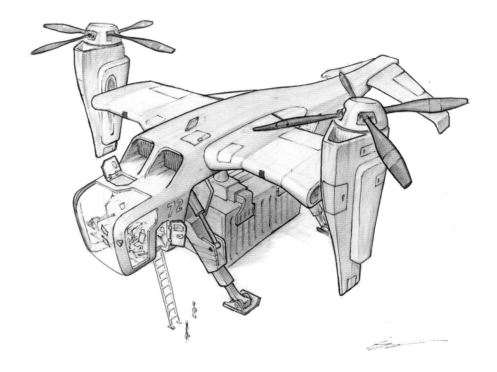

Elliot added a few modifications on
the overall shape while showing how
an oversized container would be lifted.
Some improvements appear on the
fuselage, the flaps on the wings, the
color-coding on the two engines, and
the outlines of various compartments
and access hatches. He added more
light marker tones to the rendering,
making it a much more evolved concept.

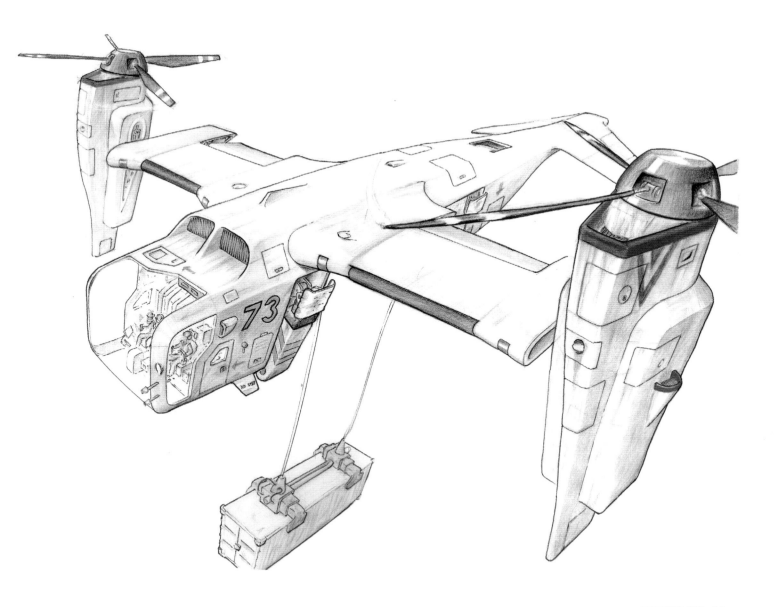

Here he explored the landing gear in more detail—retracted and fully expanded. He also added some yellow diagonal tones as safety decals. In these two drawings, we can appreciate how he works at evolving his drawings, as we can appreciate how the back is unfinished. He found it visually interesting to leave the back of the landing gear unfinished.

Note: Elliot evolved his drawings, stopping at just the right moment. We can appreciate how the back is unfinished, but instead of that becoming an obstacle, he made it work for the story. His design is symmetrical, and by leaving it unfinished we are forced to focus on the details in the foreground.

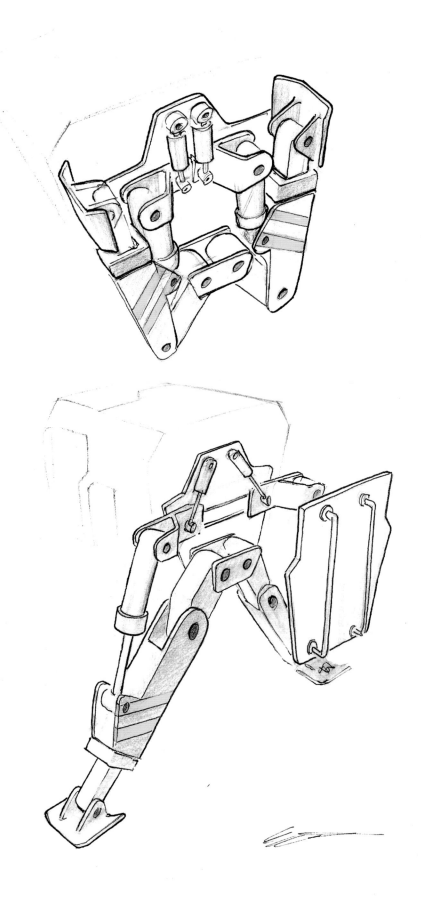

When composing a scene that involves many elements in perspective, we have to combine a variety of techniques in successive stages to make it work just right. Start by ensuring that the main planes in the perspective are drawn correctly. In this particular case, we are organizing a few storefronts of this enclosed street mall, which splits in two at the end. Since the perspective view is already crammed with many architectural features, it becomes crucial to identify foreground, middle ground, and background levels. We do that by adding thick outlines at strategic spots to separate the different depth levels.

A: *Thick outlines to separate background from mid-ground terms.*

B: *Thick outline on main perspective lines, edges, cornices, etc.*

C: *Thin lines to indicate window details.*

D: *Cobblestones small and big to denote depth.*

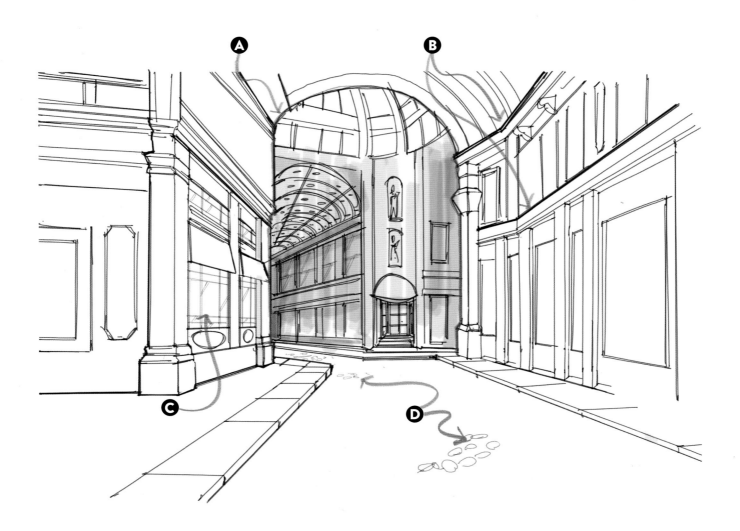

On a second step, we can start adding textural work to make the foreground come even closer to the viewer; this will also make the background appear deeper in the distance. At this stage we added street lamps, medallions, and mullions to the view to enhance our foreground, using exclusively thin black lines.

A: *Added mullions, lamps, and medallions with thin black lines on foreground.*

B: *Added more textural detail on foreground, brick, tile, and concrete.*

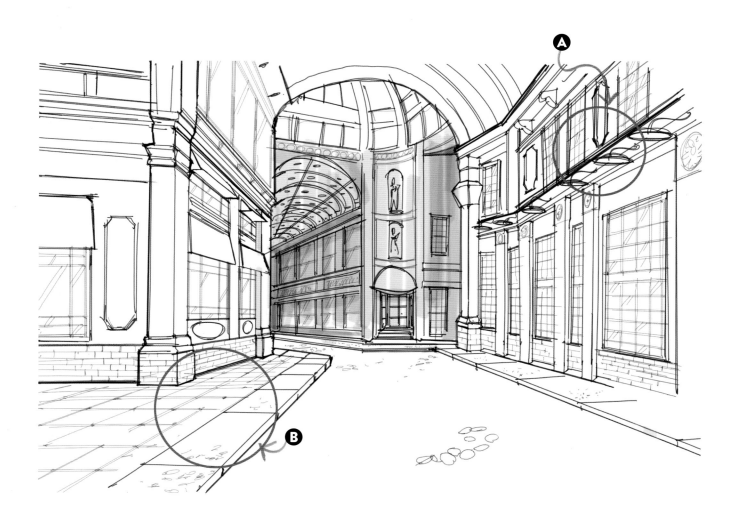

Once our main perspective lines are all covered, we can start adding light marker gray tones in one, two, and three passes. Notice how the background elements received the most layers, while the mid-ground received just some gray washes, omitting the spots where the street lamps would cast their light on the wall. A few gray vertical strokes were added in the sidewalks to make them more reflective and to visually separate the sidewalk from the cobbled street.

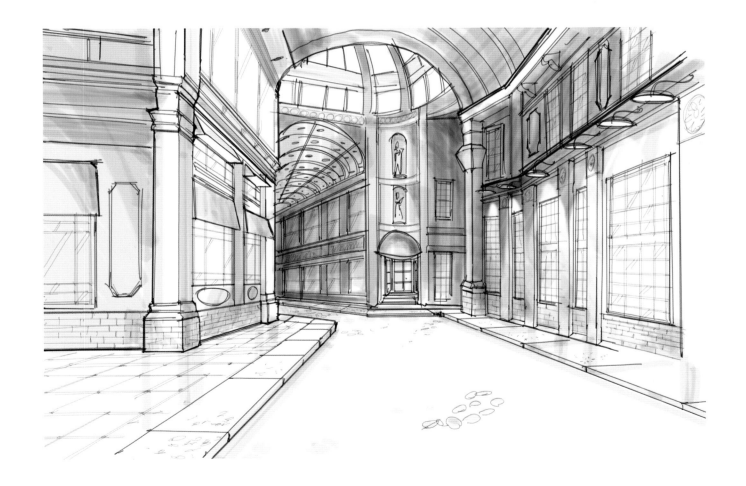

Extra details, such as furniture and figures, are added in the last stage of the drawing to enhance the perspective, focusing mostly on the foreground. We added a few figures walking in the center of the street and two in the background, making sure that they would not crowd the space too extensively or block much of the design proposal. The inclusion of the waiter on the left also adds a suggestion on how the store on the corner would be used as a restaurant. The addition of tables and chairs in the foreground helped us complete the scene entirely.

Note: As long as the perspective has a horizon line situated at roughly 5' 6" (1.7 m), all of the figures would have to be scaled up or down, to ensure that their eyes always align with the reference, regardless if they are placed as big figures in the foreground or very small all the way in the background.

A: Horizon line helps situate our figures in perspective.

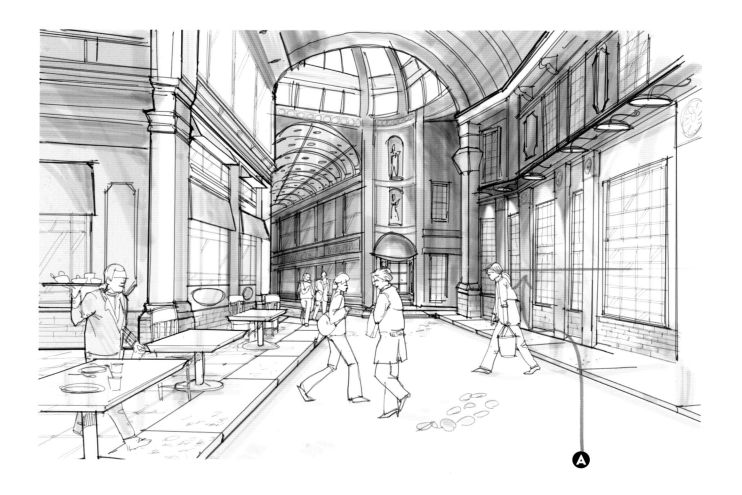

CONTOUR LINE DRAWING:
WORKING A VARIETY OF LINES TO ESTABLISH A "LINE WEIGHT VOCABULARY"

When sketching and rendering, every designer should have a good range of line weights in their arsenal. This range can vary widely from having regular wooden pencils to wide chiseled black pens. In any circumstance, the designer should utilize the different media and line weights to communicate effectively with their audience.

In the first stages of development, designers often use very thin black pens to start defining shapes of objects. In the example that we are analyzing here, we see a good variety of loose sketches—also called thumbnails— for a new type of shop vacuum. Notice how the lines were applied freely, pressing more or less to obtain different intensities of hairline weights as the shapes evolved. This type of drawing thin, loose lines is also called construction line drawing, and it helps to define preliminary shapes without constraints.

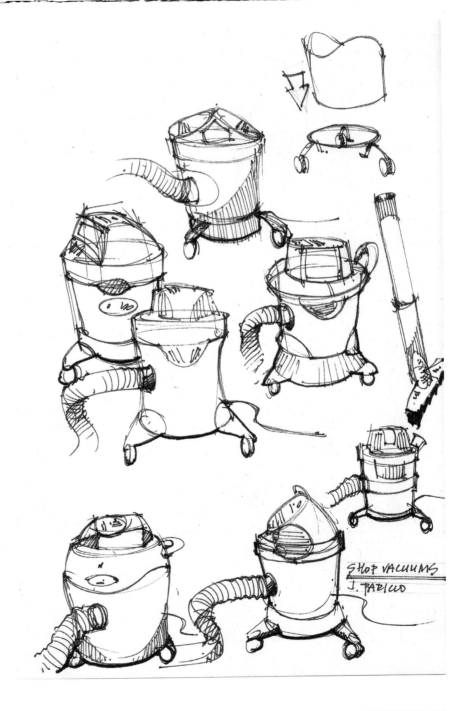

In this second-generation sketch, one design has been selected for further development. I cleaned one concept up, and have clarified some of the elements that did not get specified in the original drawing, such as the addition of a cord reel on the back, the controls and vents on the top, and the definition of the connection from the flexing hose to the main body. This second-generation sketch has been done exclusively using a No.2 black pencil on marker paper, which allowed me to press harder and more clearly define the outside perimeter.

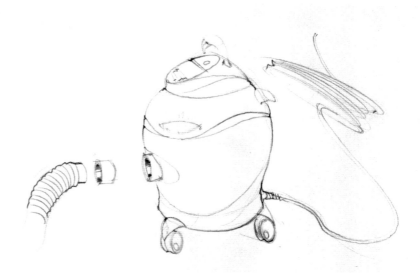

Here, I have shifted from pencil to permanent black pens to further define the shape. I chose a 1 mm thick black outline to define the outline perimeter of the object, and a 0.3 mm thick black line to define the rest: the control buttons, the venting ridges, the slight textural work on two of the undulations on the main body, and the shading lines added to the left and right of the main body and on the bottom of the flexing hose.

Notice here how a thick outline has been added to separate the main body of the vacuum into two halves. After all, the top will need to be separated from the bottom at some point so that the vacuum can be emptied or serviced, and that needs to be noted with a thicker line.

A: *Thin lines to define controls and texture.*

B: *Thick outline to show that the top separates.*

C: *Thick outlines to define perimeter of shapes.*

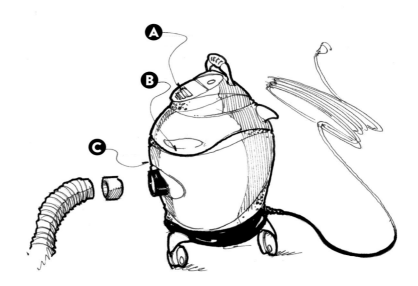

Exclusively using black lines of different weights can represent a whole variety of surfaces and materials, from shiny to rugged, from transparent to hairy. In the following examples you can see a variety of options. In our first example, we are adding cross lines through the center of our object, to make it clear that the surfaces on the side are curved, but not the top.

Using this same principle, we have added curved lines to define a small wooden cube, on our second example. On the other hand, we have a cube apparently done from a single block of wood, but a closer inspection tells us the sides and the top are probably wood laminates, as otherwise the top face would never have lines going across.

On the second row, we have from top to bottom, glass, chrome, and a square shot glass with a thick base. On the chrome sample, notice how the dark band cutting across both sides represent what would be reflected from whatever is surrounding the cube; in this case we are imagining some landscape with a mountain range in the backdrop.

The larger example shows a single object comprised of two different materials— wood on the top and glass on the bottom.

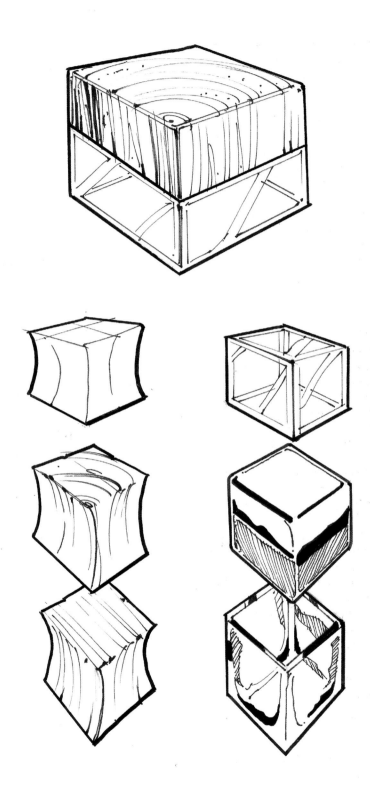

These images are representing a wider variety of materials that can be drawn exclusively with black lines in different line weights: In the first row, we have a shiny cube with soft edges and two upholstered ottomans in different materials: striped fabric, and suede. On the second row, we see the first two ottomans split in two materials: suede and a shiny plastic base, and fur and a matte base. The last piece is an ottoman that is comprised of a soft foam core wrapped with a soft fabric.

On the larger example, we see a low chair that is made of fur and a curving glass base. Note the constraint to the hairlines that define fur on the seat itself; enough lines done on the top and sides can represent the material just fine. Also, see how the lines get thicker where the strongest shadows would gather, on the bend on the seat, and on the bottom curvature.

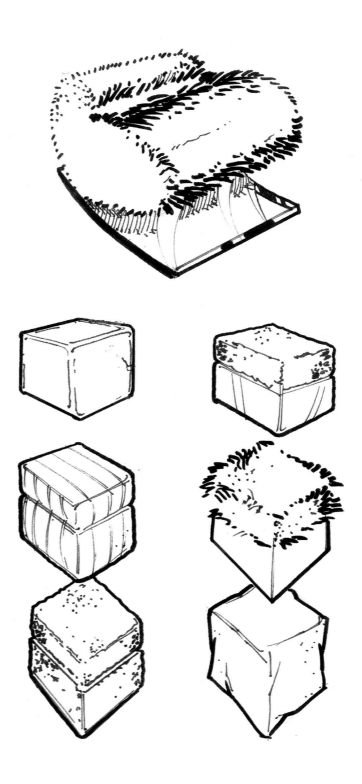

Having a sense of how to use our line weights can be very handy when drawing an object that does not have many straight lines. In this example, we see some sketches of a backpack concept over marker paper; the two sketches on the right were done using black pens, and the sketch on the left was done with a No.2 pencil. Once the main perspective lines were drawn on this larger drawing, the perimeter of the object was knocked out with a thicker line, plus the edge of the top cover and the edges of the front strap.

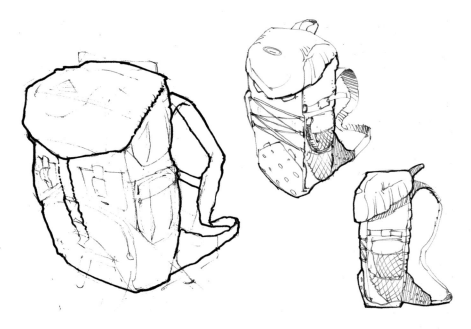

Continuing with the backpack, a few more thick lines were added and then switched to a thinner line weight to show the front straps and some wrinkles in the top cover.

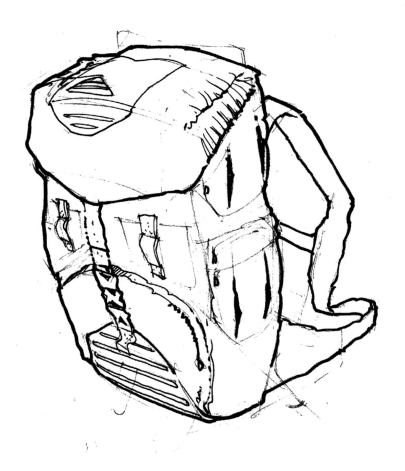

Here, the pockets of the backpack have been defined and added textural work shows the different materials that are used, from the rubbery bottom to the open mesh material on the side pockets. To gain more contrast, a strong shadow was added. It's stronger at the base and lighter as it recedes.

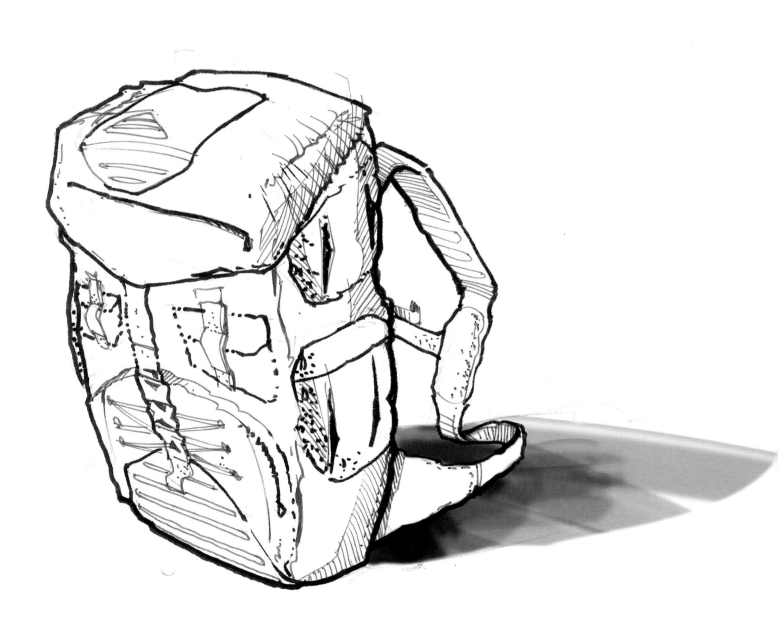

CONTOUR LINE DRAWING:
INDICATING A PROFILE WITH CHARACTER

In the following example, we will analyze the importance of defining contour lines in sketches from the early stages, so that we can define a clear character for our concept.

When working on a complex piece of equipment, such as the Diode Laser Treatment System, it has to be clear that it is easy to use and clean, and it's on wheels so it can be moved around the office. Most importantly, it needs to communicate a sense of calmness and relaxation to the patient. This can be achieved early on by drawing soft, ample curves, soft transitions in the corners and edges, and identifying areas where the doctor needs to interact with the object.

A: *This curved profile defines a handle on the monitor.*

B: *Notice how this curved profile needs to be defined more as it is too close to the angled line right next to it.*

C: *Usually thicker outlines on the bottom of our sketch make a stronger concept (not done yet).*

D: *Notice how this stepped thicker outline defines the character of this profile.*

E: *See how this angled corner would need to be better defined.*

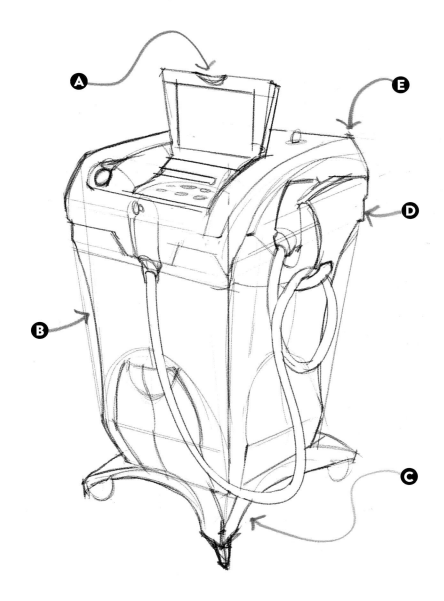

As the sketch progresses, we continue the definition of the shape and character of the device by working on the outside profile, which was cleaned up and intensified in line weight. In the front face, we also added three grooves to visually separate the front from the side, to bring the focal point to the front and continue with the idea of the front curves to the bottom drawer. Secondly, we worked on the shelf on the right by intensifying the outlines and cleaned up our corner right above it. Our next step would be to add some shading and textural work, to suggest materials and finishes.

A: Added double lines to suggest a radius.

B: Added details on the front, to define the front face. Notice how the profile was changed.

C: A thicker outline grounds the design (an added shadow helps).

D: This protruding shelf needs to be outlined to enhance its volume.

E: This chamfered corner better defines our design.

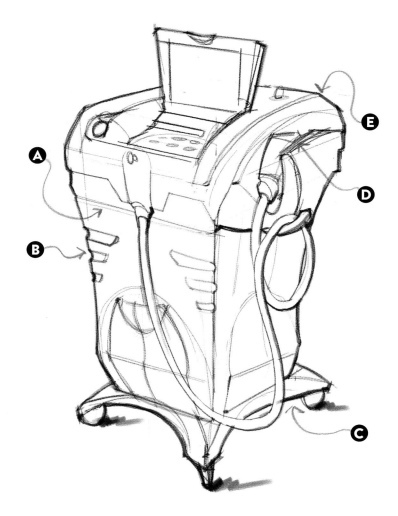

In the final stretch of our rendering process, we added a few gray and color strokes, to add more character and depth to the drawing. We also added some texture to the hose that is attached to the side and made sure that we marked clearly the breaks in between the different parts. The final touch was the addition of some highlight touches on specific corners, to bring them to the foreground.

A: *Adding color allows us to focus on the primary controls and adds visual interest.*

B: *Notch to represent a change in parts.*

C: *Extra details added to hose.*

D: *Some highlights added to bring corners closer to the front.*

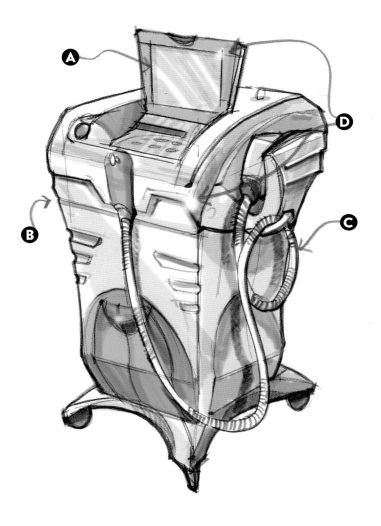

TONE AND TEXTURE:
ADDING DETAIL AND CHARACTER WITH LINE PATTERNS

Using just a digital pencil and some simple airbrush tones, we start to sketch a concept for a room heater.

In the first stage we have an outer shape, the front grill, the handle on the top, and the areas where control buttons would be located, on the top and right. While this is a good beginning, we still need to better define the nuances of each surface. In the sketch on the bottom we see how more lines were added to define the different curves, convex or concave, depending on the uses. These lines are called mid-plane contour curves and are often disguised as the natural parting lines needed to create a mold for our shell.

A: *Jump in the line to show handle.*

B: *Recessed base.*

C: *Recessed area for control buttons.*

Note: The lines that cut an object are usually called mid-line plane cuts or fin lofts and are crucial in establishing the direction of a particular curved surface. They can be drawn longitudinally or transversely across an object, as if a plane would cut through it. These lines often are disguised in our renderings as parting lines or changes in a material.

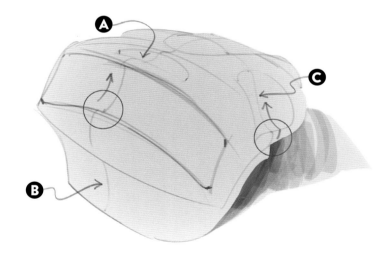

In this second stage, we see how the use of lines can be used on a more finished rendering to depict highlights or show reflections on a glossy surface. This is usually done at the cusp of a curving surface, at the edge of some parting lines, or to highlight a particular break in a component that is visually dominating the design. In this example, it was important to show vertical white lines right next to the black lines that define the open grille and obtain a stronger visual presence.

A: *Highlights next to black lines to accentuate vent.*

B: *White strokes to enhance a shiny surface.*

C: *Highlight to mark a possible parting line.*

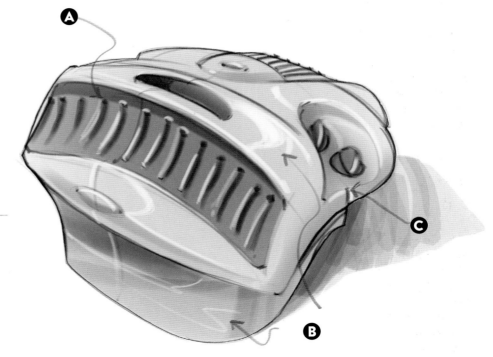

For a pair of sport shoes, we start with a fine point pen to draw the outline of the shoes, followed by some quick parallel strokes with a light brown marker. Depending on the type of paper, the strokes will blend more or less, but the ultimate goal is to obtain a consistent color application that will blend the strokes as much as possible.

Note: The use of parallel strokes with markers can produce very different results, depending on the type of paper that is being used. For example, marker or vellum papers will absorb ink less rapidly, thus allowing the ink from the various strokes, to blend into a uniform tone. On the other hand, more absorbent papers such as Bond paper (your typical printer paper or Canson paper) will show each individual marker stroke, on top of a darker tone.

A: Double strokes, 70 percent gray tone over the original brown tone.

B: Parallel marker strokes applied quickly, so they blend.

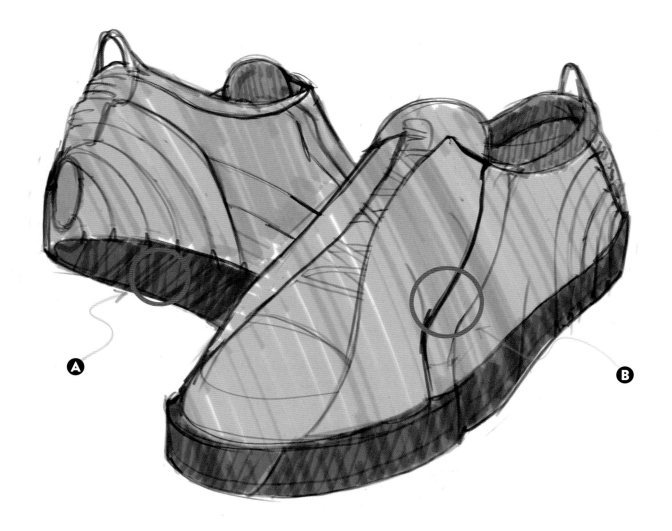

On a second pass, we used a dark brown pencil to mark the shoe's material. In this case, suede leather for the shoe and rubber for the sole and heel area. For this last part we used a 70 percent gray marker in one or multiple passes to obtain the necessary color depth on top of some light gray tones to make the whole design more volumetric.

A: 70 percent gray marker strokes for rubber texture.

B: Two passes of 70 percent marker strokes for rubber sole.

C: 10 percent gray marker lines to push volume.

D: Pencil dots added to suggest suede.

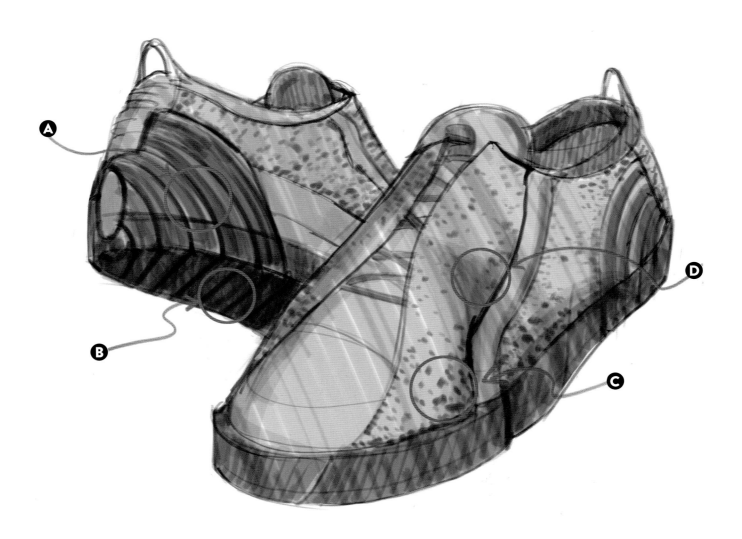

On a third and final stage, we used a few passes to make the whole design look more finished. We used a white pencil to mark some of the stitching patterns and add more volume to the rubber elements on the heel and sole. Next, orange and red pencils are used to create design accents such as the finger loop on the back, the laces, or the logo detail on the heel. Lastly, gray tones are used to separate the different stitched leather patterns more.

A: Color accent for logo.

B: White pencil strokes to enhance volume.

C: Stitch marks with white pencil.

D: Suggestion of an open mesh fabric.

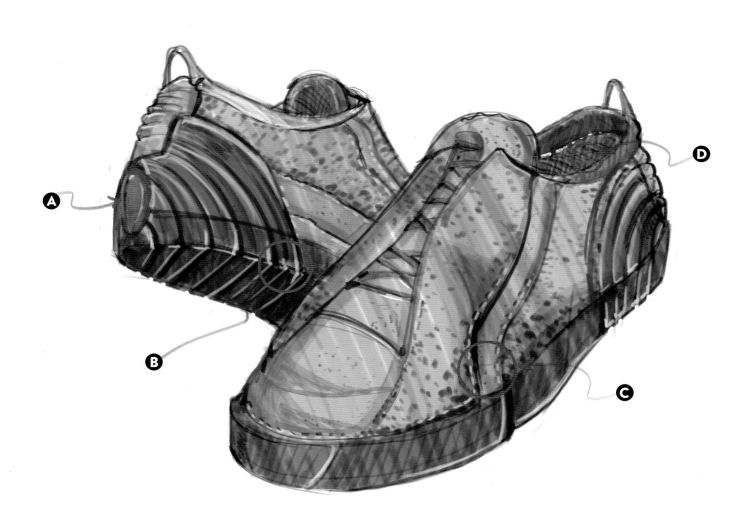

TONE AND TEXTURE:
INTRODUCING MATERIALS, TEXTURE, AND COLOR USING PASTELS, PENCILS, AND MARKERS

Showing different materials convincingly is a very important part in the process of sketching, as the designer has to communicate a credible concept to the client.

The first three concepts for a bathroom faucet are pencil sketches using different line pressures—thicker on the outline and thinner to define changes in the curves themselves. The remaining three concepts are starting to show a highly polished metal finish. The process of rendering this type of finish always involves two contrasting tones—a very light color and a very dark one. We started with the darker tones at the point where the curves would change direction.

On a second stage, we added a light blue tone right above the dark reflection, as if those areas were catching glimpses of the sky being reflected on them. Usually these lighter tones are added with either a soft airbrush stroke digitally or with light blue pastel tones added with the help of a cotton ball.

On the image on the bottom, the process was completed with mid-blue tones added below the dark reflections, along with some extra highlights and a mid-blue tone for the background to tie everything together.

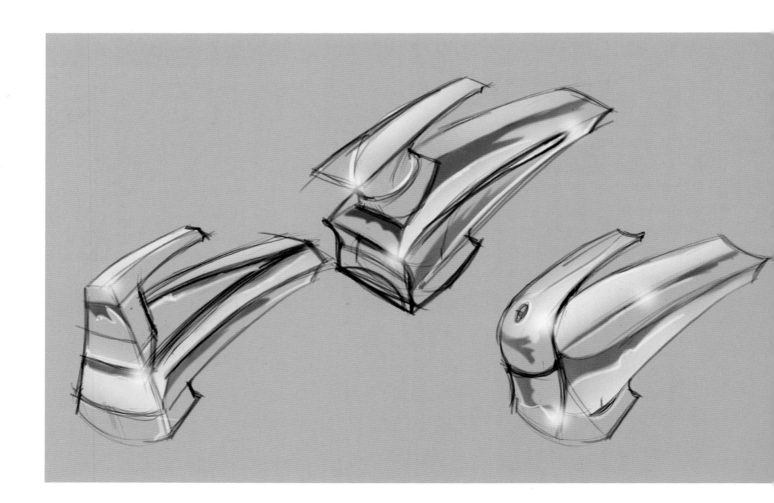

In this example, we see how we can apply gray tones—plus some white and blue highlights—to obtain a highly reflective result on a pewter teapot. We worked with three gray tones on Mylar paper, which is especially suited for marker strokes. The very nature of the paper does not absorb the ink but rather it evaporates on the surface, thus allowing us to blend our different stroke passes. Also, this situation lets us work with puddles of ink that might blend with other tones, mimicking a watercolor reaction. We started with the lightest tones and worked toward the darker tones, while trying to keep the original white tones of the paper.

The end touches of white and blue pencil highlights infuse another dose of realism, capturing other reflections that might be around the object—mainly sky tones and artificial lights.

A: Highlights added with gouache.

B: Blue pencil highlights.

C: Gray marker tones over Mylar paper.

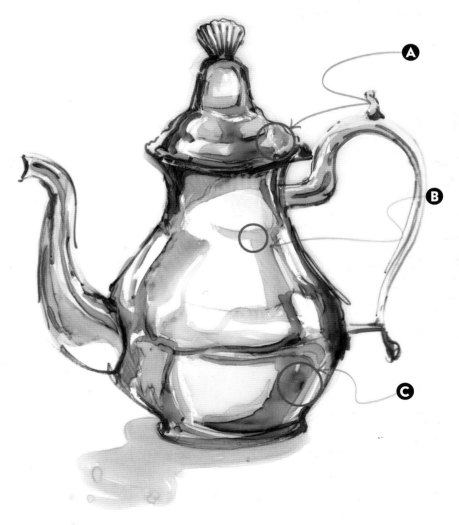

In this example, Rhode Island School of Design (RISD) student John (Tate) Sager worked on a series of front views to show a potential client a range of sizes of a liquid container. The goal here was to deliver a consistent message of a shape, going through a range of container sizes, while clearly showing the chrome finish present on the double cap system and the metallic top. Often, the rendering process can be simplified if we work on adding color, line weights, and texture on orthographic projections rather than on perspective views; that way it can happen quickly, and you don't have to worry about working with vanishing points or drawing ellipses correctly. The challenge is to communicate shapes effectively without compromising either the concept or how the materials are rendered.

To balance the lack of perspective, Tate projected a shadow behind these three shapes, making them appear more three-dimensional, and added three top views to define the depth of the three bottles.

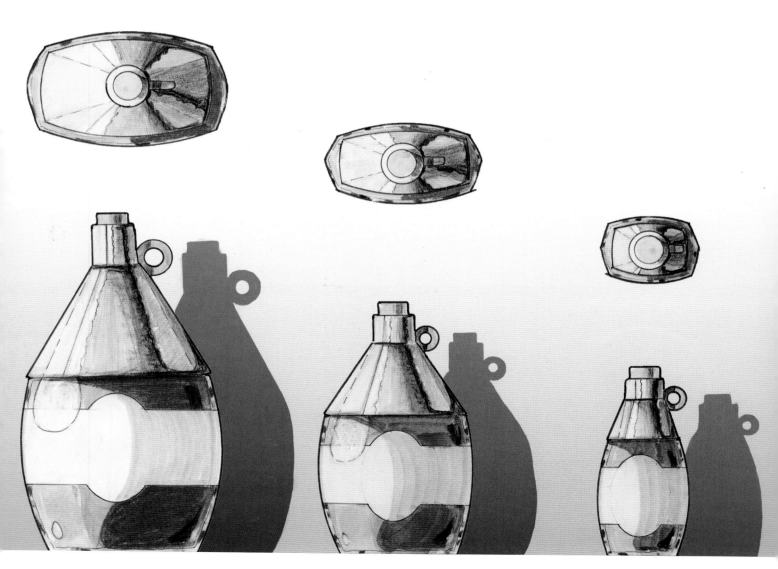

In this boat sketch, we wanted to emphasize the wooden and glass textures. To obtain this soft result, we worked with a tonal base of burnt orange and light blue for wood and glass, respectively. On a second pass, we applied some light brown pencil strokes to mark wood grain tones, and for the glass surfaces we added a darker blue tone with a hint of purple on the edges. An eraser was used to obtain highlights and glare spots on the curving surface.

A: Light and dark blue pastel tones on windshield. Glare strokes done with pencil eraser.

B: Light pastel tones with brown pencil strokes to show wood grain.

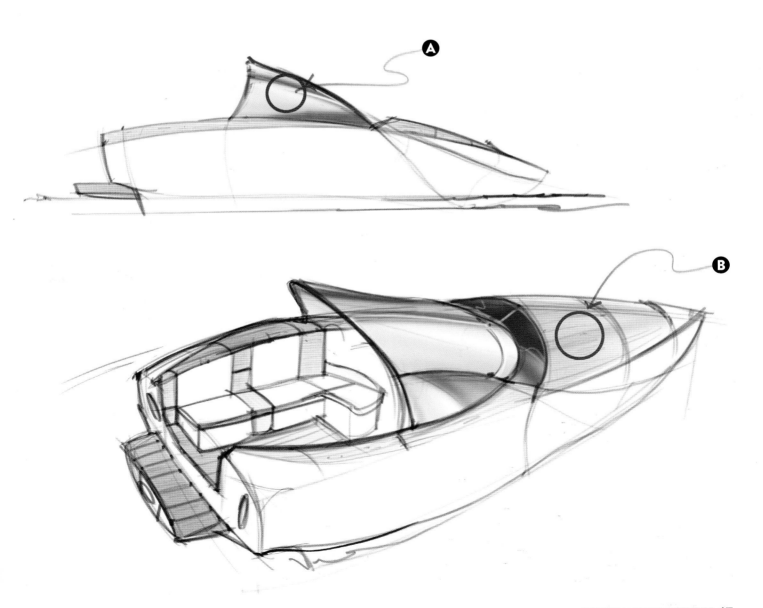

Drawing glass convincingly needs to be done with some attention to detail, as we do not have much color to work with. In this image we see two stages in the process of developing a pitcher and a set of glasses. In the image on the top, I developed the main volumes but I didn't indicate the material they would be made of. On the image on the bottom, I added some double lines to indicate the thickness of the glass. I continued working with the black pencil, finishing the water line on the pitcher on the area that is closest to the handle.

A: *Double lines to indicate the thickness of the glass.*

B: *Double line that does not define clearly if it shows the thickness of the glass or a round edge on the base of the pitcher.*

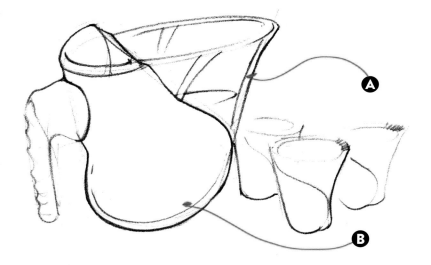

I continued working with the black pencil, finishing the water line on the pitcher on the area that is closest to the handle. Then, I added a colored background, using a small gradation from a dark wheat tone on the bottom to a light cream tone on the top. I worked out my opaque materials on the handle and the partial lid, using a dark gray tone, and vertical strokes. Then, I used a light gray tone to increase my contrast on the bases of the objects and on some edges. Finally, I added a light white wash on the left sides, to separate the glass further from the gradation on the background.

A: Light wash tones added to make the material look more like glass. This can be done with equal success with white pastel shavings and a cotton swab or digitally.

B: Glare lines done on all four objects to further suggest glass. Notice how the glare stops at the diagonal ridge in the body of the pitcher.

C: Light gray tones added on the small ridges on the glasses, to depict glass more convincingly.

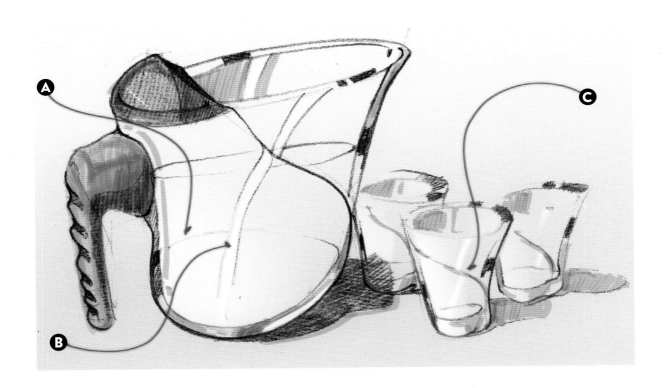

To finish the rendering, I added colored liquid to the pitcher and in one of the glasses. That also gave me the opportunity to add some color reflections on the edges of the glass material. I used two tones of orange in vertical strokes, lighter for the main body and darker for the edges.

A: Extra textural notes added to the handle to suggest rubber.

B: Bubbles added to the liquid to make it look as if it was a carbonated drink being served.

C: Light gray tones to mark a soft shadow under the handle.

D: Light black pencil strokes to add more reflections to the main body of the pitcher.

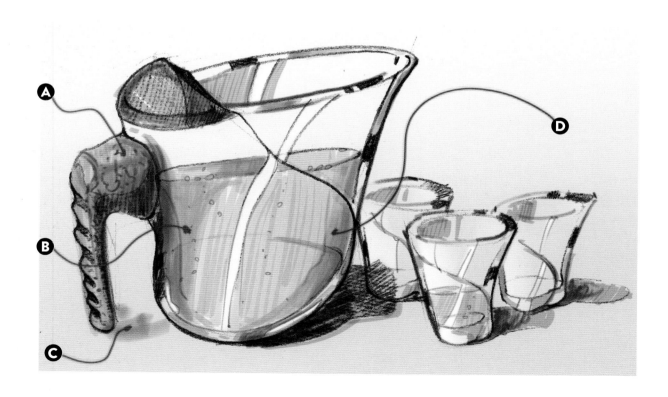

In this drawing we are going to work with two materials, metal and glass, shown on a side table design with an Asian influence. I have worked with vertical marker strokes on a gray marker paper, making sure that I would leave some gaps, as I would use them as reflections later.

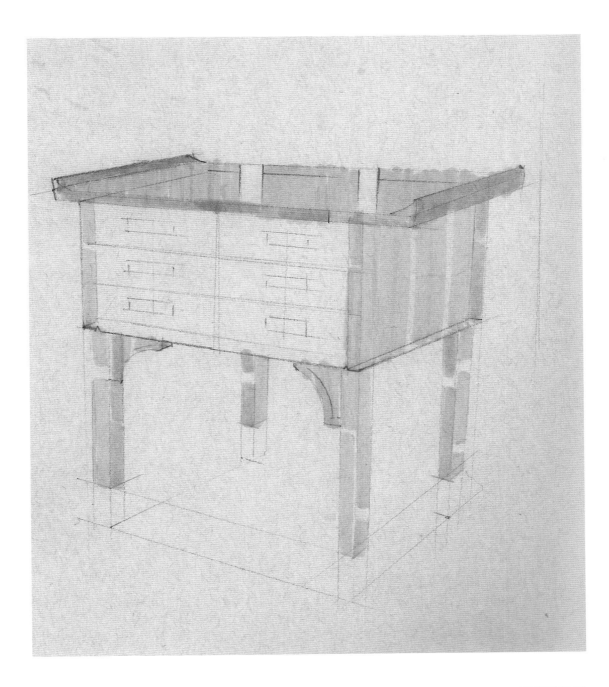

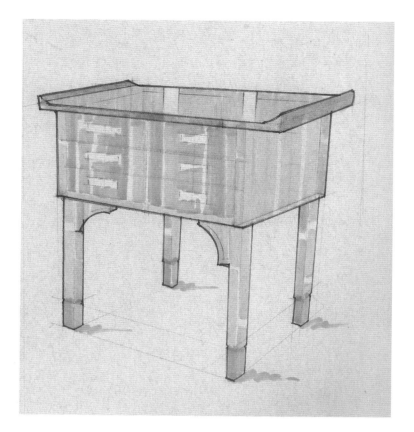

In this next step I started to work with a second tone, working with a gray marker on the remaining surfaces that would be made of metal. I also made sure to leave some gaps for my reflections, just like I had done for the glass surfaces. A thin black line is helping me to separate further the shape of my table from the background, and a slight shadow note also makes the object rest safely in the floor.

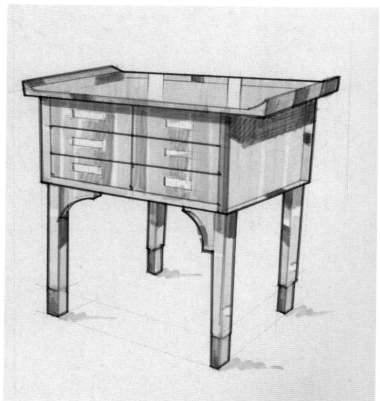

I worked with stronger gray tones to add more contrast to the table, especially on the legs on the back and on the edges of the glass top. Adding extra thicker black lines further separates the object from the toned paper.

This step is a necessary preparation for my next one, which will separate further my metal from the glass materials. I worked on a background shape with a burnt sienna tone, using lighter tones on the bottom and darker tones on the top.

Note: Placing a rectangle in perspective in our drawings can make a final concept appear more three-dimensional and visually appealing.

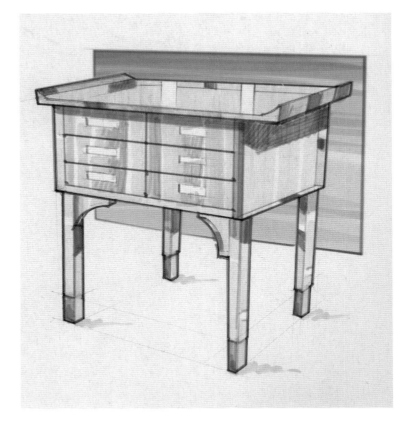

I added some final touches with the same burnt sienna tone on the glass surface to make it appear more transparent.

Note: Adding a background is the easiest way to separate transparent materials from opaque materials, as that color would still be shown only on the transparent ones.

TONE AND TEXTURE:
FADING AWAY DETAILS AS WE MOVE TOWARD THE BACK OF THE OBJECT

The creation of a well-balanced rendering needs to include many elements to make it believable, and one of them is working with tones and textures to represent different materials. Under this category we can adjust those values by diminishing the intensity moving toward the mid-ground and background.

In an architectural or interior design drawing this situation can be analyzed promptly as we can easily move from one room to the next or from one wall to the next, but it can be more challenging when we draw objects that do not have either differentiated planes or a single straight line. In this example of a pair of sneakers composed by RISD student Mary Yining Shao, she developed a complex shape with many textures and shadows.

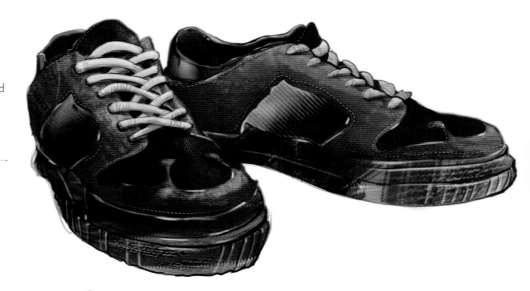

In this closeup, it's easy to see how something as simple as a stitch line can help to convey a sense of depth in renderings. To make the sneakers appear more volumetric, the stitch lines are shown in full white tones in the toe-cap area. The example on the right appears flat and uninteresting as the stitch line is treated with equal intensity all around the edge, but on the other side, the stitch line on the left fades out slowly toward the back of the sneaker, giving a clear three-dimensional sense.

A: Stitching that is faded to help with perspective.

B: Stitching not faded.

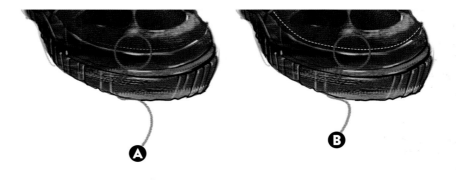

More traditionally, the way renderings can appear more three-dimensional and volumetric is by adding highlights on the areas closer to the front (or if we are rendering a group of objects or an interior, highlights would be added to the objects on the foreground only). This technique has been used for centuries by master painters who would add highlights in portraits in the areas that give them more play: by the tip of a nose, in the middle of a forehead, and in the upper lip. And of course, the glare of the eyes.

A: Final rendering without highlights.

B: Final rendering with highlights.

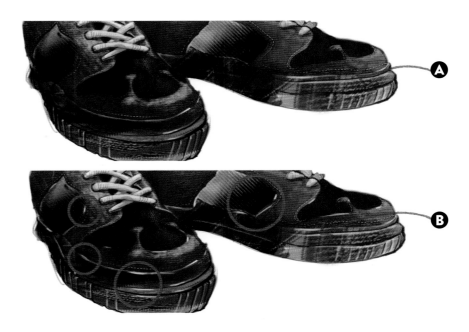

CHAPTER 2
INTUITIVE PERSPECTIVE:
FREEHAND SKETCHING

Sketching loosely is an activity that cannot be taken lightly. It allows designers to explore different alternatives quickly, but it requires concentration. There are different techniques to explore design alternatives, but usually we start with the most obvious solutions and sketch concepts that come without much thinking. Then little by little, we pick out good design solutions and details from the different sketches and combine them into more unique and sound solutions.

The sketches here are of different ideas for a cat carrier, done exclusively with pencil and paper. My starting point is the cat carrier with the cat inside. I started with a traditional shape, made of two connecting halves that can nest inside each other for storage. Then I added a carrying handle, borrowing inspiration from carry-on luggage. From there, I added more quick sketches radiating from this first one, which are marked with red arrows. As a third step, I did more sketches to fill in my page, which are marked with purple arrows.

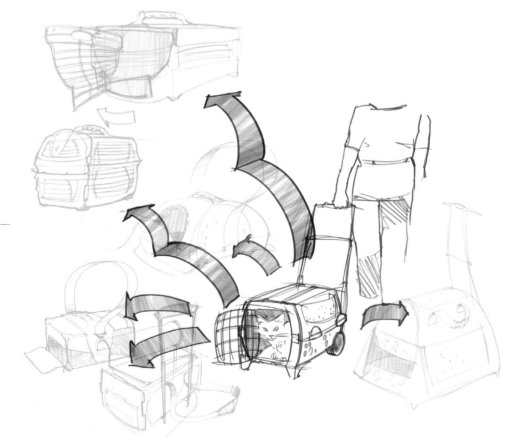

As a final thought, I added one more sketch on the top of the page, referencing wing doors on cars, and adding an extra note on a folding handle on the right. Wouldn't that be cool to have wing doors on a cat carrier? Without thinking too much about the mechanical complications, or if that design would be appropriate or not, I went ahead and drew it, just to keep a visual record of that thought. The goal in our preliminary sketching is to draw freely, without any preconceived notions. I added some quick color tones to the sketch that I could pursue for further development.

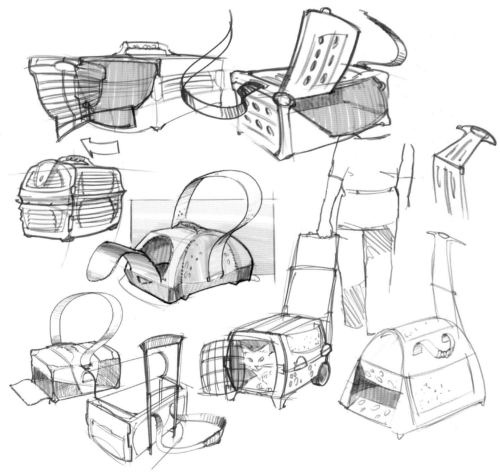

INTUITIVE PERSPECTIVE:
LOCATION SKETCHING

Sketching on location cannot be compared to any other form of sketching. On-site we get to appreciate the object or the scene that we're about to draw, in its full essence. We can walk around the object, feel it, touch it, and appreciate it in its environment. We can see so many other things that we would miss if we only had a photograph. But sketching on location can have its drawbacks, such as crowds in public spaces, intersections, or museums, or having limited materials on hand, versus everything back in the studio. This, however, can also make you a better sketcher, focusing on what needs to be captured and working quickly and efficiently to maximize the limited lapse of time that we are giving ourselves to draw on location. The following two sketches were done on location in the Santa Fe Plaza, in the city of Santa Fe, New Mexico, using exclusively a pencil, a black pen, and a portable watercolor set with a single brush.

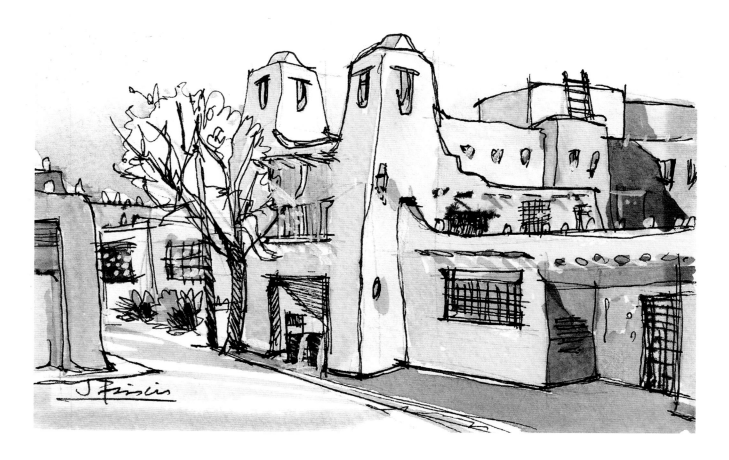

Santa Fe Plaza, New Mexico.

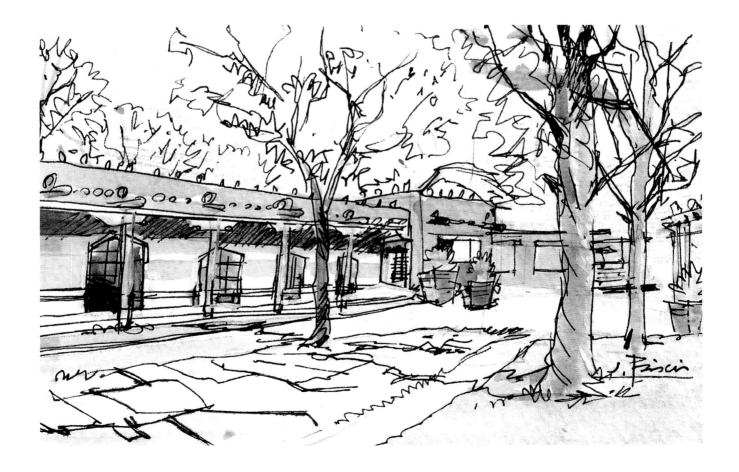

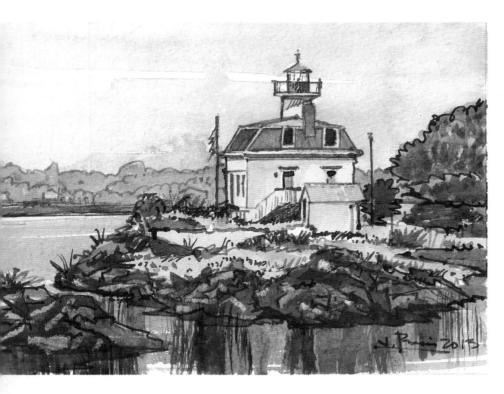

These watercolors were done quickly by hand and on site, exploring the terrain and finding just the right point of view. I later applied color on the same substrate where I marked my perspective lines. This first sketch is from a series of watercolors that I completed of Rhode Island lighthouses. I started with the secluded Pomham Rocks Lighthouse, a great structure built on a small rocky island in 1871, near the port of Providence, which can only be seen up close from a boat or from a nearby bike path.

By enlarging this view, I was able to work on three depths: the grass on the bottom left corner that defines the foreground, the wooded and rocky island to the left that define the mid-ground, and the houses on the other side of the bay for the background.

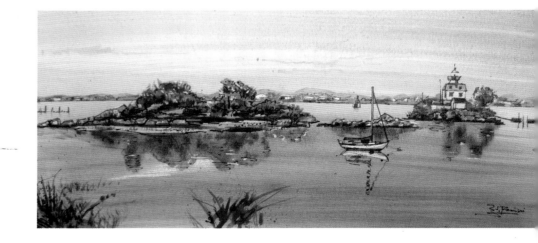

I did this sketch onsite in Warren, Rhode Island. After a survey of the grounds, I wanted to capture it from the left, as a view from the opposite angle would hide the side entrance that is slightly pushed back. I worked out quick pencil lines on the watercolor paper to find the right composition and to find out how much space I would leave for the trees framing the background and for the road in front of the structure.

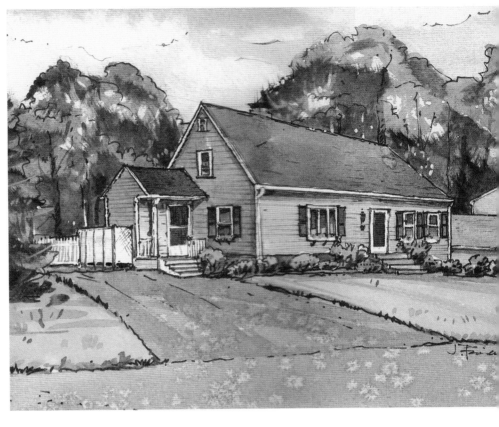

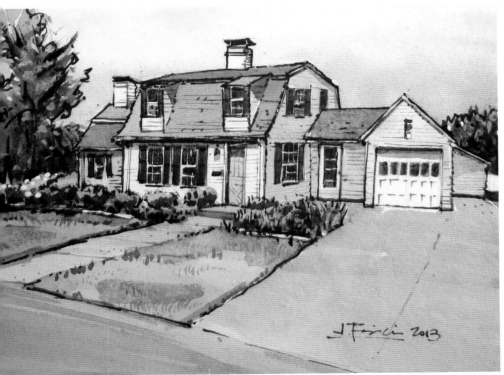

This is a house in the historic city of Newport, Rhode Island. This particular structure had many different volumes that needed to be shown without flattening them, which is why I chose to angle my view slightly as if I looked at the house from the right. A frontal view would have muted the recessed volumes from the sunroom, the mudroom, the garage, and the shed in the distance. Then, before applying my colors, I blocked out some white areas using masking fluid and applied my color by brushes and in different stages. A final pass of black lines helped me define the overall shapes and textures.

Sometimes, location sketches are done on a whim, where the only materials on hand are a piece of paper and a pencil. In this particular case, I was at an airport waiting for a connecting flight. I wanted to capture the large open space available for passengers waiting to board their planes and how the concrete columns connected to the roof rafters. It was an exercise in capturing an otherwise lost moment, allowing me to brush up on my drawing skills.

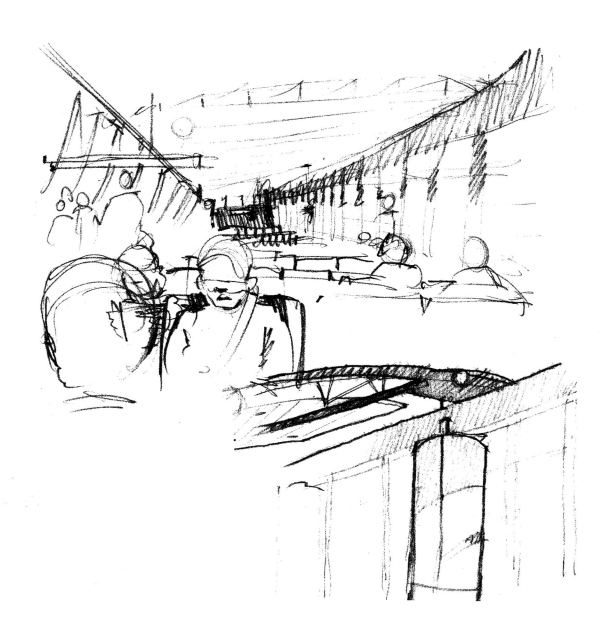

The sketch of this 1876 sofa was done on location at the Rhode Island School of Design (RISD) Museum in Providence. I completed it without erasing my preliminary construction lines, which are still visible in some places around the perimeter. I chose to work on newsprint paper, as it has a rough texture and plenty of tooth to work with pencil tones that complement my inking and marker layers. The gray marker used in some spots appears too dark, but it was used as an advantage to play with strong shadows representing the upholstered backrest with the button backs. The ebonized wood was done using a 50 percent gray marker, followed by dark red pencil tones on top.

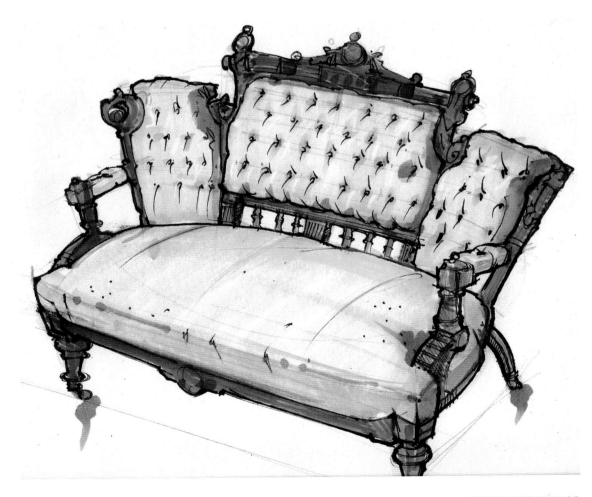

INTUITIVE PERSPECTIVE:
SKETCHING OBJECTS FROM OBSERVATION

These sketches were done prior to developing a series of sketches for a coffee service. My source of inspiration was the Gorham Manufacturing Company, and more specifically, the style developed in the 1960s, with clean, open curves and distilled shapes. The original sketches were done using exclusively a 0.5 mm black pen on acid free paper. Some of the lines drawn in the objects are acting as a visual reminder on how I would later work in the studio, adding different marker tones to further differentiate the materials.

A: *Thicker lines to accentuate the rattan-wrapped handle.*

B: *Wavy lines to mark reflections.*

C: *Hatched areas to mark darker areas.*

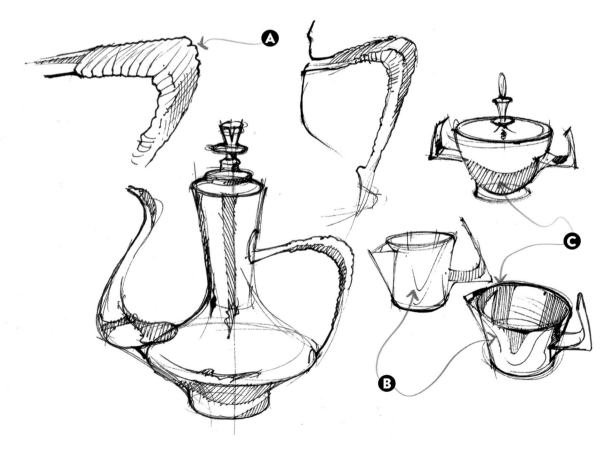

In the design studio, I added some extra color with markers to the original black pen sketches. I followed my wavy, thin black lines and hatched areas as a guide to add extra gray tones.

A: Brown lines to accentuate the rattan-wrapped handle.

B: 30 percent gray marker tones to exaggerate the reflective quality of the polished silver.

C: Color marker accent to visually separate the materials.

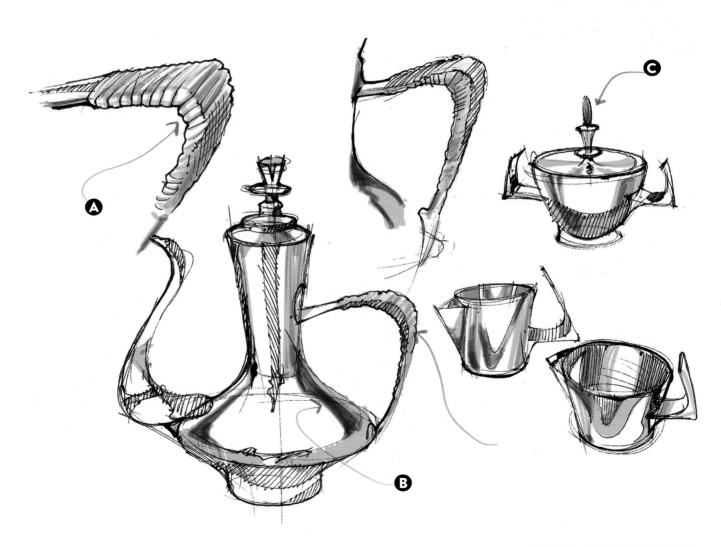

Drawing from observation also leads us to understand complex shapes, especially if we take our time to sketch. In this example, I was drawn to the copper-clad balcony on the Waterman Building at RISD. I have always loved the green copper stains and how they take different hues when illuminated by the crisp, winter light. All the interesting details are lost at street level, as this balcony is situated on a second level, but these details can be appreciated fully from the adjacent building. This drawing was done on an 80 lb. acid-free Strathmore Toned Gray paper, working in parallel with light and dark tones. I used white and black pencils, along with a 40 percent cool gray, 20 percent French gray, and a light green marker.

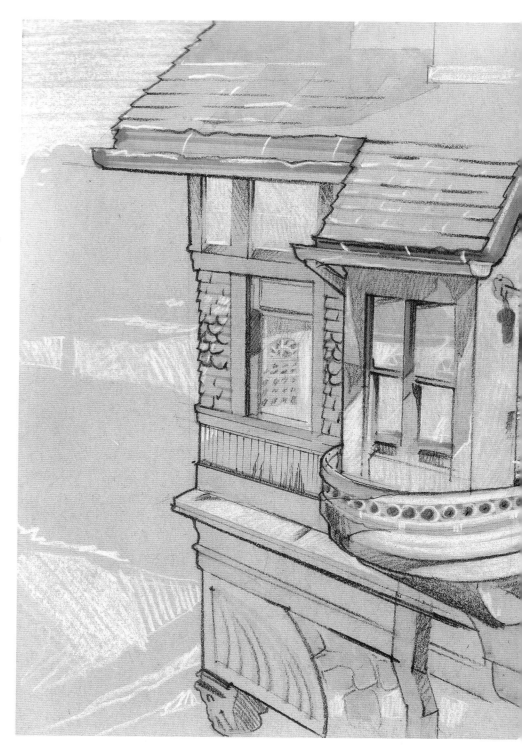

INTUITIVE PERSPECTIVE:
USING GEOMETRIC CONSTRUCTION TO MANAGE PROPORTION

When creating a rendering of an object or groups of objects that have complex geometries, it is always a good idea to start the sketching process by simplifying the composition into a series of simple shapes. In the following rendering, we see how a backhoe has been drawn in four stages, starting with two very simple boxes to define the main volumes: the cabin and the boom ending with the bucket. In this first sketch, I worked on two separate views, a very low and a very high one, just to find the best angle.

A: Simplified geometry from a high point view.

B: Simplified geometry from a low point view.

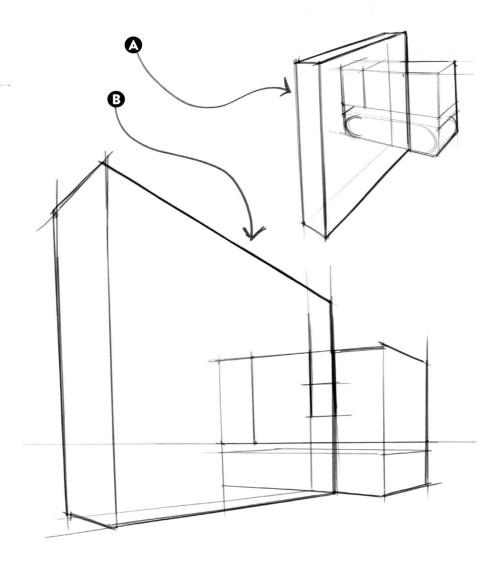

After creating the basic shapes,
I started to add more lines and cut
the main prisms into more complex
geometries. For the prism belonging
to the arm, I sliced a big corner to
make the boom look as if it was made
of two major segments, and then added
the first curves that define the bucket.
For the prism belonging to the cabin,
I separated it from the links and road
wheels and removed a big square off
the cabin, as the section containing the
engine did not need to be as high as the
cabin itself. At this point I gave up the
high point of view and concentrated on
the lower point of view.

A: *Simplified geometry from a high
point view.*

B: *First curve done to break the simplicity
of the composition.*

C: *Extra curve added to note the links
and the road wheels.*

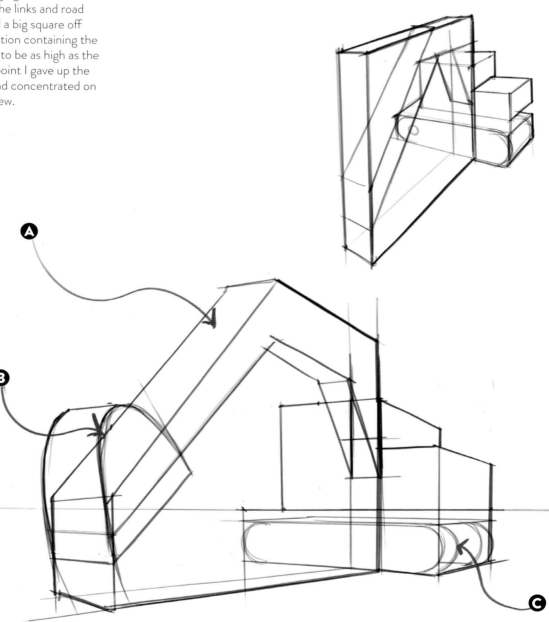

After placing tracing paper on top of the geometry previously done, I worked with thin and thick lines to define the main elements and details, such as the boom and bucket cylinders, the hoses for the hydraulic system, and the outline for the seat in the cabin. I made sure to increase my line weights as I drew toward the front of the arm, ending with even thicker lines to define the perimeter of the bucket and the teeth. I also added strong shadows on the underside of the arm links, to make them more three-dimensional.

A: Strong shadows to define the links.

B: First color notes to mark reflections on glass surfaces.

C: First color notes to mark shadow lines on the steel body.

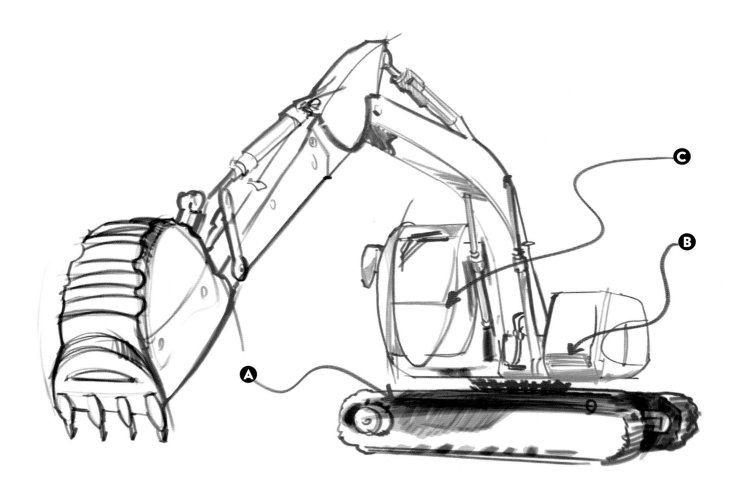

I then added color using marker tones for the painted steel—yellow for the highlights, orange for the darker tones, and light brown for the sides in the shade. I also used more blue tones for my glass surfaces. At the last minute I decided to include a quick rendering of the bucket, but from the opposite point of view, so we would have a better understanding of how it would look.

A: Dark tones to increase depth in the drawing.

B: Blue tones to define the glass cabin.

C: Brown tones to define the dark tones on the steel body.

D: Yellow tones to define the light tones on the steel body.

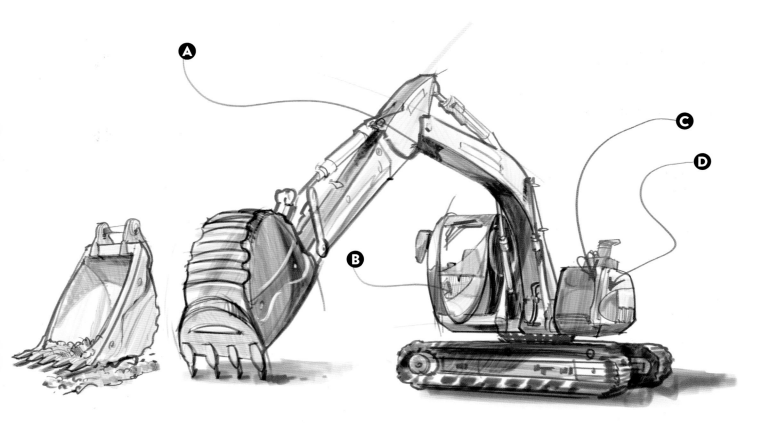

In these sketches, I am going to create an upright vacuum cleaner using simple geometric shapes to manage my proportions and perspective. First, I created a series of boxes to obtain the main volume of the body and some cylindrical shapes to generate the main body of the handle. At this stage, I did not worry about the intersections of the geometric shapes, as I only wanted to gain a general idea of the mass that I wanted to work with.

In the second stage, I added more detail to the geometric shapes by cutting curves and adding more precision to the original rough boxes, but still keeping simple geometric shapes in my range of options.

A: Left this connection unsolved, as I wanted to create a stronger visual element here.

B: Added a truncated cone to connect my handle to the body of the vacuum, but did not solve yet the resulting shape in the intersection of these two shapes.

C: Solved the intersection of the main round body with the large cylinder.

D: Worked on the intersection of these two cylinders.

E: Modified the original larger shape and made a smaller box, started to curve the two front edges.

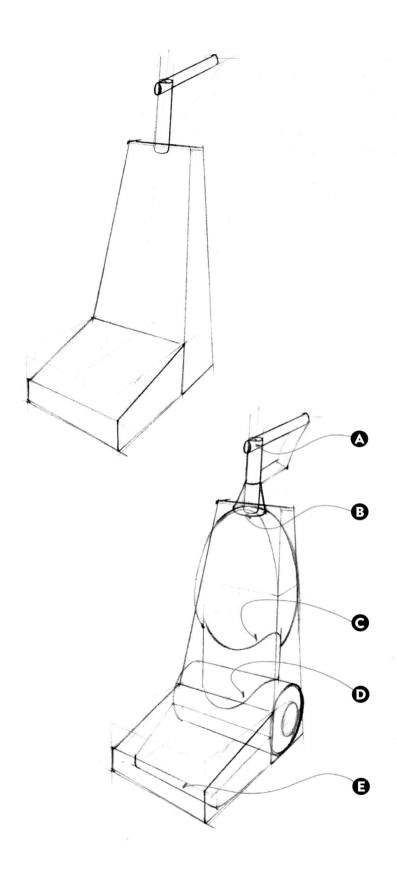

I completed the sketch of my upright design, working with different line weights to separate my main volumes. The very thin curved lines helped me understand the changes of the main volumes, especially on the bulging body of the vacuum cleaner and the front part. The hatched lines on the sides, the edges, and the handle suggest the use of a different material.

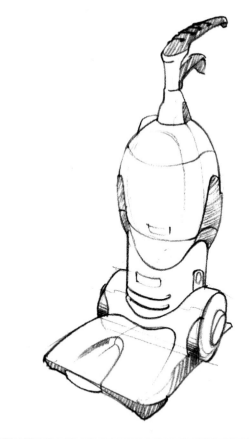

Adding color using digital airbrush techniques brought it all together along with a background tone. I separated the indigo tone for the main body parts that are plastic molded from a rougher gray tone, which could be textured later on.

A: Added shadows on the side of the upright handle, to denote a slightly shinier material.

B: Added reflection tones to make the blue parts much shinier.

C: Used a yellow color to mark the two lights present in my design, in the front and the main body.

D: Added a light shadow on the floor to ground the object.

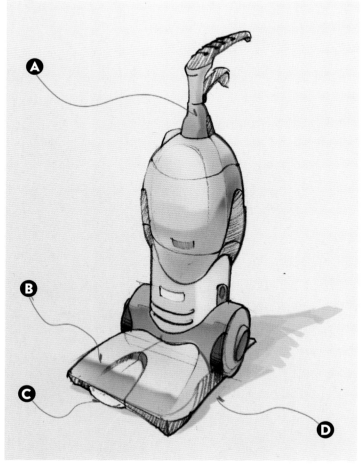

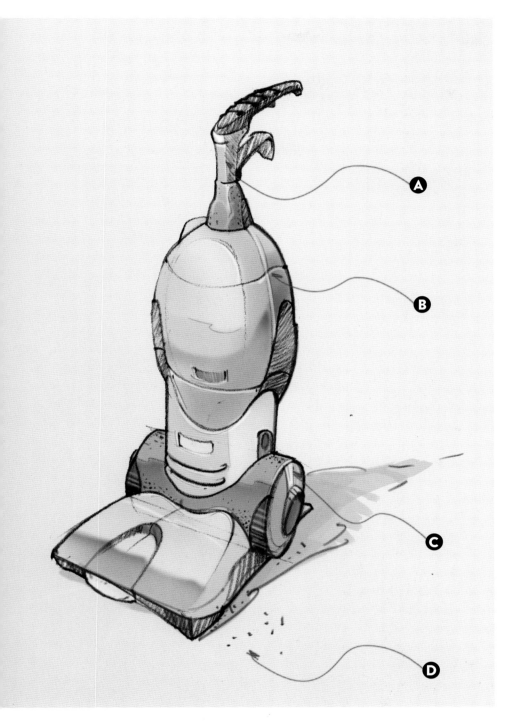

I worked with highlights to make my blue tones shinier, and also added more textural tones on the gray parts, especially on the large cylindrical shape that is on the back edge of the vacuum cleaner.

A: Some highlights added to the upright.

B: Black and white lines to mark more clearly the parting lines on the plastic molded parts.

C: Highlights added on this rim to suggest a shiny finish.

D: Textural tones added to suggest a carpeted floor.

INTUITIVE PERSPECTIVE:
LAYING IN CUTTERS TO FRAME A SCENE

When drawing a complex scene, it is a good idea to start with a frame or a cutter. That is especially useful when there is a scene with many planes or depth levels.

In this case, I wanted to capture a downtown feeling with all the different architectural layers shown almost one on top of the other. In this first stage, I worked with a white pencil to establish some preliminary contrast with the sky and white trim in the nearby buildings. Later, I added dark tones to situate the two shaded buildings that frame my scene.

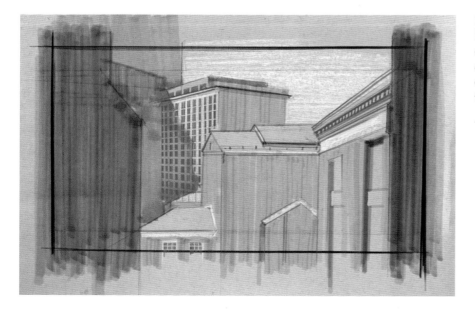

I added even more contrast on the buildings on the left and right, and more detail on the buildings in the background and on the right. Also, I chose light and dark red tones to mark the brick facades.

I continued adding contrast and specific details on the cornices and the windows that are closest to the viewer. I also added extra perspective lines on the left building, to show the brick cladding.

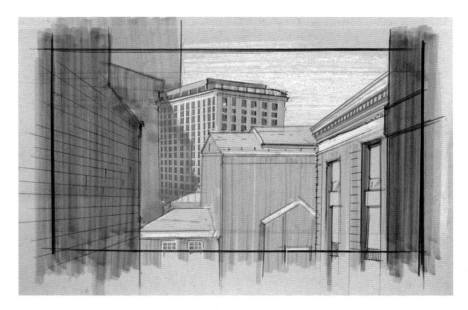

In this second example, I worked again on laying a cutter, but this time on a vertical format. I wanted to emphasize a narrow passage that I found in between two adjacent buildings in downtown Providence. What interested me was the lack of color in the two buildings on both sides and how that contrasted with the bright yellow colonial building in the background, all the way at the top of the staircase. To achieve this, I laid my cutter early on and worked again with my white pencil tones and gray markers, to quickly obtain a much needed contrast.

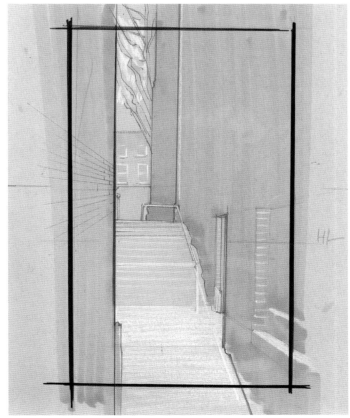

I continued adding contrast to the scene with more gray tones to the two side buildings and to the risers of the stairs, making sure that the left side would be slightly darker. I also started working on the focal point of the composition, the yellow colonial house with the white trim at the top of the long staircase.

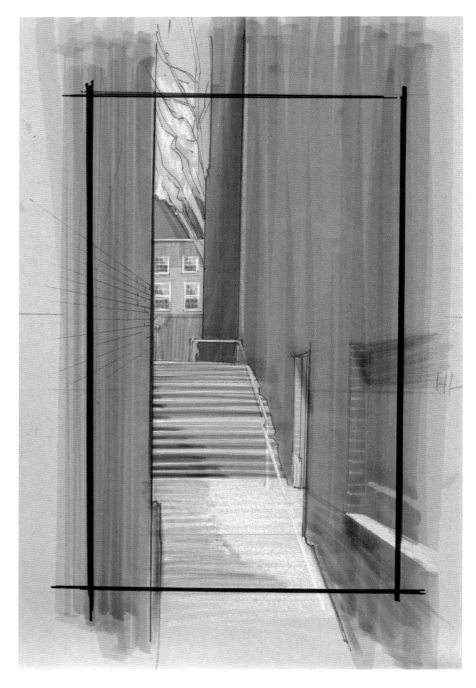

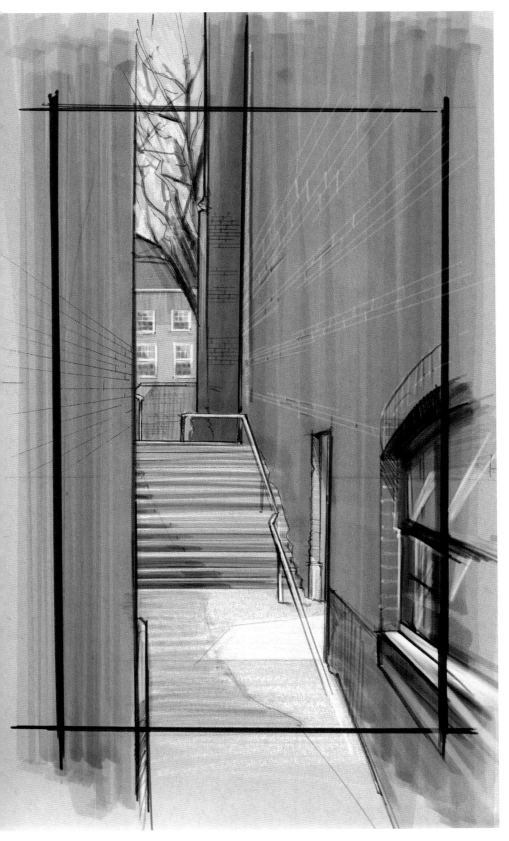

I finished the composition by increasing the level of detail in the side buildings, adding more perspective lines to define the brick-clad buildings, and completing the window on the right. I also added an arch on the window, to gain some more visual interest on the foreground, and finally I added some extra highlights on the handrails and on the floor, making it appear as if the door on the right would be partially open. That adds an element of surprise and more dramatic content to this high-contrast rendering.

These two quick color studies show how we often draw larger than we need to in interior design, so we can lay the cutter without worrying much about cropping objects in the scene. If we do not use this technique, we run the risk of inadvertently foreshortening our objects in the foreground so that they would "fit" better in the perspective. This quick pencil drawing shows how the blue table was cut in the foreground.

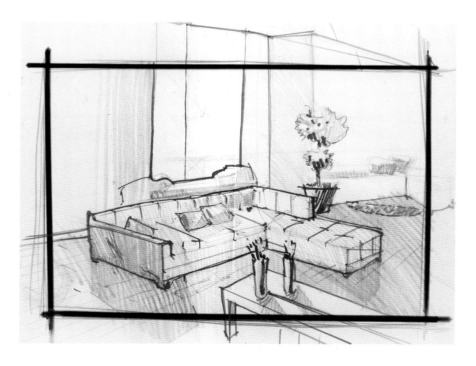

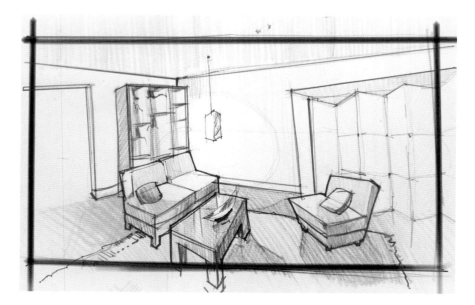

This second pencil sketch shows how the red table was also cut in the foreground once the cutter was laid down.

DYNAMIC VIEWS:
FINDING UNIQUE ANGLES THAT SHOWCASE OUR SUBJECT WITH EXTREME EMPHASIS

There are times when designers have to search for unique points of view to show a particular design detail or to fully understand how a design is put together. In the following sketches, I analyzed an all-time favorite: the famous DCW (Dining Chair Wood) 1948 chair designed by Charles and Ray Eames. This first sketch shows the DCW chair from a low vantage point, to show the intricate and clever layering of the veneer layers and how the metal screws secure them.

A: Preliminary lines done when starting the drawing.

B: Thin lines done with a brown pencil to indicate the direction of the grain in the veneer.

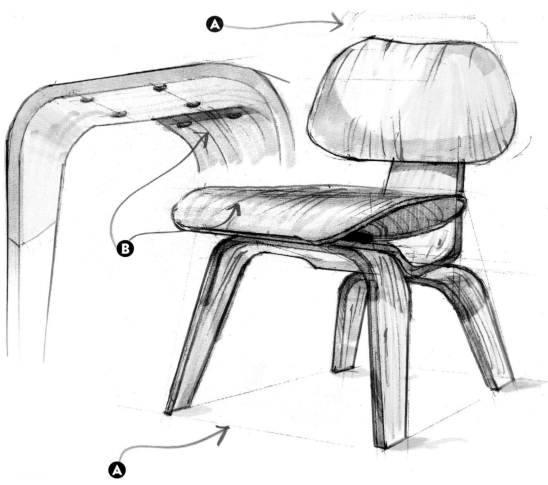

This next sketch digs deeper into the understanding of the DCW chair. If we look from a very low point of view, we appreciate four black rubber discs that provide some flex in between the seat and the backrest extension. By creating this sketch with a very low point of view, I was able to visually describe the relationship between these important parts.

A: Rubber discs.

B: Hexagonal lock-nut

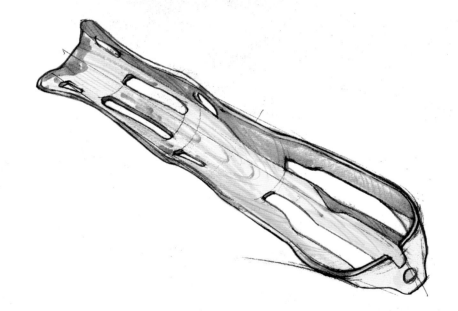

By sketching from a forced angle, sometimes we can gain a better understanding of a complex shape. That is the case of this leg splint, also designed by Charles and Ray Eames for the U.S. Navy in 1941. The experimentation with plywood allowed this creative couple to expand the limit of what could be done with this material. The sharp angle at which this sketch is done provides some understanding of the unique qualities of this shape. The strong shadows applied with a dark orange tone and the exaggerated wood grain tones contribute to describe the nuances of the many concavities we find in the splint.

This drawing done by RISD student Anthony Peer shows another interesting point of view for a vending machine. The design offers a slight curvature on all four sides and a clear body that is capped by a red cap and bottom. According to the front and side orthographic views that we can see on the top right corner, a typical point of view of five feet and six inches (1.7 m), would not show us this design with these pronounced angles, but Peer chose a lower point of view to precisely emphasize its shape and give the overall concept a more dynamic approach. The rendering itself is done with red and gray markers and black lines of different line weights. The background and the orthographic views are completed in Photoshop.

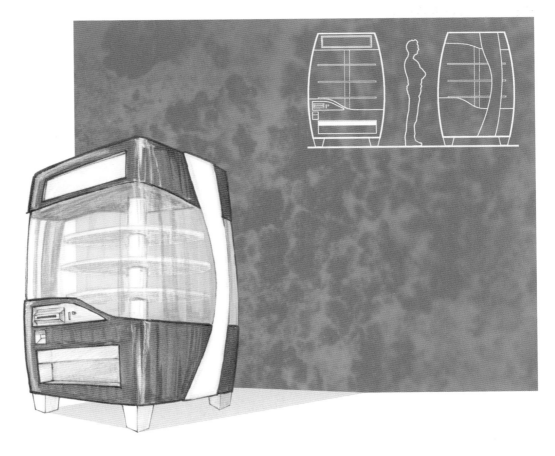

Often when rendering for the automotive world, designers show unique points of view to enhance the perspective. That usually is obtained by lowering the point of view considerably, as if we looked at the car slightly crouching down. That adds more drama, especially if we choose either the front or the back corner, at a three-quarter point of view. In this example, I chose to work on a concept for a three-door sports car with an emphasis on the hatch door and the outline of the brake lights. To add more movement to the scene, I also turned the wheel to the left, as if the car was about to enter into a curve.

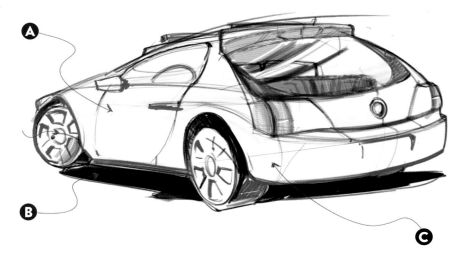

A: Light blue tones that catch the reflection of the sky.

B: A strong shadow on the ground makes the car belong to the scene in a more convincing way.

C: This corner is emphasized in the rendering.

On a second stage, I focused on adding more contrast to the rendering: reflections on the windows, and blue and brown tones to separate the reflections coming from the sky and ground.

A: Extra dark brown tones in the middle of the door mark the reflection of the horizon line.

B: Brown tones added on the bottom of the car to pick up the reflection of the ground.

C: Extra dark tones added to the top of the windows to show the reflection of nearby objects.

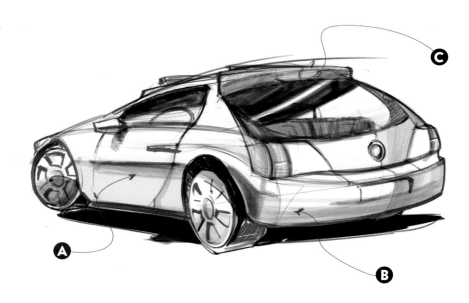

These automobile sketches were developed by RISD student Gabriel Lopez, under the supervision of professor Matthew Grigsby. When working with car renderings, just like we would do for any other object, the designer has to work to find unique angles that will define it well. But a car carries more connotations as an object than many other manufactured goods.

With so many styles in the market, a car needs to differentiate itself from its competitors, and the designer has to show an angle that will define it as an object of desire. After all, for many people a car is arguably the second most expensive investment they've made, after a house. Many of these initial sketches have a low point of view to add drama and a sense of speed. These are part of a larger collection of sketches developed with a particular car maker in mind, using exclusively black pens over marker paper.

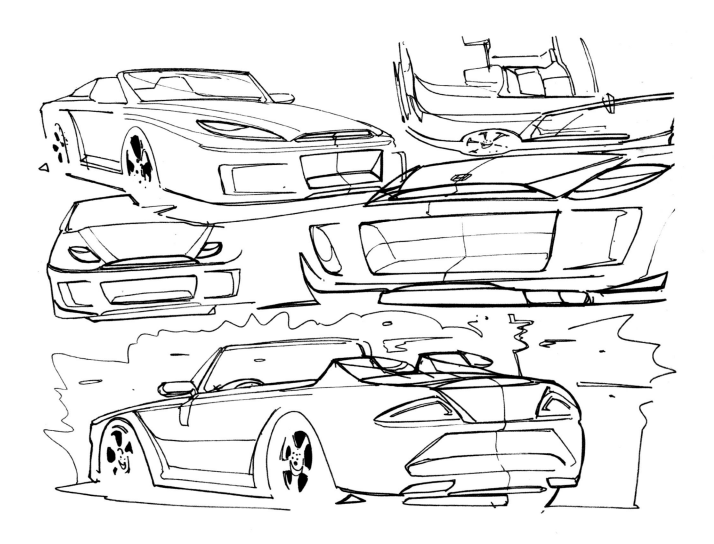

These color renderings are completed using black pens with some color markers added on top, done on marker paper. Notice how the white reflections on the body paint were obtained by simply leaving some white reserves.

Note: During the phase of adding color marker tones, it is important to avoid smudging our color over the black lines. It is important to test on the side first if that would actually happen, but the results will vary greatly depending on the type of markers and paper we are using. The safest route is always to work first on our color markers over thinly applied pencil lines and then apply our black lines. On the other hand, if we have already done our black lines, we would have to be extremely careful in applying color around them.

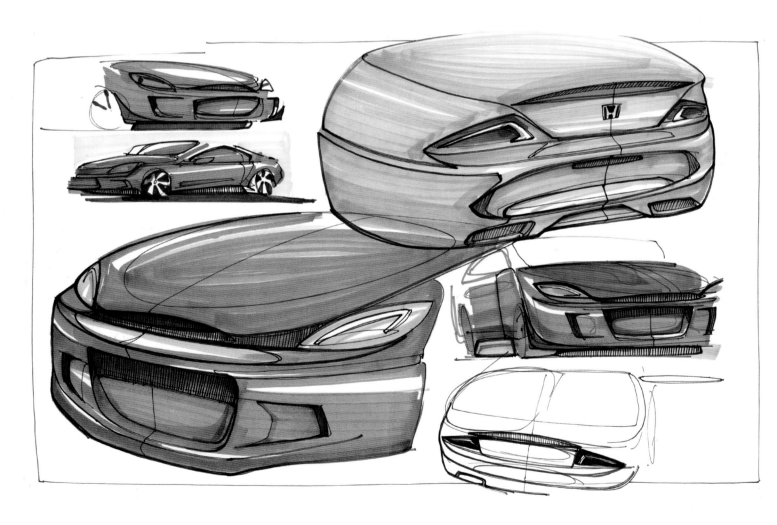

CONCEPT SKETCHING:
SKETCHING FROM IMAGINATION AND HAVING SOMETHING TO SAY

The key moment for many designers to overcome is the initial hesitation—some might call it fear—of sitting down and starting to sketch freely. Once we have read the project brief and we understand the premises clearly, it all comes down to picking up your favorite drawing utensil and substrate, digital or physical, and jotting down ideas. Many designers like to draw on newsprint paper, because it's cheap and coarse with a great tooth to draw loose lines with a No.2 pencil, while some others might draw loose sketches on napkins. The techniques vary from person to person. The important moment in all of these scenarios is we have to have something to say. In this example, I wanted to pursue the idea of using a CNC machine to carve a complex table top out of wood and make it look as if I had laid down a piece of heavy cloth, bunching up at the front corners. I started with a loose sketch on tracing paper (above) and cleaned the drawing further adding a second layer on top (on the right).

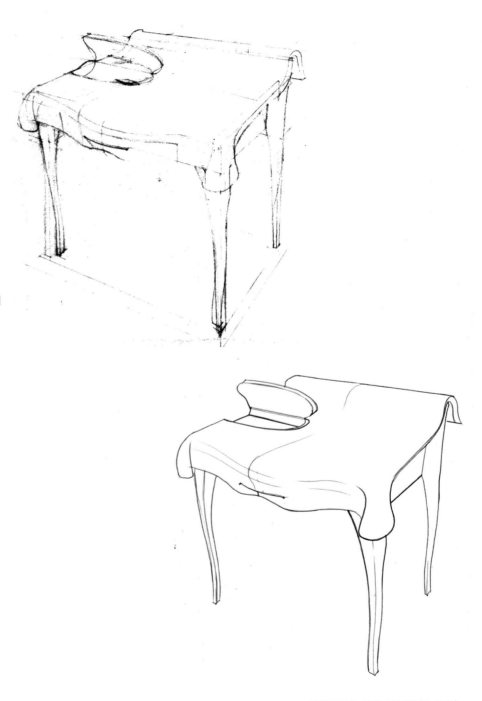

Right after I sketched this, I didn't like it and I wasn't going to use my time adding color, but that led me to the next step. I thought I could still keep the four legs and draw the internal structure, just for the fun of it. I started adding more lines (on the left) and started liking the overall design, with the addition of an angled front and two drawers, one on the front and another on the back. The moment of inspiration came then, when I thought I could design a chess table with some built-in storage and two clocks (on the right).

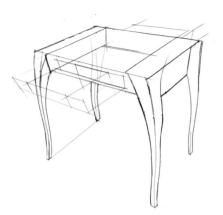
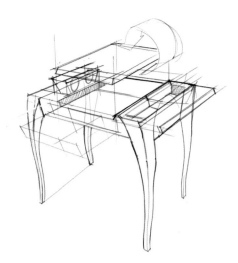

The final two stages came easily, as I had a clear direction and had something to say with substance. On the left side of the drawing, I opened all drawers and moving parts, just to give me an idea of how I would have to work with the internal structure. After I was done, I realized I had drawn the clocks sideways and did yet another drawing (on the right) with the clocks as they should be and with the board ready to be used.

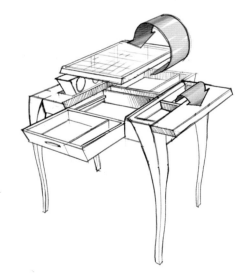
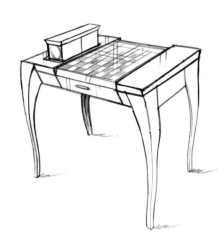

To complete the concept, I added some color strokes to indicate the tone of wood (and metal) I wanted to use.

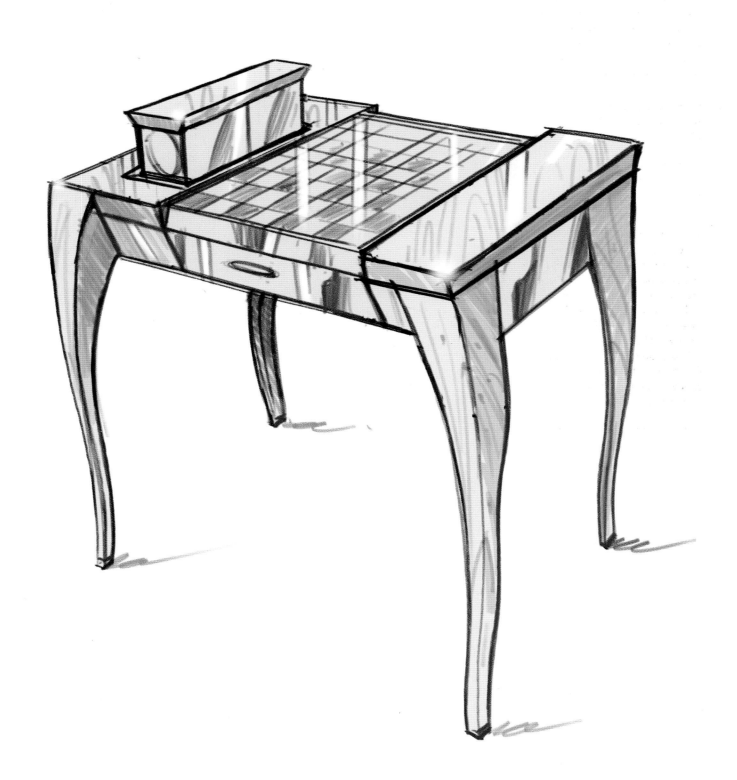

When starting a large conceptual project from scratch, often it helps to first imagine one front view if we are drawing a product, or an elevation if we have a large interior or architectural structure. Some other times, it is easy to start imagining things from a floor plan. In this case we are looking at a park proposal that was presented to a small town in Rhode Island. The lot was a superb location to let our imagination run wild. I imagined a small park with meandering paths that would tend to the needs of the young families and adolescents in the area. I envisioned a skateboard area, a large shaded sand lot, and an open theater with the water of the bay as a backdrop. These sketches are done in ink and colored with color pencils and some gray marker shading.

A: Skatepark with different obstacles and ramps.

B: Shaded sandlot area.

C: Walk boards along the water edge and sunbathing boards.

D: Elevated boardwalk around the large tree in the property.

E: Open-air theater.

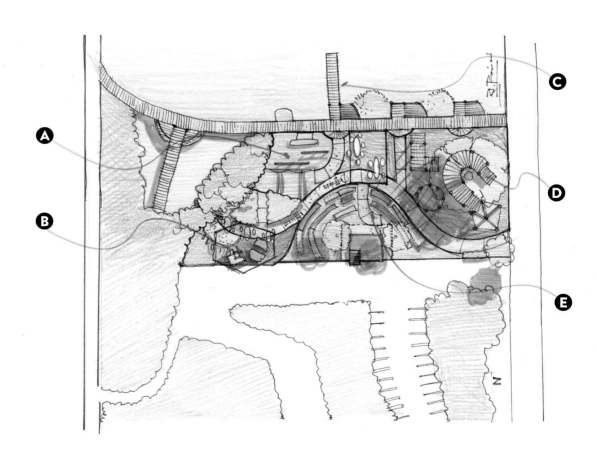

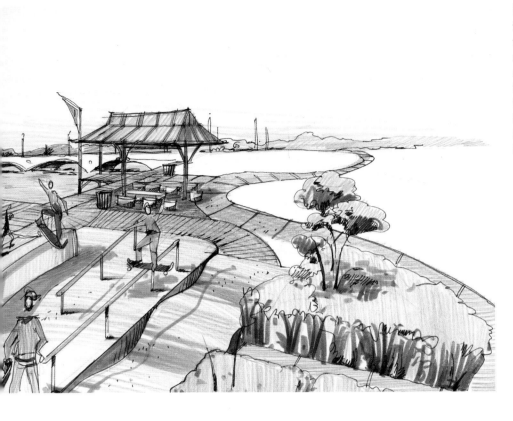

Notice how in this sketch I only wanted to showcase the skating section along with just one other adjacent area, the shaded picnic structure. The other sections of the park were omitted so that they would not be too distracting from this view. To add more realism to the scene, I included the town bridge in the background and a line of trees on the horizon.

Here, I depicted three distinct areas: a large rock that is split in half to play hide-and-seek; a tiered sand area; and a smaller sand lot for the smallest children.

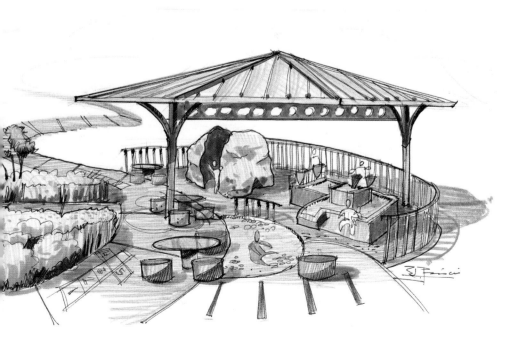

In this area I envisioned how much park visitors would enjoy their board walk in the summer, if they would have an angled plane from where they could sunbathe facing south, blocked from the wind. The tall wooden poles with the triangular banners mark where the peers would be located.

I wanted to show how children would play around the large tree in the property, taking advantage of the shade during the hot months in the summer. The concept envisions a series of ramps and climbing ropes to delight children ages four to eleven. To consolidate the idea further, I added a floor plan of the elevated boardwalk and how that related to the shade coming from the tree.

This view is slightly elevated as we would
be seeing the scene above the stage.
This afforded me the chance to show
the bay as a backdrop.

In my experience as a designer, I have had the opportunity to work for a good variety of clients and fields, ranging from packaging and point of sale, exhibit designs, trade shows, and product design. But nothing beats sketching from imagination with no preconceived ideas, and visiting fabricators. This project involved the creation of an informational kiosk to be placed in a flagship store of a well-known electronics manufacturer in Chicago. My early pen sketches did not differ much from the final model, but I loved crafting these loose sketches, mixing front views, side views, and quick perspective views.

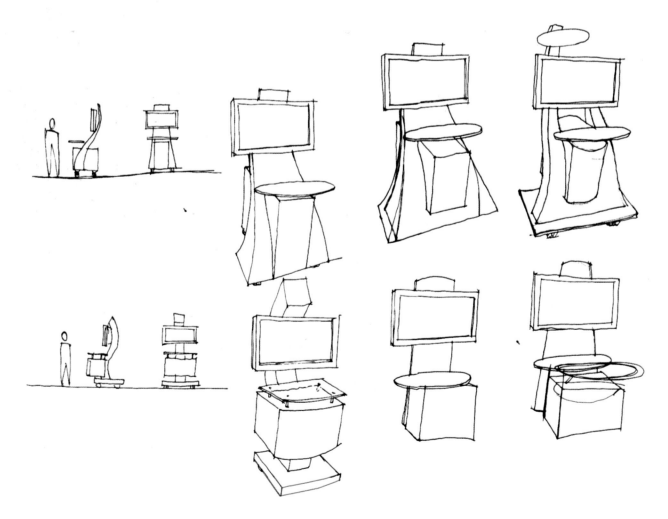

A big moment in the concept sketching process comes when we get to choose a direction from a collection of preliminary ideas, in a big pin-up session. After fifteen years of teaching, I still get excited when I see my students share their progress with the whole class, as that fosters communication and allows them to compare skills and share experiences. This photograph shows how this process usually gets done: Every available surface, horizontal or vertical, is used to display the concepts.

Also, during the sketching phase, I often sit down with a single student or a group of students with a roll of tracing paper and do a live demonstration, focusing on a particular detail that might need further clarification. This is an example of how that would happen; these sketches show how to shade different objects that are affected by one or multiple light sources.

Teaching concept sketching sometimes requires the setup of a longer demonstration in front of an audience. This pair of hand drills was completed on newsprint paper in front of my class in twenty minutes to show the importance of color and volume when developing sketches.

Note: Designers often use backgrounds to emphasize their designs, but in this case I chose to work with a purple color, which complements the orange tone I was using for the drills. It made my sketch more interesting visually.

I developed a series of quick demonstrations to show my students that they can create their own gradations that can be cut to fit a particular shape of a background later. These can also be scanned and incorporated digitally, to the sketches. This one was created using two tones of pastel shavings—orange and purple. These brush strokes were obtained by dousing a cotton ball with nail polish remover and applying pastel dust to the paper. Then, with ample strokes, I blended the two colors to generate this interesting background texture.

In the spring of 2012, I created a website to showcase videos of different rendering techniques, focusing primarily on quick concept and sketching skills. This first website, www.renderinginteriors.com, focuses exclusively on interior design. The following sketches show how to create different textures on elevations and perspective views: grass, stone, glass, brick, and wood.

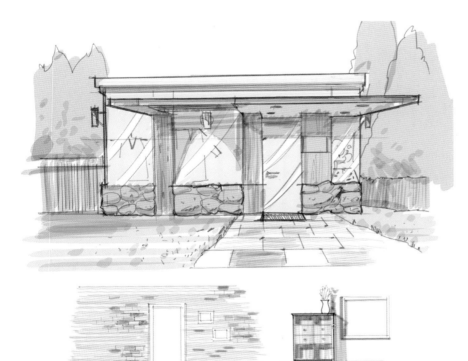

Based on the success of the website for interior designers, soon after I opened its counterpart for industrial designers, www.idrender.com, focusing on the same issues of quick concept and sketching skills. These sketches show how to get quick chrome reflections on a tea kettle, how to start a concept for a pair of binoculars, and how to organize and label the main parts for a hair dryer, in an exploded view format.

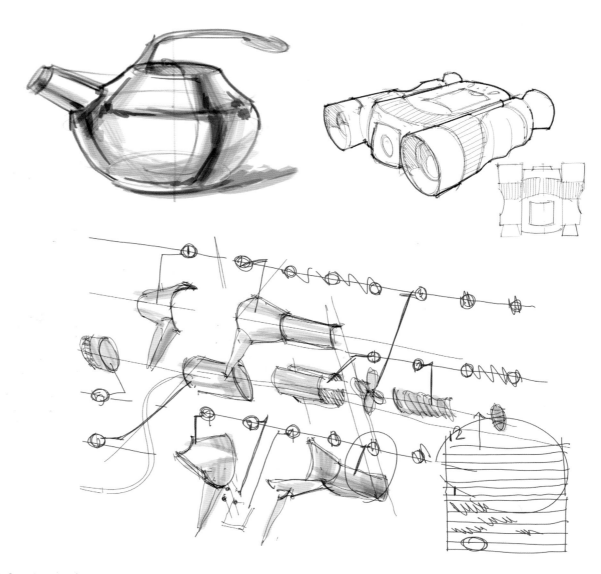

CONCEPT SKETCHING:
STARTING WITH A BLANK PAGE AND WORKING WITH OVERLAYS TO REFINE DETAILS AND DEVELOP A SCENE

Starting with a blank page can sometimes be a daunting experience. Before developing these sketches for a coffee maker, I did some loose warm-up sketches and chose these two concepts as my starting point. I drew this pair of sketches with a blue pen on a regular sheet of paper in landscape format. I worked with quick strokes to get a sense of volume, and completed them from left to right. I was not afraid of over-stretching my blue lines over certain corners, and crisscrossed them at will to make the lines appear looser. At this stage, I liked the sketch on the right, and I thought I could add some extra hatching to gain an extra sense of depth.

A: *Crisscrossing the lines on the edges gives the drawing a loose appearance.*

B: *Hatching our lines allows us to indicate a shaded area or a change in material.*

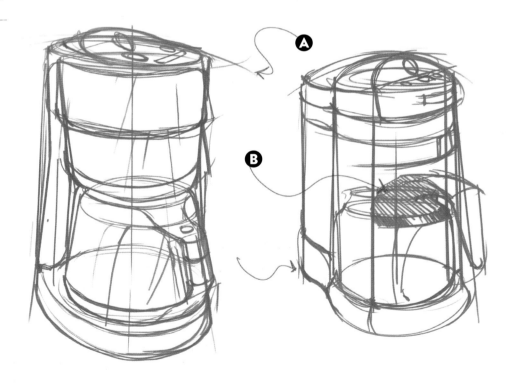

Working with tracing paper over the first set of sketches allowed me to narrow down my ideas further, while still being able to see my loose sketches on the bottom layer. It is reassuring to work with overlays of tracing paper, because that allows designers to develop concepts slowly and surely and with a good sense of continuity. In this image, we can see how some pencil lines were drawn to clean up the first two concepts, but at the same time both designs kept on evolving, although at a slower pace.

A: More precision added to the buttons.

B: Contour line is redefined.

C: Bumps added on the contour line.

D: Added nuances in irregular shapes.

E: More hatching to emphasize a change in material.

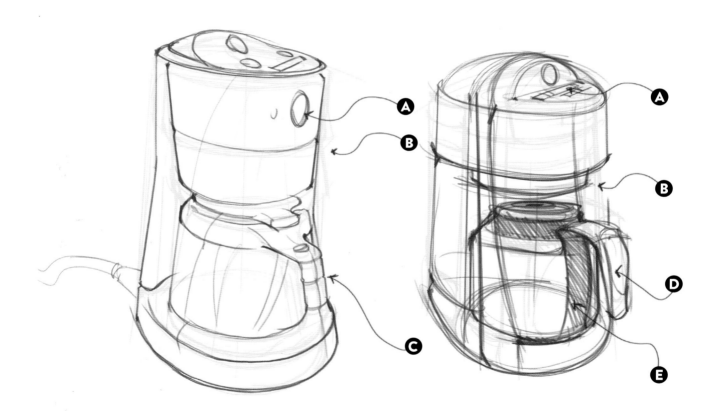

On the next layer of tracing paper, I kept evolving the shape, but this time I paid close attention to cleaning up the curves and making the overall design more uniform visually. I added more definition to the base, the cover for the carafe, and the surface that contained the operating buttons. While reworking the base of this coffee maker, I became convinced that I had to revisit the design of the handle for the carafe. I was not sold on the idea that I had in the prior design, as it still appeared too busy, and I thought the shape was too arbitrary. The tracing paper gave me the confidence that this change would be done in slow progression, while having the freedom to explore other alternatives.

A: *Double lines added to show a small radius.*

B: *Thin lines to represent a mid-contour plane.*

C: *Careful shading on selected areas to show change in shape.*

D: *First notes to mark reflective surfaces.*

E: *Added lines to show complex shapes.*

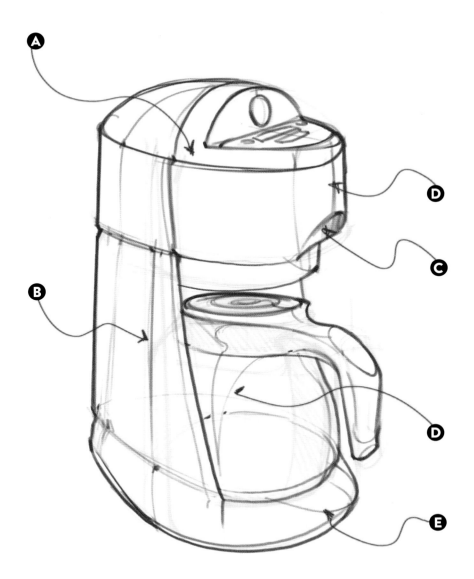

Depending on the substrate being used in the final rendering—mainly vellum or marker paper—we might run the risk of smearing the colors if they are applied over the black lines. Do a test on the side and if the color smears, add color first without the black lines. That means you should use the last black line underlay as a guideline for color. In the following example, I added a first pass of color on the left using two shades of blue and a gray tone, followed by a few extra dark blue tones, using the underlay as my indicator.

In this last phase, the hard work paid off when I retraced all the black lines. On top of redrawing all of these lines, I added a slightly thicker line on the per meter to emphasize the resulting volume.

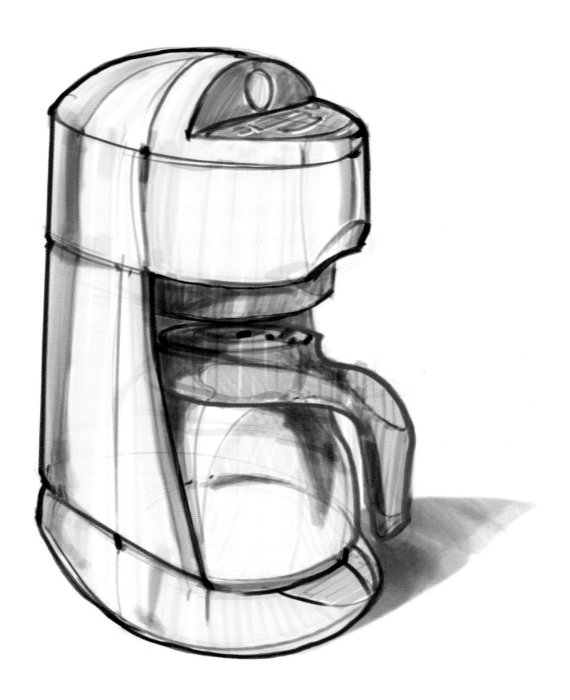

The same principles that we have applied to work in layers can be used for interior design or architecture. If we are developing a concept by hand and we are not sure of our design options yet, we can always work in layers until we get the right concept. The image on the left shows my first sketch to remodel a house in a New England town. The house was small to start with, but since it faced the water, I thought it could benefit from the addition of a wraparound porch and two dormers in the front, for the upstairs bedrooms. In my first sketch, I also added a chimney, which didn't exist in the original design. The first image shows my second take on the same house. I drew this image in Photoshop but used the same principle of working with layers. The original design had some good things, but I changed the roofing material from metal to architectural shingles and made the chimney taller. I also changed the location of the entrance steps and the landscape around the house. Finally, I made the dormers slightly higher, eliminated the octagonal window, and continued working with some other landscape ideas.

To complete this rendering, I added some color with a reduced palette: three shades of green for the landscape and forest, two shades of brown for the stained wood shingles, a dark purple/blue tone for the architectural shingles, and some light blue tones for the glass panes in the windows and the sky in the background.

NARRATIVE SKETCHING:
PLANNING SEQUENTIAL VIEWS TO DESCRIBE AN ACTIVITY OR PROCESS

Some years ago, I was approached by an inventor/entrepreneur who had developed an all-in-one tape dispenser/mud applicator for dry walls to simplify the otherwise cumbersome process of finishing them. Although the client had a great product to sell, he did not have a visual that would describe how easy the process could be.

I was asked to create a high-quality rendering that would showcase the product in use so that potential buyers would be able to understand how it would be held and operated. In the life of a designer, this is often the case; we have to communicate how a product works or describe an activity or process of something that has not been seen yet. I worked with a soft airbrush in Photoshop, using the image of the machine that my client provided, and enhanced the shadows to better fit in the scene.

I had to draw a small pen that attaches to the user's finger and can be switched on when ready to write. After some patent searching and discarding some preliminary ideas, I set out to create as many variations of shapes as I could possibly think of, but always making sure that the shape and the motions would be understood from both sides of the hand. These preliminary sketches were done with pencil lines over tracing paper.

A: Slide pen in resting position, on side of index finger.

B: Slide pen in resting position. Notice the channel on the ring to facilitate movement.

One of the initial concepts was chosen for further work, and the original pencil line was cleaned up. Then the line work was scanned and color was applied in Photoshop. I was careful in balancing the use of color in these two views, so that the focal point would rest on the pen itself. For that reason, I faded the color of the hand as it reaches the wrist and added extra highlights with a white airbrush tool on the body of the pen, to bring it forward. This view shows a final concept in a retracted mode; the arrow in orange by the thumb suggests that the orange button on the body of the pen could slide forward to operate the pen.

A: Wrinkles in the hand partially erased to fade them into the background.

B: Extra highlights added to the body of the pen, done with a small white airbrush.

C: Shadows added under the hand, using the lasso tool in Photoshop, with a feathered edge for a soft look.

D: Color of the hand applied with the Gradient tool in Photoshop.

This second view shows the same final concept in an extended mode. In this rendering, it was important to get the shadows right, especially reaching the tip of the pen. I wanted to convey the idea that the user was about to lay the pen down on a writing surface.

This project involved the creation of a series of sequential views to explain the process of using a battery-operated saw. The main innovation of this design was in the shift of the weight of the battery pack, from the saw itself to the work belt. This eliminated fatigue produced by both the constant lifting of the saw and its use for a prolonged period of time with the arms lifted. These sketches were done using pens of different line weights and some light gray marker tones to the object to make the figure appear more volumetric. The addition of a blue strip as a background provided continuity from sequence to sequence.

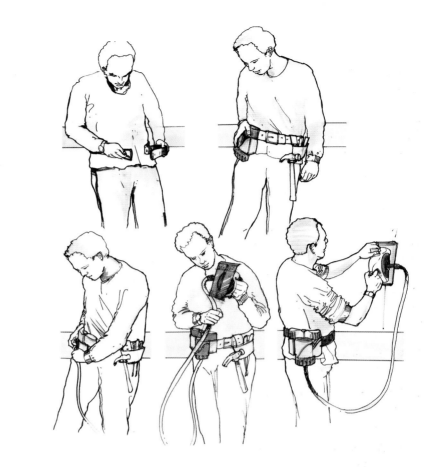

These drawings, done by Daniel Morgan, explore what we call an operational sequence. Sometimes we have to describe how a complex system works or how we make a product usable, but using mainly visuals. In these four vignettes, the designer describes, with an economy of resources, how a new pair of training shoes would work. An athlete would use these to gradually learn how to run barefoot. These vignettes show sequentially how the shoe is attached securely to the foot, how we would remove the cushioning in stages, and finally how we would not need them any more. It is also noteworthy how his shapes are carefully describing the motions with balanced line weights and a light color tone that is applied uniformly to all four vignettes.

NARRATIVE SKETCHING:
PRODUCING SKETCHES TO INDICATE HOW SOMETHING GOES TOGETHER OR OPERATES

Often the concepts that we develop are not as simple as they initially appear. Behind a simple structure we might find moving parts or drawers or other elements that separate from the main unit. In these circumstances, it might not be enough to show a parting line to indicate that we have a collection of parts. Adding arrows can indicate movement or a sense of direction. Here, I drew a concept of a refrigerator with two doors and have indicated how the shelves on the door are detachable for easy cleaning. On the right, I have indicated that the drawers on the freezer unit can be pulled out.

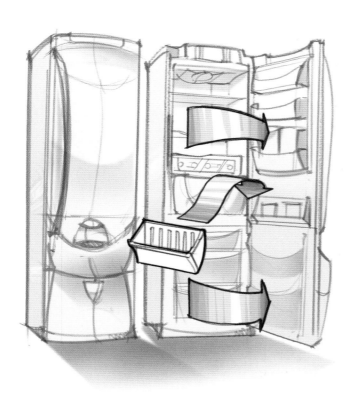
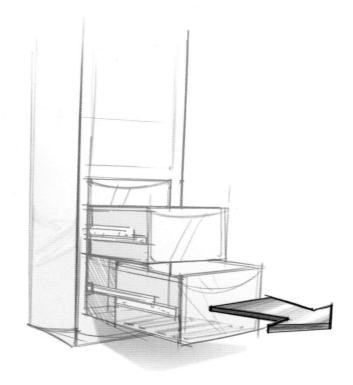

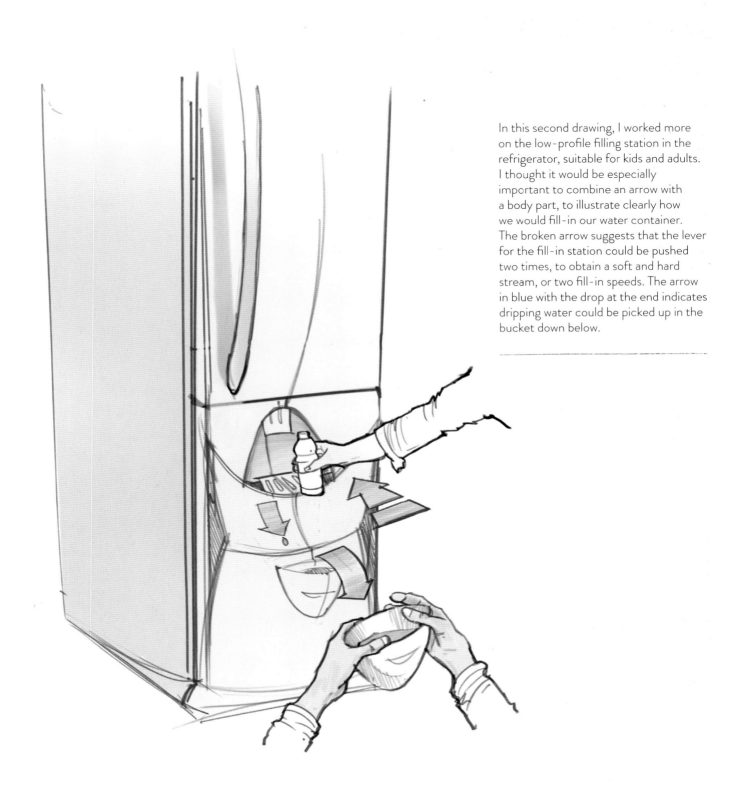

In this second drawing, I worked more on the low-profile filling station in the refrigerator, suitable for kids and adults. I thought it would be especially important to combine an arrow with a body part, to illustrate clearly how we would fill-in our water container. The broken arrow suggests that the lever for the fill-in station could be pushed two times, to obtain a soft and hard stream, or two fill-in speeds. The arrow in blue with the drop at the end indicates dripping water could be picked up in the bucket down below.

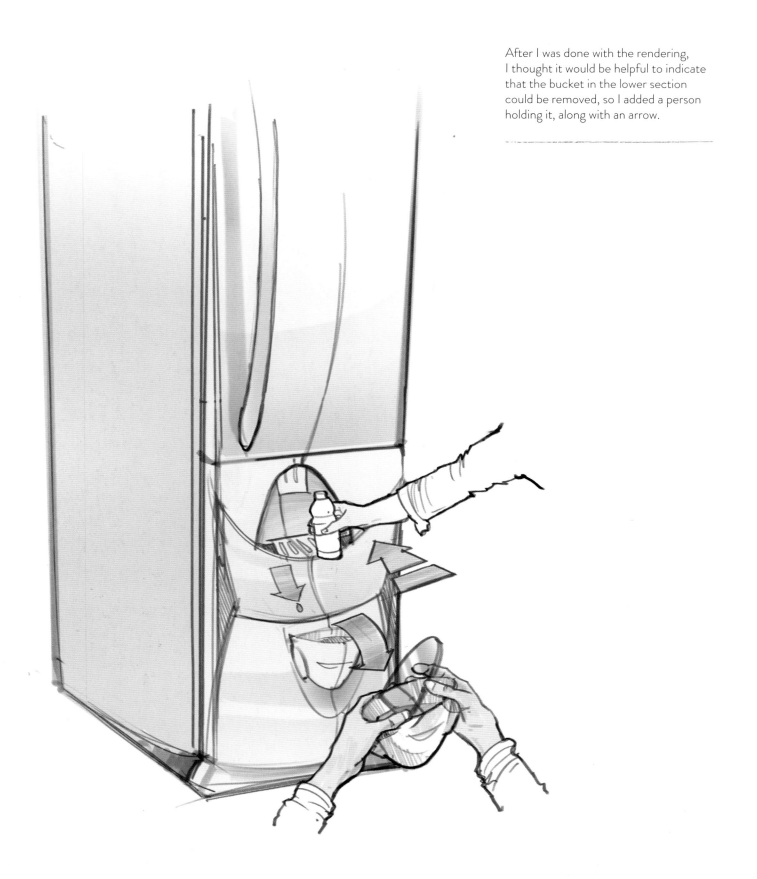

After I was done with the rendering, I thought it would be helpful to indicate that the bucket in the lower section could be removed, so I added a person holding it, along with an arrow.

This drawing, done by RISD student Stephanie Willemsen, shows how complex a drawing can be when we want to display the internal components of a product. When putting together presentations, sometimes designers want to emphasize not only the internal architecture but how all the parts are assembled and, most importantly, how they are organized into sub-assemblies or clusters. In this seemingly simple alarm clock, we can appreciate four distinct clusters. On the top left corner and with a dark brown background, we see the transformer assembly, followed by the button/screen assembly in the center of the page. On the bottom center of the page we can see the battery box/bottom assembly, and finally on the right, we see the buttons and the top housing as our last assembly.

This drawing was done on tracing paper, and later it was assembled and colorized in Photoshop but with a carefully balanced play of line weights and shading. We also appreciate how the few color notes were left just for the background, as a tool to help us separate our four clusters of parts. And finally, Stephanie added a large arrow shaded in blue, to connect the button/screen assembly with the top housing assembly.

In this other example, student Benjamin Snell from Brown University developed a drawing showing all the parts involved in the design of a clock. This type of drawing is called an exploded view and can be beneficial to communicate a multitude of assembly and manufacturing issues with other designers or engineers. Despite the inherent complexity of the drawing, it is still easy to identify all the parts because of the arrangement of components and callout numbers, as well as the clever use of color and soft gray tones to emphasize volume. This drawing was first developed using tracing paper, one cluster of parts per sheet. Later, each cluster was scanned separately and the resulting larger drawing was assembled using Photoshop. Assembling the parts into a larger drawing works well only if you follow a strict isometric grid. This way, all the parts can be repositioned any number of times, and they will always be placed correctly, because we do not have to worry about the vanishing points.

NARRATIVE SKETCHING:
ADDING CALLOUTS, ARROWS, AND SYMBOLS TO EXPEDITE THE VISUAL UNDERSTANDING OF CERTAIN ACTIONS

This car dashboard concept was developed to show how arrows can focus on one section of our drawing. This is a busy sketch with many buttons and dials, and it would be hard to focus on the glove compartment if it was not for the red arrow indicating that it was pulled down. We normally visualize a drawing from left to right and top to bottom, and following this criterion, our eyes stop intuitively at the red arrow. This is by default our focal point in the rendering. I still had room to add two details on the bottom showing how this compartment could be designed with two other storage nooks for documents, once it is open.

Quite often, the design solutions are not self-explanatory and need the support of arrows, symbols, or notations to help the viewer understand what is being depicted. This is a concept for a free Internet hot spot for a convention center, provided as a way to advertise a particular Internet provider. While this initial concept shows three computer screens and a seating area, we want to be sure that the concept conveys some points clearly, about the use of the space and the materials or finishes we are using.

Once the first concept is sketched out, we can start to identify some areas that need to be explained further. For example, we have to provide a description about the materials used in the floor. The added dots address the pile of the carpet, but we also have to explain the circles behind the computer stations, and the very small circles inside the circular carpet. Once we add notations, the main areas in the concept get explained. If we are using freehand architectural lettering, it would be a good idea to draw the lines and spacing for our text with 3H pencil (marked in red in the drawing). Notice too how I made an effort to align the different blocks of text. On the bottom a label was added to name the drawing and to situate it in context with the whole presentation.

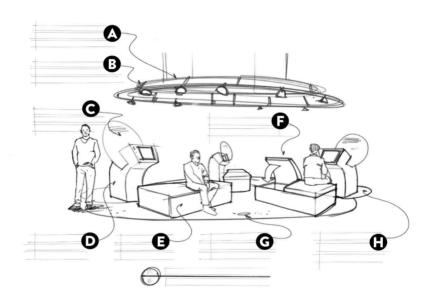

A: Notation to explain the lighting fixture, its material and finish.

B: Notation to explain the lighting fixtures attached to the outer ring.

C: Notation to explain the area that is given to the sponsor to advertise the name and how the computer stations can be used.

D: Notation to explain the material and finish of the computer pedestal.

E: Notation to explain the seating area.

F: Notation to explain that the storage inside the seating area, for maintenance.

G: Notation to explain the upward spotlights in the floor.

H: Notation to explain the extra base added to the computer pedestal for visual impact and stability.

These sketches, developed by RISD student Elizabeth Connolley, depict a selection of enclosure studies for a packaging concept for ground black pepper, but keeping in mind the needs of persons with arthritis. It is important to note that Elizabeth felt she had to use many arrows to explain how some of these tabs would be operated to gain access to the goods packaged inside, by peeling, turning, pulling, sliding, or flipping over a tab. In some cases, these arrows are shown in conjunction with the tip of a finger, to facilitate the understanding of how it would be operated by this group of users.

SHOOTING BOARDS:
DEVELOPING A SERIES OF SKETCHES THAT DEPICT A STORY, FRAME BY FRAME

In certain situations, designs are better understood when we associate them with a particular story, which is normally linked to a user's experience. In this case, we see a concept for a package holding chocolate-covered chips. This board by RISD student Hanna Oh, shows the package design in three stages: closed, halfway open, and fully open. It is completed using color markers, color pencils, and black pens over marker paper. Everything is looking good in this board, but the designer felt that the concept would be stronger if the viewer could associate a story beyond what is initially shown here.

In this second board, Hanna has gone beyond explaining the function of the package (how it can be opened), to describe a more complex story. First, we see a hand ready to pick one chip, and that gives us a good sense of scale. Second, we see two touching wine glasses in the background. That indicates that this packaging concept would be purchased to maybe mark an anniversary or other important celebration, and that is what makes this design so special after all.

Shooting boards is a term that is borrowed from the movie industry to indicate that a drawing or a series of drawings will represent a particular scene or point of view, usually in sequence. This is also called a storyboard, or in product design we might see them described as an operational sequence board.

The important thing to remember is that they are done quickly with pens or pencils and one or two gray tones. They might show the same operation from different angles, just to make sure that the story is well described. In this particular shooting board, we have four vignettes done in pencil and gray tones to describe the concept of a magnifying glass designed exclusively for the elderly with arthritis.

SHOOTING BOARDS:
CREATING VISUAL INTEREST BY USING A VARIETY OF CAMERA ANGLES CUT TO KEEP THE VIEWER ENGAGED

When we are sitting down to sketch an object in perspective, the drawings need to be engaging, communicate clearly, and to a certain extent, they need to have a certain amount of emotion. These cut sketches of a belt sander are showing three different points of view. This first one represents the belt sander from the angle that would be most likely understood, showing the front and the side. The board is more predictable and shows the product as it will be displayed in a showroom—what you see is what you get.

This second view shows the belt sander form the opposite angle. It makes us appreciate it from the user point of view, as if we were about to grab the handle and squeeze the trigger to get it going.

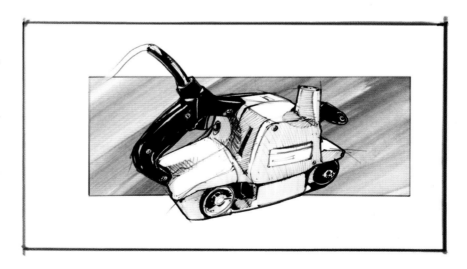

And this third view shows the belt sander from a very low vantage point. This board is the least descriptive of the three renderings, but it certainly shows motion and a good deal of drama. The question then arises, which one of these three images would we share with a client? The answer depends on the purpose that we want to give in our presentation.

These sketches of an exhibit design done for a trade show reflect how we can use different angles to emphasize different details. My client, a large home and office printer manufacturer, wanted to display the latest printers they had to offer, and I thought of using different large-scale volumes to emphasize the bright primary colors used in the printer cartridges. For example, on the two sketches on the top right corner, I wanted the large structure in the center of the exhibit to be the focal point, dwarfing everything else. To make it more evident, I lowered the horizon line to make the structure appear even taller on the sketch. The large volume in the center represented the documents that we could generate with the help of these printers. These sketches were done with a black pen and color pencils, over newsprint paper.

CHAPTER 3
DIGITAL BLOCK-OUTS:
WORKING WITH SKETCHUP TO DEVELOP AN OBJECT OR ENVIRONMENT

One of the advantages of digital technology is the ability to look at a 3D model from different points of view, using the pan, orbit, and zoom tools. If we are in the preliminary stages of ideation, we could quickly build a model focusing only on the main shapes, just to develop a rudimentary sense of volume. Our goal would be to avoid building our model with total accuracy, as that is usually a time-involved process and we want to first explore different options.

This model of a school park for an elementary school was built with the aid of some photographs to build the model in SketchUp—tracing of existing photographs can be done under Window > Match Photo.

In approximately four hours, and with the aid of some found benches on SketchUp's website (https://3dwarehouse.sketchup.com/index.html), I was able to create a model that was just right for my final goal, which was to develop quickly a series of pencil sketches.

Working with pencil exclusively, I traced the main lines done in SketchUp on a new layer and sketched out a concept that later was shared with the client.

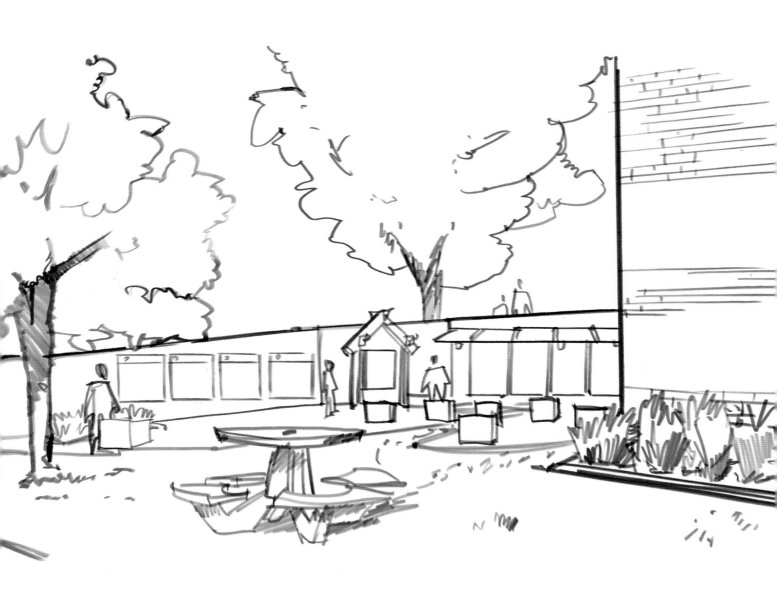

DIGITAL BLOCK-OUTS:
BUILDING WHITE MODELS TO FIND THE BEST VIEW AND USE AS A SKETCH UNDERLAY

This image shows a model of a dump truck that I was able to build in under an hour in SketchUp Make, with the idea that it could help me in the process of concept ideation. Once the main model was built, I saved a set of different points of view. I clicked on Window-Scenes and chose the Plus sign to obtain them.

To see my model in a sketchy appearance, I chose a style called Charcoal Loose, under Window > Styles > Sketchy Edges. The images below show a collection of some of the scenes I captured. Notice how the model has a sense of movement as the cabin is veering to the right.

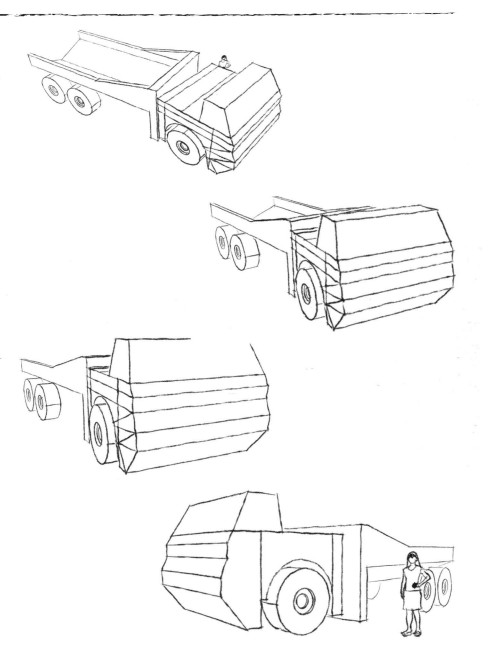

In this second stage, I worked on two concepts in parallel. The underlying wire frames done in SketchUp provided great guidance, as I did not need to worry about perspective or proportions. And placing the original layers under our current page can be done digitally in Photoshop or by hand, using a light table. Using underlays is especially helpful when we are designing for transportation, as there are wheels and cabins and other complex shapes that require especial attention.

Note: Circles, such as those found in wheels, are drawn in perspective as ellipses, and those need to be done very well to make our transportation concept appear solidly grounded. This can be particularly challenging if we haven't loosened up our hand enough or if the front wheels are turning. In that scenario, we face two different types of ellipses, those in a straight line and those belonging to the axle that is turning.

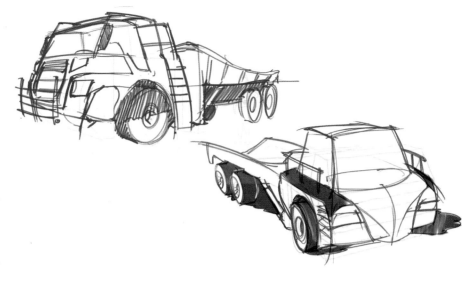

In this phase I refined my lines and worked on cleaning up the concept. After that was completed, I added a strong gray value for the wheels, the shadow, and the areas to be painted in black.

In this next step, I worked on the areas that would receive a bright body paint, using two different passes of blue. The first pass would be light and would affect the hood and sides of the dump back and darker for the curved sides that face the ground.

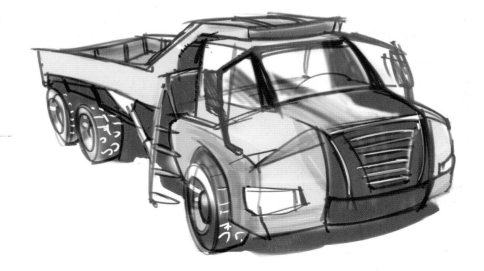

In this last phase I worked with more blue and gray tones to complete my rendering, focusing on gaining enough contrast on the model. As a last touch, I added some yellow tones for the headlights and some white touches in the cabin, the front grill, the hood, and the tire treads.

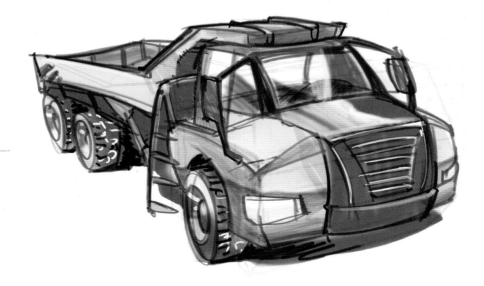

This figure shows a model of a living room that was made in SketchUp. This software has proven that it can be a great aid to the designer when drawing an interior view in perspective.

This model was built in less than an hour, using simple modeling tools, mainly the rectangle tool, the pencil tool, and the extrude tool to create 3D. The objective here was not to create a fully detailed interior with all kinds of furnishings and accessories but rather to build a collection of blocks with very little detail, to help us situate the main volumes in the space. If the chairs are drawn with a slight rotation, then the process becomes more challenging, because we need to find two new vanishing points.

Once the model was built, I saved four different points of view, high and low, showing them in a style called Sketchy Edges. In some of these shots I played with different angle lenses, which can be found in SketchUp under Camera > Field of View (the tool gets activated when we click and drag on the scene, with the left button of our mouse).

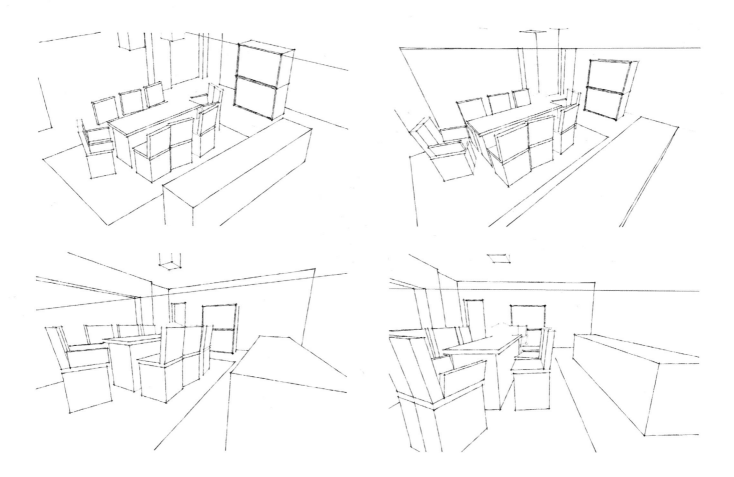

I used one of the perspective views to get the concept drawn without worrying if my perspective was off (the original SketchUp line work is marked here in red). The process was a lot simpler this way. It was particularly helpful to correctly draw each of the lightly rotated chairs to the right. Notice how I did not bother to build the tone wall in the background in SketchUp or the wood plans on the floor. It would have taken too much time to get it right in the computer and I can add those textures by hand.

Note: When building in SketchUp I recommend that you set up a time frame for yourself. Whether it is one hour or two, it is a good idea that you define a time limit to build in 3D when you use this technique. We can very easily spend one or two days building in 3D, but that can be counter-productive if you only wanted to use the wire frame as an underlay to help you with the perspective.

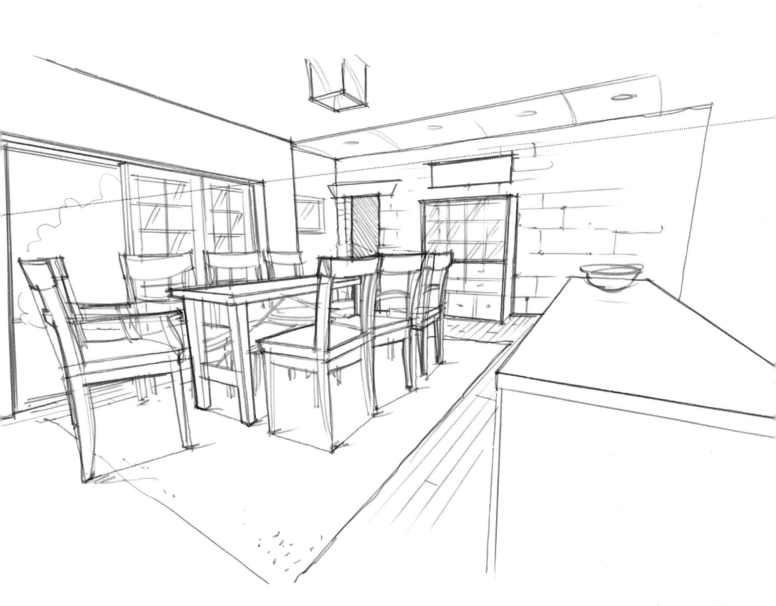

In this next step I chose three marker tones to work with: a gray tone to situate the carpet under the dining room table and to mark the ceiling, a dark red tone to mark the wood tones for the dining room set, and a light blue tone to indicate sky tones that could be seen beyond the sliding French doors in the dining room.

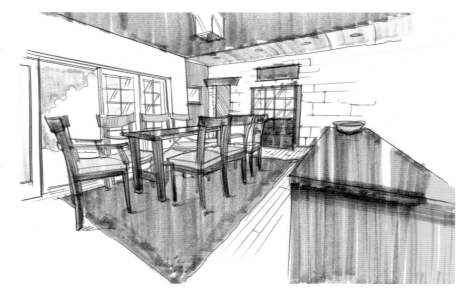

Here, I added more color to the scene: a light brown to define the wood planks and more pencil work to darken some of the shadows under the chairs and table. I also added some extra black lines to define my objects and edges placed in the foreground, and some more detail to the outdoor deck beyond the sliding doors, just to make the perspective look richer visually.

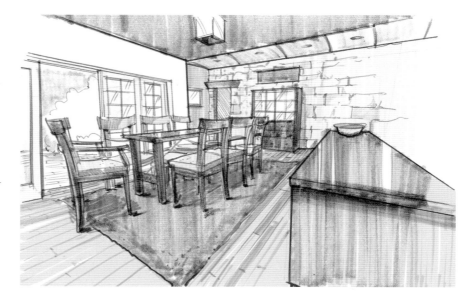

SketchUp has a great feature called Match Photo that can help designers sketch their perspectives correctly. This tool allows users to utilize an existing photograph as a guide to build models. You can use more than one photo to build the model, then you can Orbit around the model and find other points of view to draw.

Once you select an image as a starting point, then specify the type of corner to base the grid on, and what plane to start working with—green-red, red-blue, or blue-green (as seen in the small image on the top left corner). Once that is done (plus selecting the right spacing of grid and texture options) SketchUp generates a unique Scene tab.

I moved the red and green handlebars to match the perspective in the photograph to the model. In this example, I worked from a beautiful building in Providence and found some perspective lines on the yellow wooden trim and the Mansard roof line to match my perspective.

Note: We need to be aware that the moment we use the Orbit tool, we lose the placement of the photograph, because it is linked exclusively to the particular point of view we are working on. To gain the view back, select the Scene tab at the top of the page.

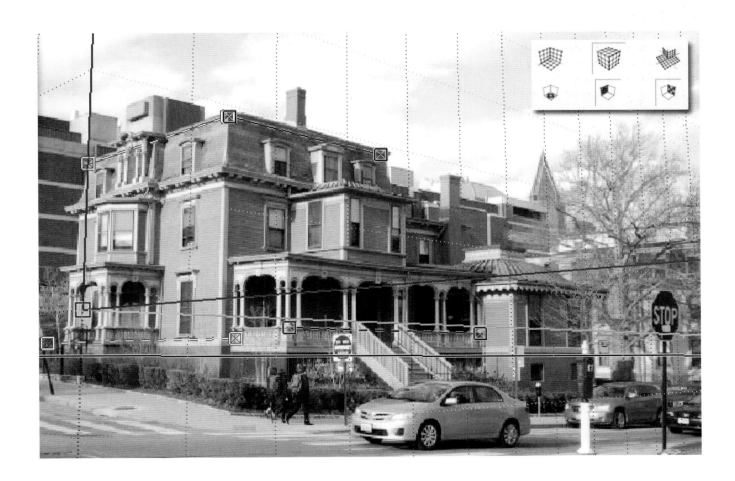

In this stage we see the model of the house, built just to represent the basic volumes and nothing else.

I was careful not to spend too much time building the structure in full detail, as it would have been a time-involved process. That is the reason why I left behind the columns in the front and side porch, and why I did not elaborate on the windows any further. I still had to Orbit around my model to gain a good bird's view that would help me do my hand sketch.

Note: SketchUp also allows us to project the textures found in the photograph onto the model we just built. While that process is not shown in this image, it is another good way to get a sense of how materials could be shown in perspective. When we Orbit the model, the projected textures travel with us and get attached to the model, but only if it's visible in the photo (in other words, SketchUp will not fill in for the textures that are hidden from view).

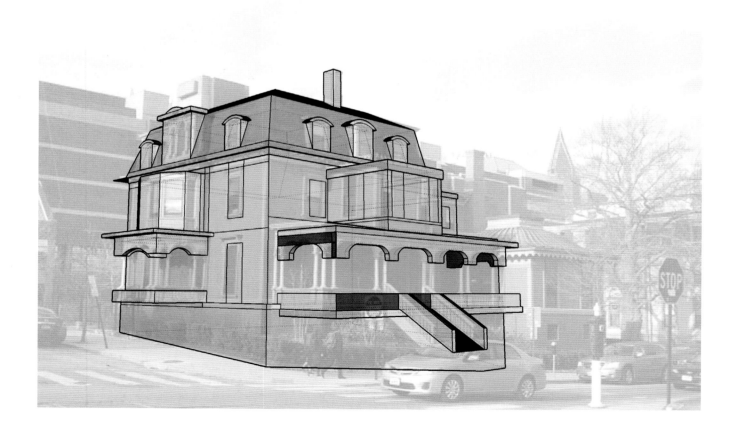

Here we see a lower view and a much higher one. The image on the bottom is the one I wanted to develop. These Scenes in SketchUp are captured with a Sketchy Style to make them appear closer to my own sketching style.

I am finally working on a sketch on my own, from a higher point of view, so that I could clearly show the roofing. I am using two different black pens, a fine black pen of 0.2 mm and a thicker pen of 0.8 mm.

A: Double lines to represent the thickness of the roof line.

B: Thicker lines to mark the outlines of the protruding objects.

C: Thin lines to represent roof shingles.

D: Thin diagonal lines to represent glass panes on the windows.

E: Thin lines done with a ruler to mark the main architectural features.

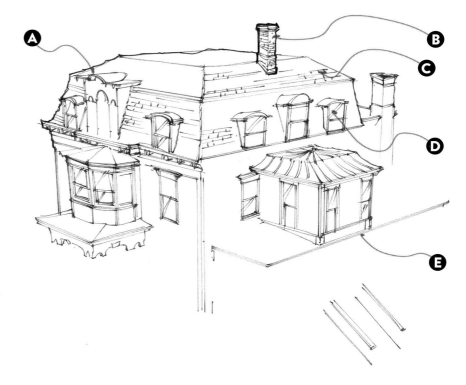

In this perspective drawing, I have finished working with different line weights—thin to show textures and materials, and thick to show outlines and the main volumes and protruding elements.

In this final stage, I have finished my perspective drawing by adding some gray marker tones on some sides and on the ground and background, and black tones to enhance shadows on the eaves of the different roof lines and window panes.

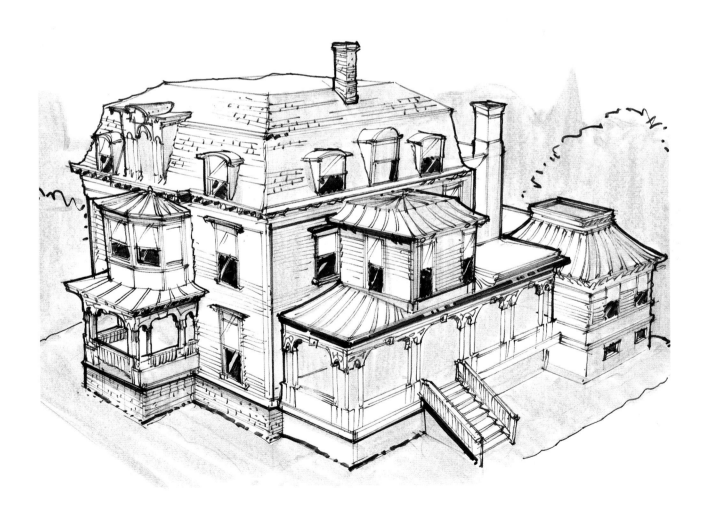

This second example will demonstrate
how the Match Photo feature in
SketchUp can be used in a different
scenario that is not related to an
architectural setting. I drew this concept
of a street sweeper with a thin black pen
on vellum paper and working exclusively
by hand.

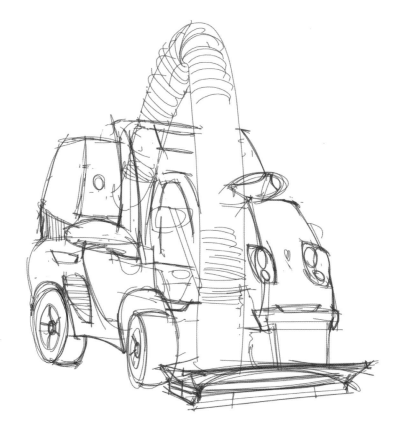

Here, I added marker tones and thicker
black lines to more clearly define my
shapes, working on a new layer but using
the previously done sketch as a guide.

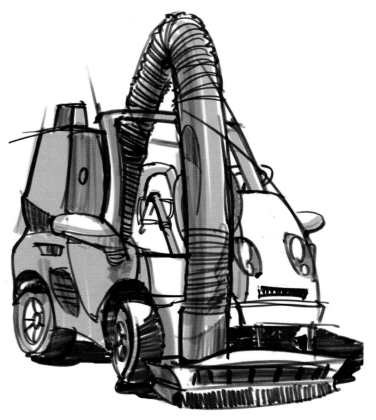

When I finished, I used my utilized my finished sketch in Match Photo to create a model in SketchUp that would help me rotate my model later to find another interesting point of view. Notice how I have modified slightly the position of my wheels, tucking them in more and rotating the front axle even further.

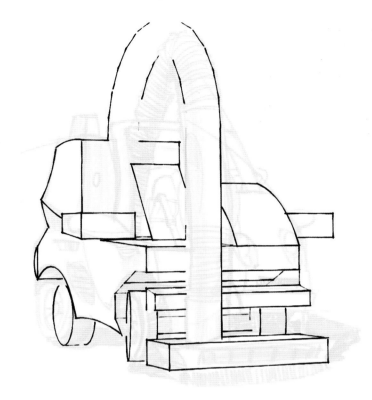

This view shows the scenes that I chose to work with but from opposite angles. I also chose a sketchy viewing Style in SketchUp.

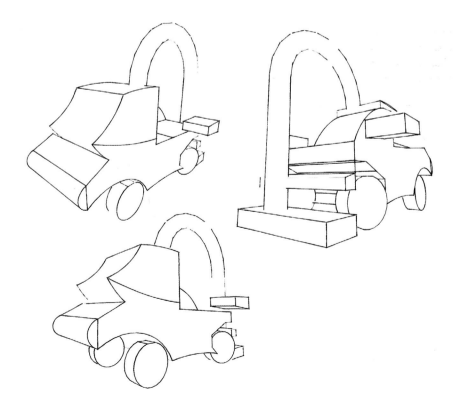

I sketched on top of my printed wire frame, using an ivory black watercolor pencil and two blue marker tones to enhance the volume, on tracing paper.

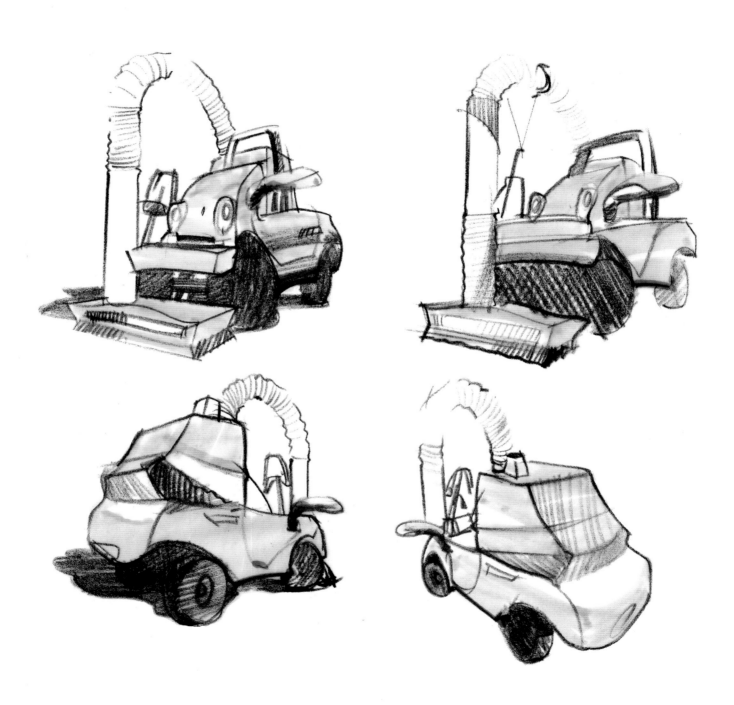

DIGITAL BLOCK-OUTS:
WORKING EFFECTIVELY WITH STYLES, COMPONENTS, AND GROUPS

Mixing digital and freehand techniques is often the best route on certain types of drawings. This is especially true when we create preliminary three-dimensional studies in SketchUp that have Components. A Component in SketchUp is nothing more than a block of something built that can be repeated multiple times. If we modify one of those shapes, all the other pieces will follow suit. This can be particularly gratifying if we are repeating the same shape in the same object or interior.

In this case we are designing an oil heater. In the first stage, I built one model making sure that each fin was a Component. Then, to compare the results, I captured four different views, in isometric perspective, and three different two-point perspectives, modifying more or less the distance between the vanishing points. Once I liked my point of view (the fourth one), I set to modify my original Component into something more exciting.

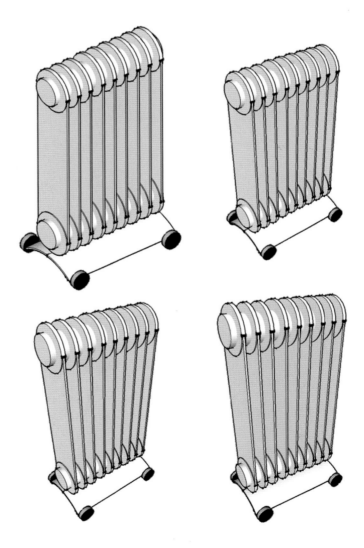

I used a more freehand style here and worked on the single fin, which was built as a Component (image on the left). Once I edited that Component by right-clicking on it, I changed the straight lines for two gentle curves, and as expected, all the other fins change accordingly (image on the center). After that, I started to freehand my sketch with a new layer placed on top but using this new underlay as a guide to aid me with the curves on the fins and the ellipses in the model.

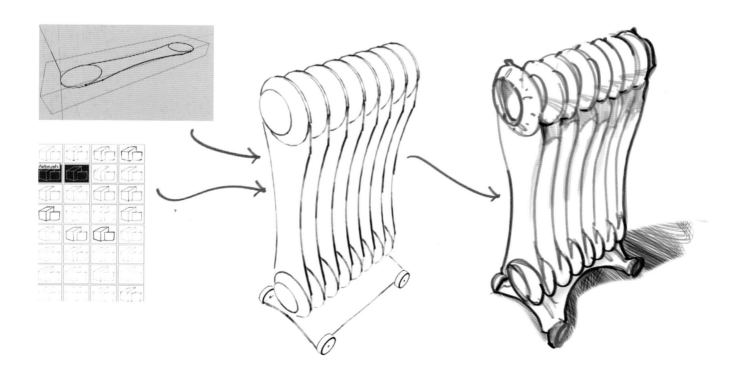

PHOTOSHOP PAINTING:
SCANNING AND RETOUCHING FREEHAND SKETCHES IN ADOBE PHOTOSHOP

This is an example of how we can retouch a pencil drawing and get it ready to be used in Adobe Photoshop for digital rendering. This drawing was done using a dark blue pencil, it was scanned at 300 dpi, and the contrast was increased at 150 percent.

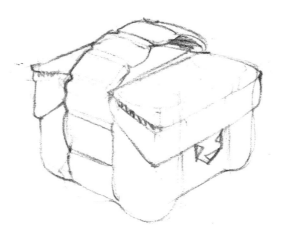

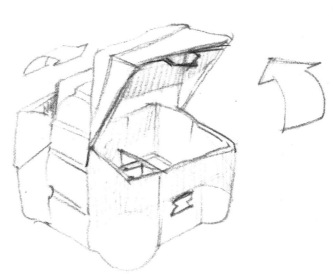

In Adobe Photoshop we can go to Image > Adjustments > Levels or click on Control + L to bring out the Levels panel automatically (Command + L in a Mac). In Levels, select the black color picker and then carefully select a line in the scanned sketch that would be dark but not too dark. That way we can push the lighter tones to be slightly darker.

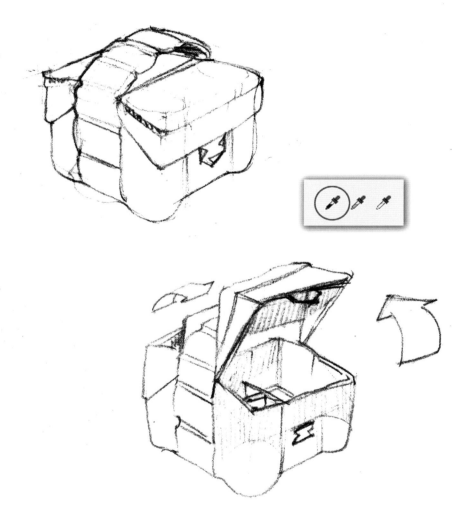

After completing the first step, use the Input Levels graph to slide the dark triangle slightly to the right, followed by moving the gray triangle toward the dark triangle.

The next step is to remove the excess color from the lines; right now there's a bright range of blue tones, and we need to reduce the saturation. To do that, go to Image > Adjustments > Hue/ Saturation and slide the triangle in the middle of the Saturation line to reduce the intensity of these tones.

The prior steps got us to a point where the lines are well defined with the right color tone. Next, open the Layers panel from the main menu (the icon looks like two pages stacked one on top of another). Once the panel is visible, it is revealed that we've been working in the Background layer, which is locked. To unlock it, double-click it.

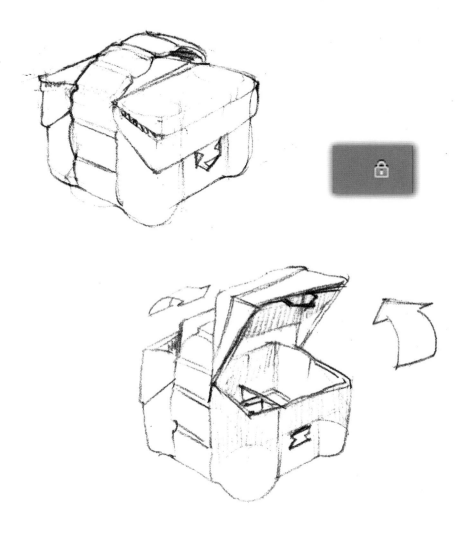

Now we can produce a new layer where the color will be applied. With the Layers panel open (Control + L or Command + L on a Mac), we select the icon that will let us create a new layer. It is marked as a circle in the bottom right corner of the screen capture. Once it is clicked, the layer will be called Layer 1 by default. Double-click the layer and rename it. We'll call it Color.

Now, we can change the properties of this new layer, from Normal, the default choice, to Multiply. This will allow us to paint without losing our outlines just underneath, in the Background layer.

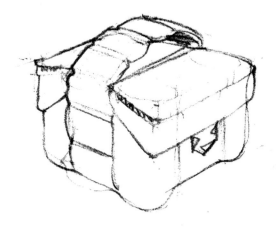

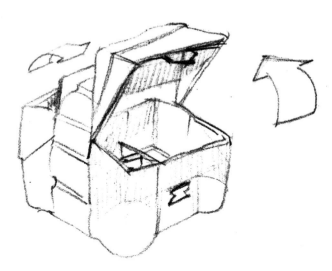

Here, we can apply some color background to the whole scene. First, we chose a blue tone that would go well with darker pencil lines that we have in the Background layer. To do that, double-click on the color swatches, as noted in the bottom left corner of our screen capture.

Once the right blue tone is selected, proceed to choose a Brush from the Brush panel. There are thousands of possibilities, if you consider the overwhelming range of permutations to choose from. Since we are using a simple airbrush, we chose brush #30 on top of our selection panel. Then, we chose a very large brush size, 2680 pixels, and the rest of the choices were left intact.

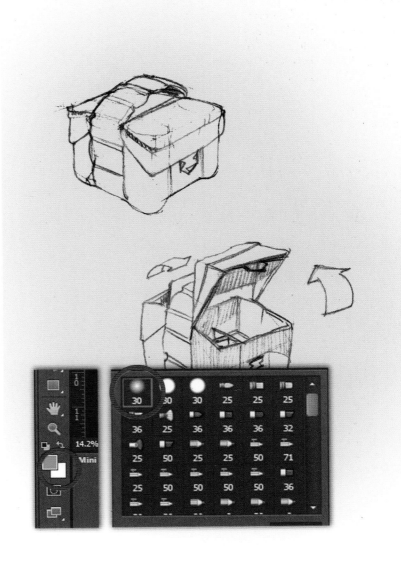

After adding a light blue tone for the background, we'll add a darker side to the lunch boxes, to add contrast in the designs. Typically in the rendering process, consider the light sources and how that will affect the different sides of the object. In this case, the light source was placed to the right of the object, darkening the lunch box on the left. Consequently, the lunch box should be lightened on the right.

There are many methods of applying light and dark tones. Here we'll use the hue/saturation method using the Lasso tool in Photoshop to capture the areas that need to be lightened (or darkened up), but with a feather of three or four pixels to achieve soft edges. This last step should not be missed.

Once the areas that need to be darkened have been chosen (you can choose multiple areas by holding the Shift key in your keyboard), access the Hue/Saturation command in Photoshop (Image > Adjustments > Hue/Saturation). Then play with the corresponding sliders, Saturation and Lightness—leave the Hue slider intact for now.

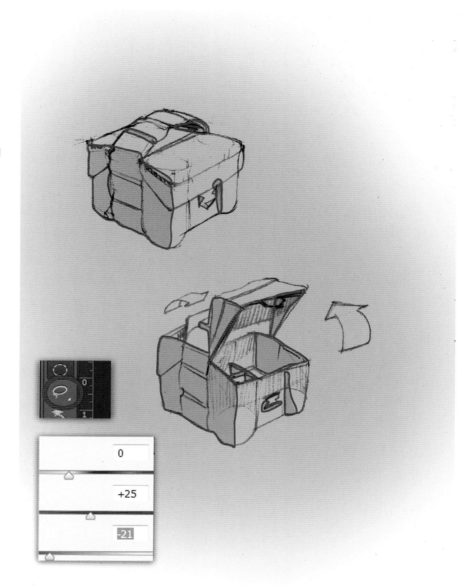

Now it is time to apply some digital marker-like strokes to enhance some shadow lines. To do that, go to Window > Brush and pick the already-made brush #36, which is very close to how a rendering marker reacts. Then, we test the marker on the side of the digital paper (see the loose strokes on the left margin), and with a gray-blue tone, we enhance some of the most prominent volumes in the lunch box, as seen in the example. If we need different shades of gray, we can always play with different opacity levels, as seen at the top of the figure.

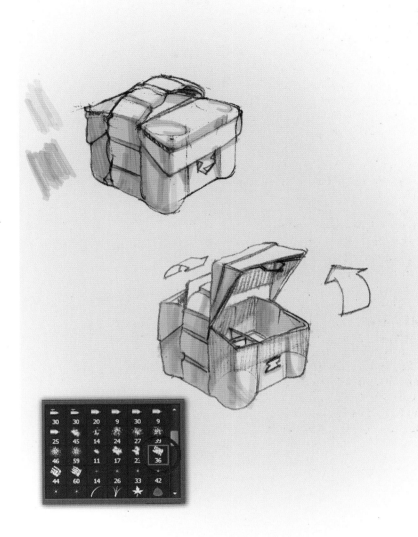

Once we have a sense of the dark tones, we can introduce a second tone, using the Brush tool. In this case, it was necessary to separate the arrows indicating movement with a complementary color so we chose two shades of salmon.

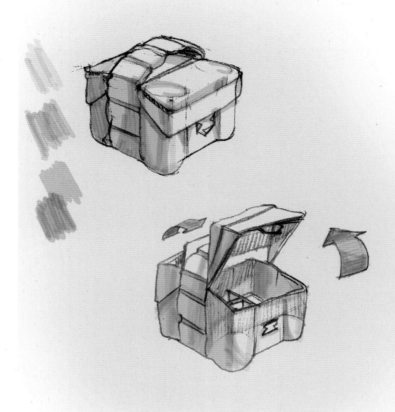

Now it is time to add some strong shadows, and it is better to add a new layer. You can do that by clicking on Layer > New. That gives us some leeway in case we need more than one attempt to get the shadows right. Next, we chose the Lasso tool with a feather of four pixels to draw the outlines of two shadows to the left and behind the lunch boxes.

When applying shadows we used a very large brush—brush preset #21 seems to work just fine—but with a 400-pixel size. Then we render our shadow using a 100 percent opacity stroke closer to the object, and a 60 percent opacity stroke on the outside. We applied the strokes at an angle so they are visible in the design.

The final steps now will involve working with lighter tones on the right side, and then trimming the background. For the light tones, we can just simply choose brush #36 and apply some strokes in a white tone and with an opacity of 15 percent. At this point we would have to be sure to be situated on the layer that contains the blue background tone.

The final step will involve cropping the background tone in a rectangular shape to clean up the rendering. First, we turn off the color layers that we have worked on, so that we see only the Background layer that contains our line work. Then we select the Background layer with the Magic Wand set at a tolerance of five pixels.

Once this step is complete, we use the Rectangular Marquee tool to shave off a generous margin from the original selection by holding ALT down, which allows us to remove parts of an original selection. This process will leave us with a rectangle that gives depth to our drawing.

This next step involves painting a dark background using the same brush type that was used for the shadows on the left and applying a variety of diagonal passes with different opacity levels. Then we darkened some of the most prominent outlines with a #30 brush with a size of fifteen pixels and 53 percent opacity, in black.

PHOTOSHOP PAINTING:
PAINTING UNDER LINE ART ON TRANSPARENT LAYERS

The following rendering exercise will show how to effectively use the Pencil tool in Photoshop to create quick design concepts. The first step would be to choose a tone that would work for the type of concept being developed.

In this particular example, we are working on a series of trigger bottles for a window cleaner, so a blue tone is selected because that is the color most consumers associate with this product. The second step is choosing the right Pencil tool. We chose a standard pencil #25 from the Brush Preset panel, with a brush size of twenty-five pixels.

Note: While a track pad and a computer mouse can potentially work, we recommend investing in a drawing tablet. Luckily, there are a bevy of sizes and manufacturers to choose from, at a wide range of prices. The digital pen allows users to draw curves that would not be faceted or interrupted, dramatically improving the overall quality of the sketch. Having said that, there are designers who prefer to sketch with a mouse, but the process is more cumbersome as you lose fidelity and precision.

Now, it's time to organize our layers in Photoshop in a way that will simplify the rendering process. First, we left our original Background layer intact in white color, and from top to bottom we added the following layers: Layer 1, for our blue color background, which we locked because we are not planning on modifying it in any way. Then, three more layers, for concepts, highlights and for nozzle designs. The concept layer containing the black pencil lines defines exclusively the body of the container, done with a black tone. The highlights layer holds the highlights or reflections added on top of the black lines, and finally the nozzle layer just holds the trigger concepts. This last step is done so that at some point we can analyze the body shapes independently from the trigger concepts, if we so choose, by turning one or another on or off at will.

In this figure we can appreciate how the digital pencil lines have been drawn applying different pressures to obtain soft or more intense black lines. Usually, the outer-most profiles get a slightly thicker line, to define best shapes. Some hatching has been added to indicate the back of the trigger on the nozzle.

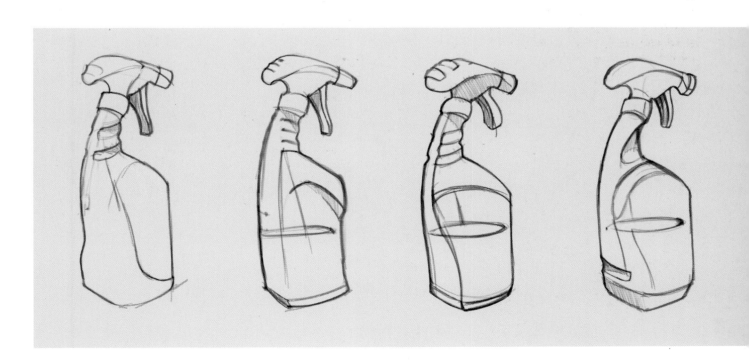

Highlights were applied using the same pencil brush but in a white tone. These strokes are added on the corners and edges to enhance the understanding of the volume that is being represented.

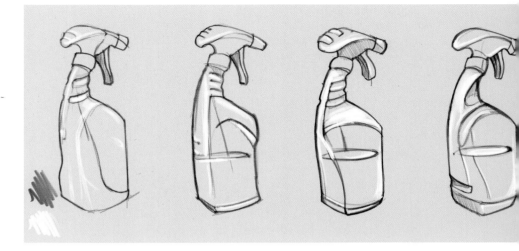

To increase the contrast in these sketches, add a shadow projected on the floor. First, we create a new layer, called shadows. Then, we chose the Lasso tool with a feather of four pixels, and after drawing the first shadow, we held Shift down so that we could draw the other three shadows left in the page, without losing the original selection. Once this process was complete, we simply chose the same Pencil brush in black and worked with some diagonal strokes, but with a brush size of 150 pixels.

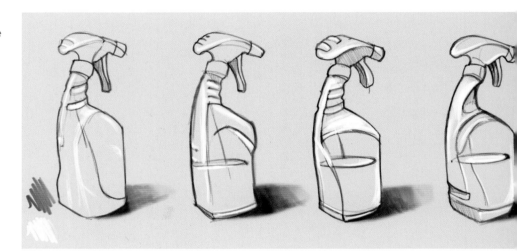

An interesting effect that we can always play with is to change our color of brush from black to blue (the same blue of the background); therefore, we can "erase" our shadows if they got too strong, by painting back some blue tones. We did that on the edges of the shadows, just to make them fade more quickly into the blue background.

Note: If the selected areas ready to shade are bothersome—these flashing edges or marching ants—you can always apply shadow strokes with a hidden selection. Press Control + H (Command + H on a Mac) to make the selection visible again.

More colors are added to the original composition, on two different fronts. One, we created a new layer called Fill, using the Lasso tool technique described earlier. Next, a pale purple tone was selected to render the containers with some liquid inside. Then red was used to render the nozzle tip, the trigger, and the cap using the Lasso tool.

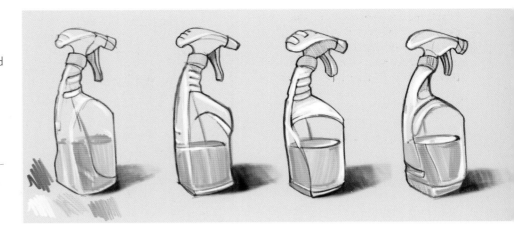

Using the layers allowed us some flexibility. For example, if we chose to change the nozzle color to purple, and the fill to dark blue, this would be as easy as selecting the layer we want to change and then going to Image > Adjustments > Hue/Saturation. Playing with the Hue slider will let us change the original color, the Saturation will allow us to saturate more or less that same color, and the Lightness will make the final selection brighter or darker.

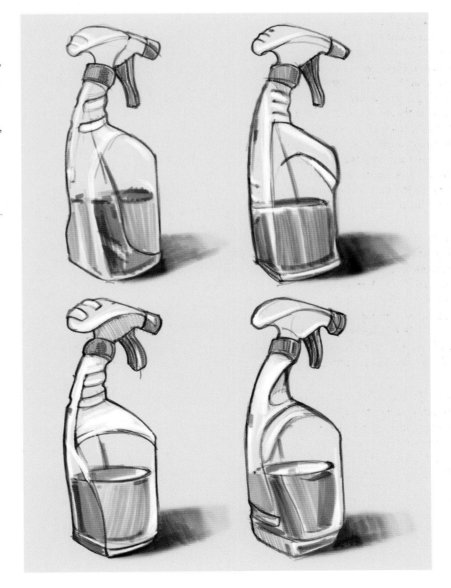

Rendering in Adobe Photoshop can be a fun project to do, especially if we combine some freehand techniques. In this concept of a car, I have started with a gradation done by hand, using pastel shavings in pink and purple. On top of this gradation I sketched out in pencil a car design and then scanned it into the computer. I then selected the outline of the car using the lasso tool and reduced slightly the lightness (found under Image > Adjustments > Hue/Saturation).

Note: In the rendering process in Adobe Photoshop, working with masks is the easiest and safest way to get the colors under control. We can apply larger brush strokes in our layer, but the mask will crop them to exactly the shape that we want. The Mask took can be found at the bottom of the layer panel and it is represented as a rectangle with a circle in the middle.

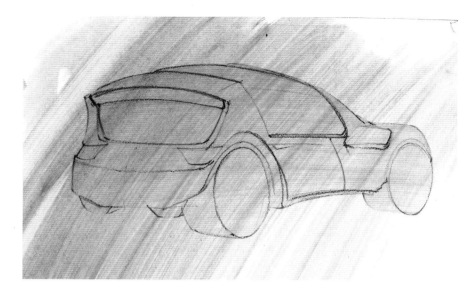

My next step was to simply cut out the shape of the car from the background, leaving my gradation only for the inside of the car and leaving everything else white.

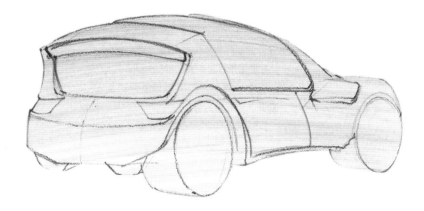

Adding a strong contrast is the surest thing to bring a drawing to life. And in a car rendering, this process can be done uniting the wheel wells, the rubber of the tires, and the shadows with the same dark tone. I made sure to leave out the rims, as they would be reflective.

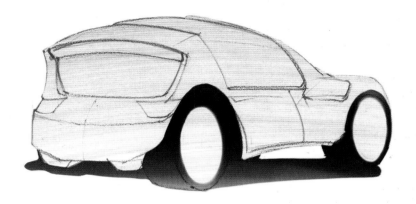

I worked with two green tones for the body of the car, using an airbrush with a light tone for the roof and the top edge of the bumper and the door, and a darker tone for the bottom of the bumper and the bottom portion of the door and the whole side.

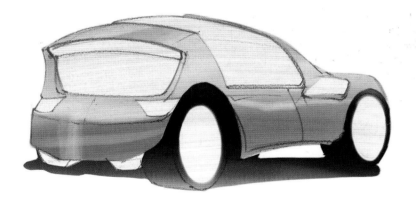

Here, I utilized even darker green tones to increase my contrast on the bottom of the car.

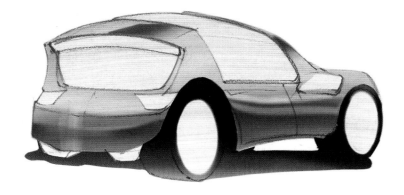

In this stage everything starts to come together. With a fine point airbrush and using a 20 percent opacity, I added some highlight tones on the car, marking the major breaks in the surface and some reflections on the edges. I then switched my white airbrush to black and paired my white strokes with black lines. Also, I worked on the rims and started to note my reflections on the windows. Finally, I added some loose strokes on the shadow, to make it less defined.

Note: See how I used the same white and black pens to add some detail to the wheels to show the tread.

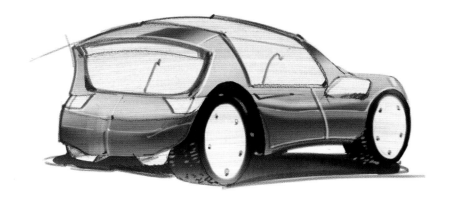

Here, I added some red tones to situate my brake lights.

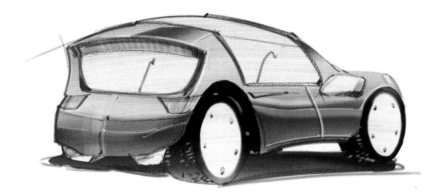

With the help of a mask, I used a large airbrush to show my reflections on the windows.

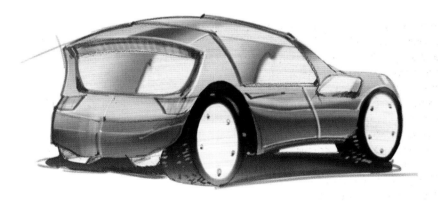

I added some extra tones on the side window to suggest the shape of the dashboard and some dark tones on the back window to indicate the edge of the seats.

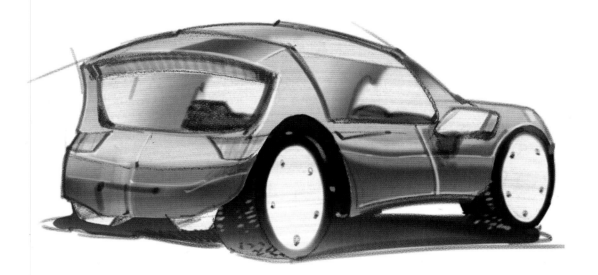

This is a point of purchase (POP) display design developed by RISD student Molly Harwood. To develop her concept, she worked with open curves that would remind the viewer of how simple it is to sweep the floors with this product. On the practical side, she also needed to offer enough storage within the perimeter and a banner that would display the logo prominently at the top.

The smaller sketch in the top right corner shows a volume study done exclusively with gray markers, and the bottom image shows a Photoshop rendering done with airbrush techniques and some masking.

Since this is a POP that displays a cleaning device, it was important for Molly to show a color rendition that would have bright and clean edges, with crisp reflections. The reflections are done using a small white airbrush, and the textured background is done by first drawing a rectangle in orange. Later, she worked on another layer set in Difference mode with the same size as her background shape. Then she added a Cloud texture (found in Filter > Render > Clouds).

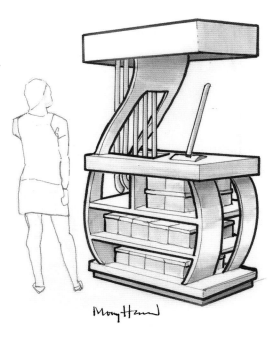

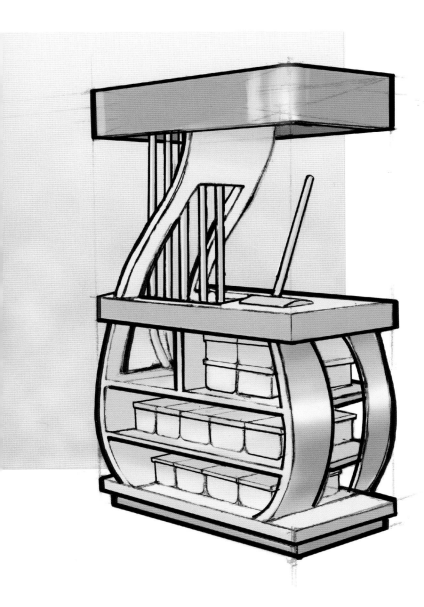

This rendering of a coffee machine was done by placing a series of layers, one top of another, over a line work developed by hand. In this first layer, I worked with soft airbrush strokes to obtain a gentle transition from a light tone on the left, to a highlight in the center, to a darker tone on the right. I also started to work with a second tone to mark the cord that would be coming from the back of the machine.

In this second layer, I started to emphasize the shadows that some profiles would cast over certain surfaces: the top lid over the filter area, the filter storage over the carafe, the shadow of the electric cord over the floor, and the shadow of the machine cast on the floor, to the right.

Note: To work effectively with the airbrush I recommend working with a low opacity, maybe 20 percent to start. Always mask the areas with a feathered edge of four or five pixels, to get a consistent and smooth transition from one color to the next, and allow the airbrush colors to blend well.

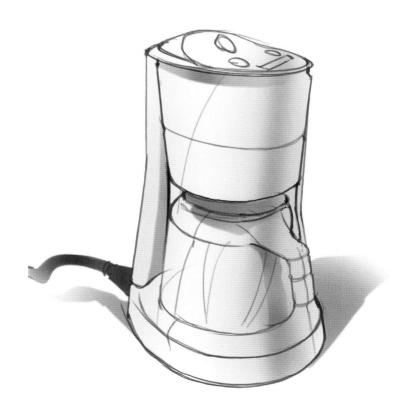

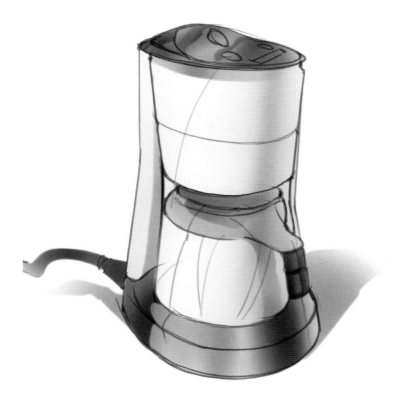

I continued working with the airbrush techniques, using a darker tone to separate my colors and materials.

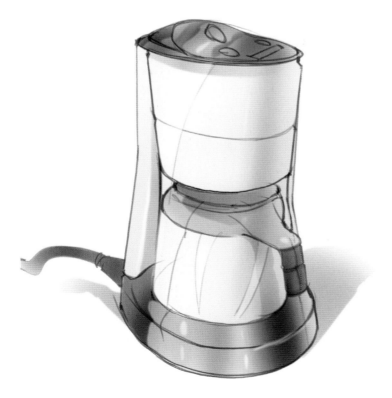

I added some white strokes to make the plastic material shinier and to make the coffee container appear translucent. The whole process of digitally airbrushing can be done quickly using masks.

Note: To make color variations on our initial sketch, we can always change the Hue, Lightness, and Saturation of our layers. We can do that easily by going to Image > Adjustments > Hue/Saturation and then we can adjust the different sliders for those three categories.

In this Photoshop rendering, I worked first in 3D to create a model of my table and chairs and the basic wall lines. Once that was obtained, I printed the wire frame and drew the rest of the elements by hand, such as the yellow cabinets in the background and some extra lines to define my dropped ceiling. I colored the areas, one by one, in a variety of layers with the airbrush.

Note: When rendering each shape in a different color in Photoshop, make sure the area is fully closed, surrounded by black lines. Use the Magic Wand and select the areas quickly without spilling into neighboring shapes. Once the shapes are selected, we can always expand the selection by one or two pixels. This will ensure that we do not have any white pixels left behind. To expand our selection we click on Select > Modify > Expand.

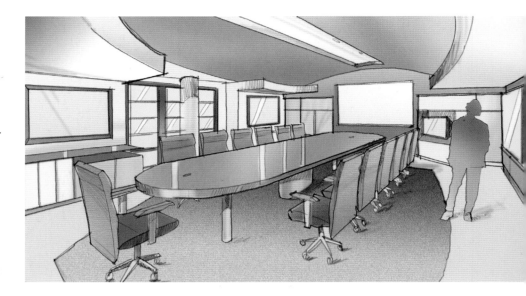

In this Photoshop rendering, I used the same techniques that I have described before, one color per layer, making sure that the selections are fully closed. The texture on the carpet in the foreground was obtained by adding some Noise to the selection—that can be done by clicking on Filter > Noise > Add Noise.

Note: To obtain soft shadows in the floor, select the areas and make sure there is a feathered edge of at least four pixels. Then, we can work with the Burn Tool in Photoshop (it looks like a hand making the letter O with the four fingers and the thumb). The trick is to experiment with the three different Range options: Shadows, Mid-tones, and Highlights. The latter will give us more effective results. To hide the selection, click on Control + H, while keeping it active.

PHOTOSHOP PAINTING:
COMPOSING A LIGHTING SCHEME, RAKING LIGHT, AND CASTING SHADOWS TO DEFINE FORM

In the following pages, we are going to explore the steps necessary to render shadows and work with a lighting scheme, using the line work of an exhibit design concept as a starting point. After having worked on a preliminary sketch with pencil on vellum, we scanned our sketch and opened it in Photoshop. Then, similarly to what we had done with earlier examples, we organized a few layers in the model. The background layer that contains the line art is locked by default, so we unlocked it and renamed it as Line Work, and set it up in Multiply mode.

Then, we created a new layer and renamed it as Color Background, and we used the Gradient tool to create a gradation on it. In order to do that, we needed to have two tones selected—see our selection in the bottom left corner of this image located in the main side toolbar panel. The Gradient tool is sometimes hidden underneath the Paint Bucket tool. Finally, with the Gradient tool selected, click in the top part of the image and drag down. When you release your digital pen or mouse, your gradation will be complete. You may need to practice three or four times until you get the right tones and the right direction for your gradation.

The next step involved adding the layers Color 1, Color 2, Shadows, and Lighting, just in the order that is shown in the figure. The Line Work in Multiply mode needs to be all the way on the top, if we do not count the Lighting layer. Color 1 layer is where the main colors in the exhibit would be; Color 2 is where the accent colors would be; the Shadows layer is obviously where we will place our shadows; and the Lighting layer will be placed all the way at the top of the layer stack. The reason for choosing a gradation as our starting point is because this will enhance our shadows and the resulting rendering will end up being more interesting visually.

To render the tone for the tabletops, go to the Background layer and, using the Magic Wand tool with a feather of two pixels, we select all of the surfaces that need to have a tone to set them up apart from the background gradation. We start with the white tones using the Magic Wand tool. To ensure that the white tone will be placed right beneath the line work, we expand our selection by three pixels (Select > Modify > Expand).

Note: The Magic Wand tool works best if the surfaces being painted are all closed off. If a surface or shape isn't closed off by a black line, the Magic Wand tool will spill out from the intended selection and pick all the pixels up to the next boundary. Be sure to hold Shift down to pick multiple surfaces at the same time.

Next, we're changing layers from Line Work to Color 1, and painting in white with a large brush. We choose the preset Brush #30, with a brush size of 700 pixels and 26 percent opacity. To get the white tone just right, we experiment with a couple of passes to slowly gain color.

The following step is repeated on the same layer, this time working with an orange tone.

In the next step, we choose a blue-gray tone for the exhibit carpet, working this time on our layer Color 2.

Continuing with the exhibit carpet, we add some texture to make it look as if we can see the pile of the carpet. We go to Filter > Noise > Add Noise and choose the Gaussian effect to add some extra color to the selection and play with the slider until we reach 44 percent.

To finish with the carpet, we choose Image > Adjustments > Hue/Saturation and play with the sliders to obtain a lighter tone for the curved piece in the front side of the exhibit.

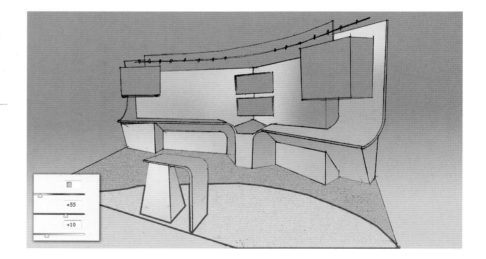

To prepare ourselves for the shadows, we need to consider the shapes of our shadow profiles ahead of time, using our Polygonal tool and Lasso tools. Also, our shadows need to have soft edges so that they appear believable, which means we will choose a generous five- or six-pixel feather. Since this selection is quite complex and we do not want to lose all the effort invested in drawing, we save the selection.

We go to Select > Save Selection and name it Shadows1. If in the future we lose it, we will be able to retrieve it easily by visiting Select > Load Selection and choosing our selection name listed under Channel.

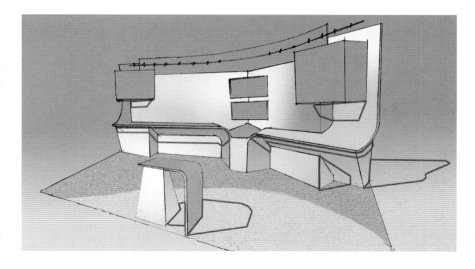

The next step is a bit involved, as it requires that we turn off our Line Work layer and the Lighting layer (we do not have anything on that last layer yet). Then, we need to situate ourselves in the Shadows layer and we will hit Control + Alt + Shift + E (Command + Option in a Mac) to create a flattened copy of all visible content from all visible layers into our Shadow layer.

After this, we need to select our previously saved selection Shadows1, as discussed in our previous step. Now, we will make a mask using our Shadow1 selection (as shown in red at the bottom of our Layer panel).

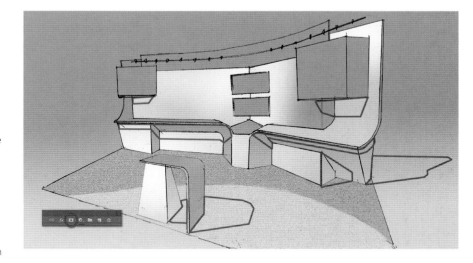

This step will show us nothing really, as we created a mask of the same colors that we had in the background, but the truth is we set up our working space so that we could have some fun now using the Burn tool (it looks like a hand that is making the letter O with all the fingers). If you cannot find this tool, it might be hidden under the Dodge tool, which we will use soon to create our Lighting effects.

To work with the Burn tool, we need to select not the mask itself but the color in the Shadows layer.

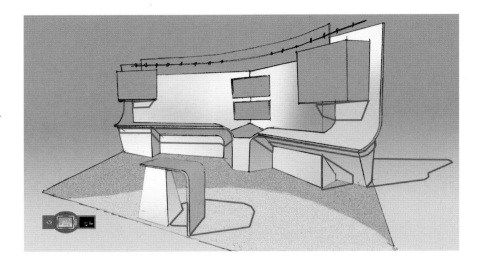

The finished shadows are then rendered using Brush #30 with a brush size of 125 pixels, 39 percent exposure, and choosing the range of Highlights.

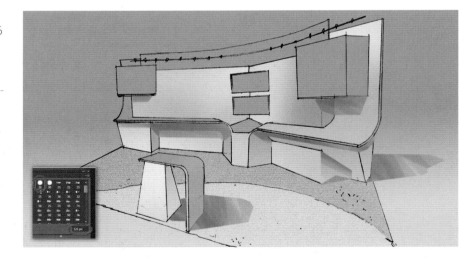

To create some raking light effects, we will use the Lighting layer. The process will involve the same steps we have covered in our previous steps: Creating and saving a new selection using the Lasso tool and the Polygonal Lasso tool.

While on our Lighting layer and hiding all layers minus Color 1, Color 2, and Color background hit Control + Alt + Shift + E (Command + Option in a Mac) to copy all visible content into our layer. Thus, we create a mask with our selection for the raking light effects.

Apply the Dodge tool selectively, again using Brush #30 with 125-pixel brush with an exposure of 31 percent, choosing Highlights.

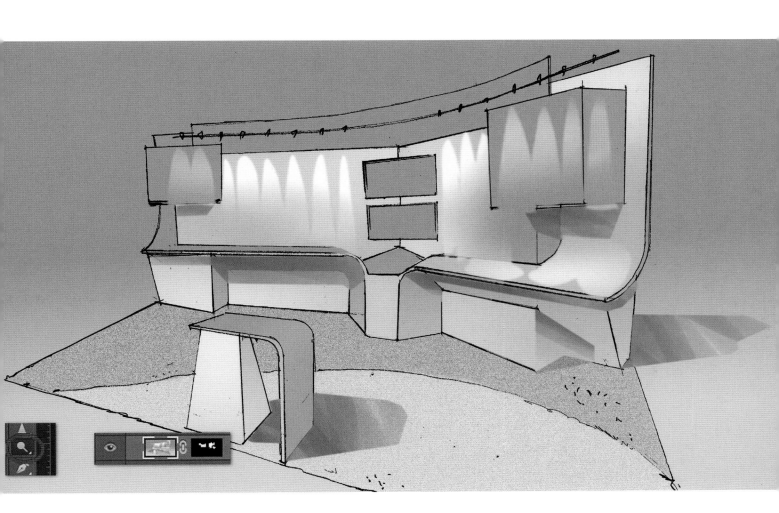

The last few steps involve adding more detail to the rendering to make it more believable, such as including more colors, objects that we are selling, and a sense of scale.

We added a dark red tone on the back panel and on the side to lower our sight line to the text on the main panels in the exhibit as well as highlights to the counter tops to make them come to life.

Shelves were also incorporated to display product samples as well as a profile of a person strolling our space, making sure that his shadow would match the general shadow direction we have for the main exhibit.

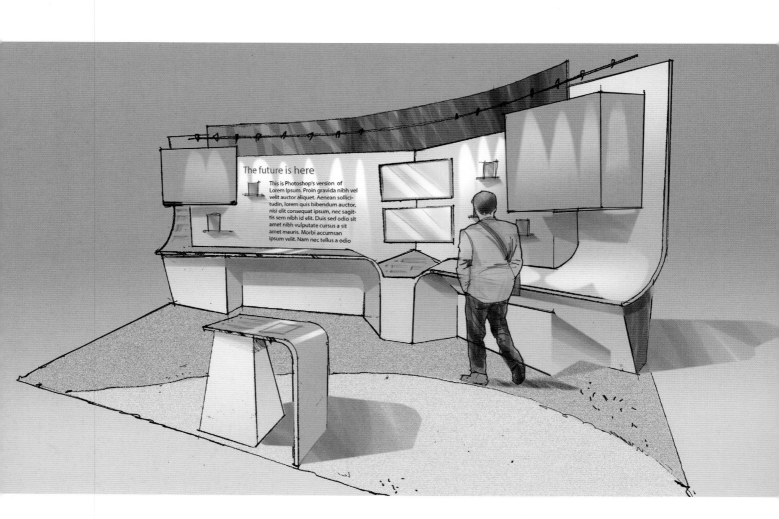

PHOTOSHOP PAINTING:
IMPORTING TEXTURES OR PHOTO IMAGES TO ENHANCE THE COMPOSITION

This collection of sketches shows a new concept for a room heater. While the overall shape is important in this design, the focal point resides on the large area dedicated to the front metal grill that lets the warm air out. Therefore, it is important that this area be clearly defined, so I used the Displace tool in Photoshop

To start the process of adding a grill in perspective using Photoshop, I made a new layer and drew my first shape using the Rounded Rectangle tool (shown in the top left corner of the image).

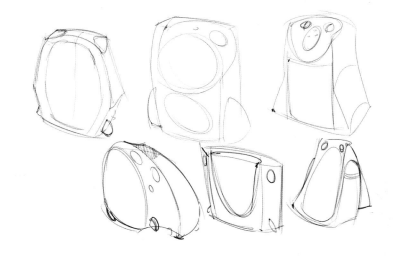

Next, I filled my selection in white and copied this layer numerous times to create a pattern that would fit in perspective later. I moved each successive copy to make my pattern as I thought would work best. But since I have my pattern with a white fill, I created a new layer below my pattern and filled the entire screen in black and set it in Multiply mode. Then, I reduced the opacity to 50 percent so that I would be able to see the sketches underneath and the pattern on top.

Note: In the process of copying the pattern I ended up having numerous layers—these can be flattened down by selecting Control + E. This can also be done in Illustrator and imported as a Path into Photoshop.

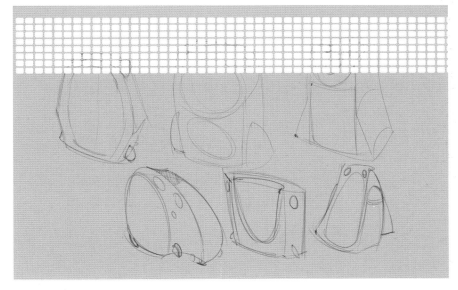

I ended up copying more patterns and reduced the size so that I would have a closed cell structure that would resemble what we see on a metal grill in a room heater.

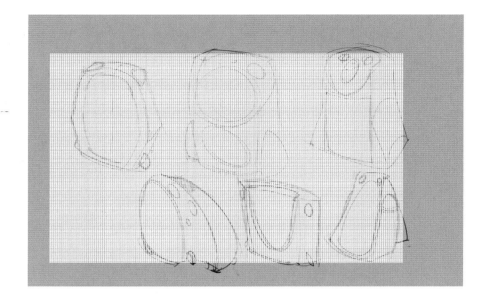

This image is a necessary side step so the Displace tool will work properly. Once we have a pattern to work with, we need to have a separate Photoshop file that will tell the pattern how it needs to be displaced or distorted, so I created an entirely new file in black and white, exaggerating the shadows. These strong shadows will guide the pattern as it gets fitted into these front grill shapes.

The last step in the process is to actually displace the patter, by going to Filter > Distort > Displace, and choosing a Photoshop file to work with. The default settings worked fine in this case.

Note:Once the Displace filter has been applied, we can also add other secondary operations, such as a Layer Style, by clicking the FX symbol at the bottom of the Layers panel. With that in mind, we can add a bit of a bevel or emboss, if we want to give our pattern a more three-dimensional look.

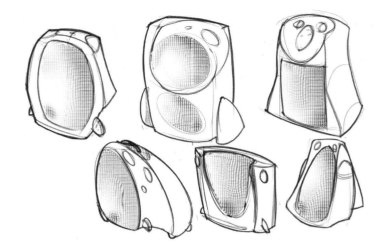

After working with the Displace filter, I masked the body of these sketches and worked with a soft red airbrush tone to give them a general tone. And with a small airbrush tone, I added some white edges to the most evident parting lines.

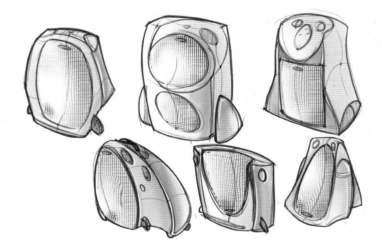

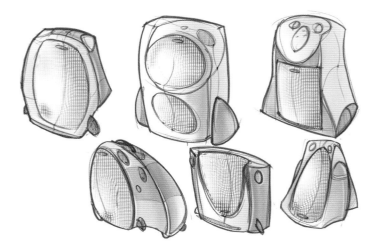

This step shows how I worked on a slightly darker tone, to gain some more visual interest in the sketches. These darker areas have been treated with a slight texture, which was added by going to Filter > Noise > Add Noise. In this particular case, I chose 2 percent, Monochromatic and Uniform.

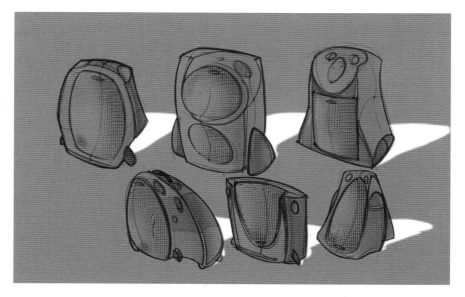

I worked with another mask to add shadows behind the sketches. This image shows how I worked with the mask on my Shadows layer. The red tone shows the areas that are blocked, while the white color shows the regions that are open to receive the shade.

Note: In Photoshop we can create a Mask by clicking on the white rectangle with a black circle on it, on the bottom of the Layers panel, next to the FX symbol. Once the mask is activated, you can work on the layer itself or on the mask. If we click on the newly created mask, the colors in our palette will go off, as Photoshop will allow us to work only in black or white: black to add to the mask, and white to remove masked areas. If we want to see how the masked areas looks in a red tone, we can always click on the backslash keyboard, which is what we seen on the current image.

This final step shows the sketches with the two red tones, the front metal grills, and the shadows behind the room heaters; this suggests the supposed light source was located in front of these objects.

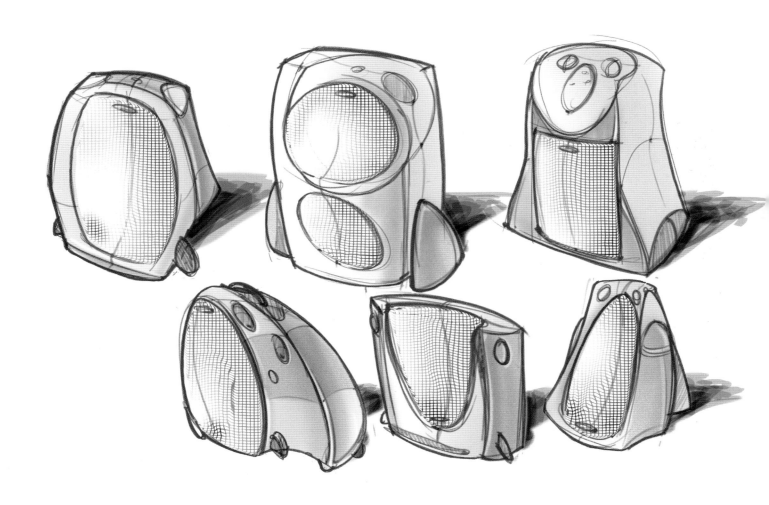

The design for these cleats was
developed by RISD student Jacob
Amrhein. These preliminary sketches
were done with pencil on bond paper.

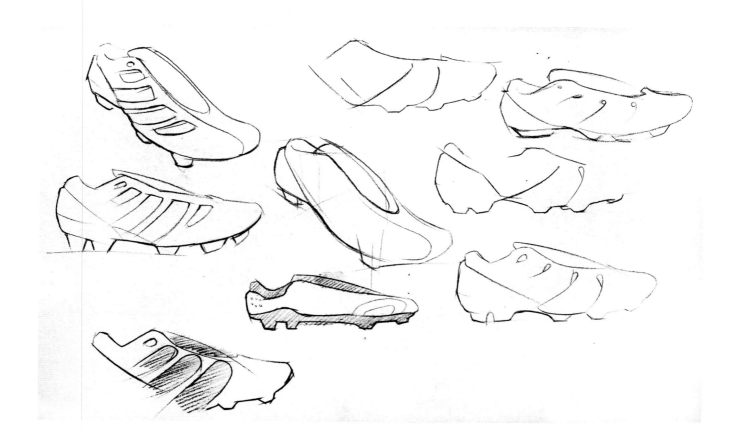

Jacob visited The Edna Lawrence
Nature Lab at RISD, which has a large
natural history collection on display
to serve as inspiration for students.
He sketched the head of a snake,
focusing on the texture of the scales.
This helped him choose the color
combination and define the shape
and texture of the cleats.

Jacob continued working on the
initial concept, switching to Photoshop
to explore a variety of textures.
To simplify the process, he worked
with orthographic projections, so that
the textures would not have to be
formed around a curving surface.

Jacob switched back to the three-quarter view from the first sketch, because it showed the hexagonal texture on the side of the shoe and on the front. But that switch made the process a bit more challenging, as the texture looked fake as a flat image.

After deciding on the final size of the hexagonal cells, Jacob added some Bevel and Emboss effects and worked with the Displace filter. The edges finally were masked to fit the area designated for this texture.

RISD student Elizabeth Connolley drew a chair that would convert into a bench. This chair is to be made of laminated wood, and that needed to be shown unequivocally.

The rendering itself was created with the mixing of freehand and digital rendering techniques. While the outline was done by hand using two different line weights, the color was applied in Photoshop. The texture depicts birch plywood, and it was done utilizing the Filter Gallery, under the Filter tab in the main window.

The process is shown at the bottom of the illustration. First, she drew a large ochre rectangle, which was later modified choosing Texture > Grain > Grain Type > Horizontal direction. The last two steps involved choosing Edit > Transform > Distort, to place the best direction for the grain, and finally the ochre color was masked out to fit inside the chosen areas.

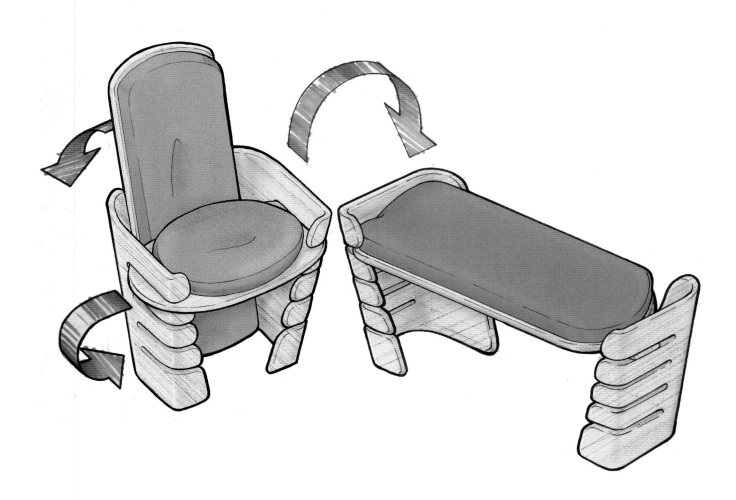

Here, I am showing how to add textures to a hand rendering to increase the level of realism. The wooden floors in this space look good, but need more texture. To the right, we have a rectangle of approximately the same size that we need to cover in the space. We applied a Horizontal Grain with an intensity of thirty-three and a contrast of three.

In this next image, we worked with the Liquify filter, found under the filter menu. This option will bring a new window over your original image, and with some care you can add burls and wood knots by playing with different brush sizes and options. The one that has given me better results is the Bloat tool (marked in red).

The Distort tool, found under File >
Transform, allows us to pick each
individual corner of the texture
and situate it right where it belongs.
This image shows the layer all stretched
out to match our floor perspective.
Note that in order to stretch it to fit
it in the perspective, we reduced the
opacity to 50 percent.

We repeated the same process of
distorting an image for the red carpet
in front of the entry door, but reducing
the opacity to 30 percent.

RISD student Kegan Tawney, depicted a series of concepts that were developed for a slip casting class. Kegan worked in parallel, learning the technique in the ceramic studios, and developed a series of sketches to define the shapes that he wanted to pursue further. While Kegan's precision with his line work is notable, he still needed to add shadows and color to define the shapes with more precision.

Kegan scanned his sketches and added color and shadows digitally to obtain a better sense of volume. He also needed to depict the right color choices and surface treatment, to mark clearly if certain designs were going to receive glaze or not. On top of that, some of his designs had to show textures or line art in the surface. The cup with the wooden handle was done in Photoshop, and later it was deformed to make the wood grain wrap around the handle. The two white cups with the blue background have two different motifs that were done in a two-stage process. First, he created his line art in Illustrator and imported that as a Working Path into Photoshop. Then he distorted the path to fit to the curves, and finally picked a color to fill them in.

RISD student Hanna Oh sketched
a concept for a pair of sport shoes.
First, she concentrated on developing
as many ideas as possible, with an
emphasis on the transition from one
material to the next. These sketches
are done with a thin line brick-red pen.

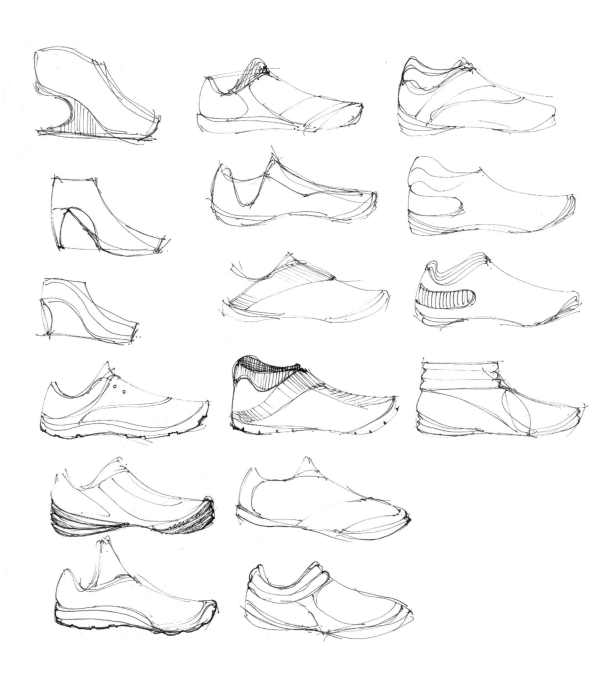

Once one concept was chosen, she explored one idea, using all freehand techniques. She started with very thin pencil lines and later added marker tones in red and gray. Then she added black lines, very thin to show texture and stitch lines; intermediate lines show changes of materials, and a thicker line to mark the perimeter of the shoe. The bottom edge of the shoe got an even thicker line to make it be more grounded.

Note: If we want to reduce the intensity of our saturated markers, we can always apply them on the back of the paper. This would only work if we use either vellum or any other lighter type of marker paper.

A: *Shading on the edge done with a soft black pencil over a red marker tone.*

B: *Stitch marks done with a thin black pen.*

C: *Texture done rubbing black pastel over a metal grill placed underneath.*

D: *Texture done rubbing white pastel over a metal grill placed underneath.*

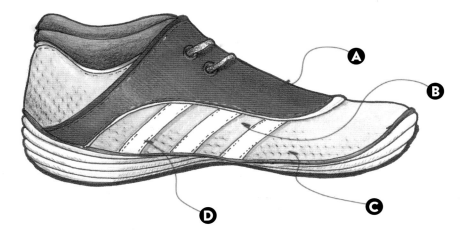

Hannah scanned her sketch into Photoshop and added different colors progressively in layers, one on top of another.

A: *Photoshop Mesh, masked to appear only on the shaded side of the gray area.*

B: *Stitch lines done with a custom-made stitch brush, done in light gray. Stitch lines are also masked to appear stronger on the shaded side.*

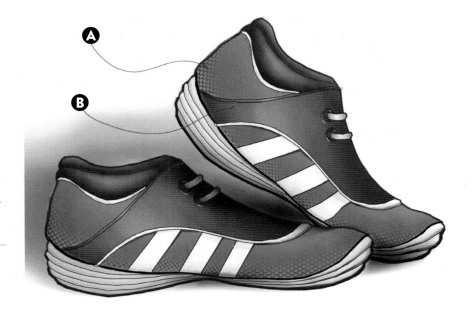

RISD student Emily Fang developed these athletic shoe concepts with a breathable mesh. This is apparent in the different shading on some of these sketches.

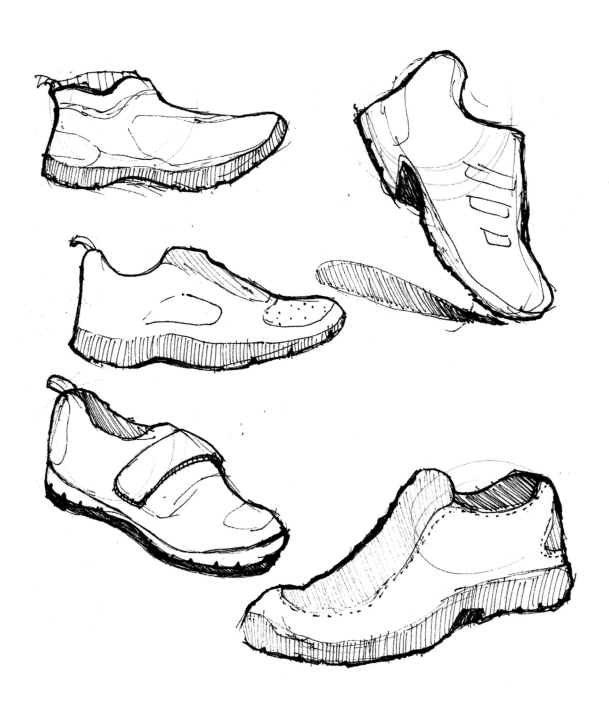

This Photoshop rendering shows how the mesh became the focal point. Emily scanned a piece of fabric that had the right texture, and then masked it to fit the final shape. Then she worked with the Dodge/Burn tool to increase the highlights and dark edges, thus avoiding the impression that the scanned mesh would appear too flat.

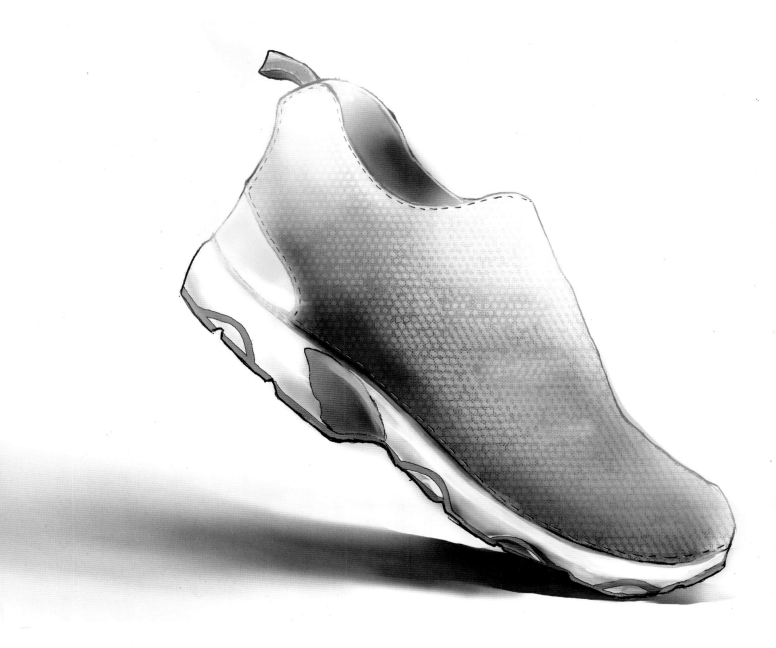

GLOSSARY

Axonometric view

An axonometric view is a type of representation of an object or in the space where all the lines are drawn as parallel lines, without converging into a point. The lines that define the three directions in space, x, y, and z are drawn with a specific angle from each other.

Background (*see* foreground and mid-ground)

A background relates to the atmospheric elements that are placed around an object when we represent it. If we are drawing a product, the background could just be a color rectangle that is placed behind the object to give the illusion that there is some depth behind it. During a perspective, the background would relate to the elements that are placed far away in the scene. Those elements are usually drawn with a lesser amount of detail.

Brief

A brief, or project brief, is a written description of a project. This is normally produced by the client and handed out to the designer or artist, establishing the specific terms of the project. It can be as short as half-page or as long as a booklet. The difference between a contract and a brief is that the latter might include a description of the existing client profile, references to previous research done, description of technological equipment or internal architecture, references to color, textures, emotions that the new design might evoke, or inspiration drawn from other disciplines.

Callout

A callout is a written note added to a drawing to specify a particular feature that needs to be highlighted. These notes are accompanied by a callout arrow that points to the specific area being described. When adding numerous callouts to a drawing, a designer would have to consider aligning them to create a balanced composition in the page.

Chamfer

A chamfer is a flat edge that divides the two planes that define an edge.

Cone of vision

The cone of vision represents the range of vision that we have in a particular perspective. If we imagine ourselves seen from above, the cone of vision would be the maximum aperture that we can capture from a specific station point. Typically, that range covers from 60 to 90 degrees. It would be entirely possible that one (or both) of our vanishing points in a two-point perspective rendering would fall outside the cone of vision.

Construction lines

In the process of getting a drawing completed, often designers work in stages, evolving the work with different types of lines. Construction lines would appear after having added some preliminary lines (*see* underline) to the drawing surface. These lines tend to be more geometric as they would be capturing the main volume of the object or series of volumes in a scene. These lines are often drawn with crisscrossed edges to speed up the process.

Contour, contour line (*see* perimeter)

Cutter (*see* frame)

Dimension

For an artist or designer, accurately recording a dimension is quite important, as it has to exactly represent the distance between two points. The distance is usually recorded on an orthographic view. When placing a dimension in the drawing, we would have to first draw two leader lines, parallel to each other to define from where to where we are dimensioning. Then we would draw our dimension line until we touch the two leader lines. The dimension line would be redrawn with two arrows at either end and would show the dimension, either above the line or in the middle of it. Sometimes the dimension line is drawn with dots or diagonal tick marks at the end instead. When dimensioning an object, we always start with the three basic measurements: the width, height, and depth.

Exploded view

The exploded view is a rendition of a product where all the parts are displayed a certain distance apart from each other. This allows the designer to quickly see the number of parts, or clusters of parts, involved in the design. An exploded view would normally be drawn to indicate how parts are assembled together. These types of drawings are done as axonometric views, as they are easier to draw and allow the designer to wedge other parts in the layout, if they had forgotten to include them in a preliminary layout.

Fin loft (*see* mid-plane contour curve)

Floor plan (*see* orthographic views)

A floor plan represents an orthographic view, or a scene, as seen from above. For example, if we are representing the first floor of a two-story structure, we would have to first consider an imaginary cutting plane that would slice it at a height of four feet. This particular height will allow us to represent with clarity outside walls, doors and windows, interior partitions, furniture layout, and the materials chosen for the floor.

Focal point

In a perspective, the focal point will be the specific area in the drawing where we would want to center our efforts and attention. The designer would have to choose whether it would be situated in the foreground or background, although most often it would be in the front. When drawing an object, the focal point usually shows an important feature that defines its character.

Foreground (*see* mid-ground and background)

The foreground relates to the object or cluster of objects that are situated in a scene closest to the station point. Usually, objects in the foreground receive a thicker outline to define their perimeter and are drawn with more detail or color. Objects placed the foreground usually become the focal point of our perspective.

Foreshortening

In perspective drawing, foreshortening describes objects, or parts of objects, that would be drawn with a certain amount of distortion. This situation is quite common in perspective drawing and it might occur when we see objects that are at close range—any detail that would be drawn on the side would be barely showing. Also, objects that are situated at the periphery of our range of vision would appear foreshortened. For example, an office building with many windows would be drawn with foreshortened windows on the side facade. Regardless of the range of foreshortening, more or less acute, all the lines that are parallel to each other would still converge into their appropriate vanishing points.

Frame

A frame is a rectangular border added onto some drawings to trim the amount of information that we want to include. This border can be set off the edge of our page by 1 inch (2.5 cm), or any other distance. If preparing illustrations for a story board for a television commercial, for instance, we could probably conside the proportion or screen ratio of most screens of 16:9 (the screen ratio is the relationship between the width and the height of the screen). On the other hand, if we are preparing a series of cutters for the cinematography industry, the frame size will have to consider a screen ratio of 1:2.35. Often we want to draw lager than what can fit in the frame we have set up and then lay the cutter or frame on top to find the best cropping area.

Gradation

The gradation is a smooth transition from one color or shade to another. Gradations are often used to represent objects or surfaces that have clean, uninterrupted surfaces. Properly cropped gradations can also be used effectively as background shapes behind rendered objects.

Hairline (*see* underline)

A hairline can be interpreted as the very thin lines usually added to a drawing to emphasize materials in a scene, texture, or graphics applied on the surface of an object.

Hatching (*see* shading, shading lines)

Highlight

In the rendering process, a highlight is a bright spot that is added to represent a sheen or a reflection in the surface. Highlights are usually completed toward the end of the process when most of the color has already been applied. Highlights are usually added with a white pencil, or with an opaque whiteout pen if we need to achieve a much brighter spot. Sometimes highlights can follow up a contour, if a strong light is directed to a corner.

Horizon line

The horizon line represents the viewing height of the person who is standing in a scene or looking at an object. In a perspective drawing that is capturing a scene, the most common viewing height would be considered at a height of 5 feet, 6 inches (1.7 m). In product design drawing, the horizon line would not necessarily be situated that high and will vary depending on the point of view chosen. In a two-point perspective drawing, the line that results from joining the left and right vanishing points would give us the horizon line.

Isometric view

An isometric view is a specific type of axonometric view where the space in between the three existing space (x, y, and z) is creating a 120-degree grid.

Layer

In the context of freehand drawing, a layer would represent the different pieces of translucent paper that would be added progressively on top of one another as a concept is defined in its entirety. During the early stages of defining the concept, designers often would work with very thin pencil lines (normally a 2H or 3H) or would use a non-photo blue pencil to create some preliminary directional lines on the first layers, often done with very gestural and loose strokes.

In the context of digital drawing, a layer does not necessarily have to represent a progression in the developing of the shape, but rather it can hold just a specific amount of information separate from the rest. Layers are stacked one on top of another, just like we would do with normal paper, but the opacity (as well as other filters) can be applied at will to show or hide all the layers that are placed underneath.

Line weight

Artists and designers need to have a good range of line weights at their disposal when drawing scenes or objects. Showing a collection of at least three different line weights in a drawing is advisable. In product design, the thickest line usually represents the perimeter of an object. An intermediate line weight would represent a parting line or a transition from one material to another. A thin line would show textural notes, graphic elements placed in the surface, and/or dimensions.

When drawing a scene, a thick line would be used to define the perimeter of the objects situated on the foreground only. Intermediate line weights would be used to define the inside lines of objects in the foreground as well as all the lines that define the other objects in the scene. A thin black line would represent the textural nuances of the different materials used.

Logo

A logo, or logotype, is a graphic representation of a commercial name employed to allow users to recognize the brand across different platforms. The logo needs to be designed consistently so that it reads equally well across different media and substrates, whether it is printed on a surface of an object, on a business card, or placed in front of a corporate building.

Medallion

A medallion is an architectural feature—round or oval—that carries a particular design on it. It can have a geometric design, a floral design or even a bas-relief carving on it. Depending on the use, they can be made of plaster for indoor use, or carved wood, stone, or composite materials for outdoor use.

Mid-plane contour curve

A mid-plane contour curve is a curve that delineates a particular curvature that appears in an object, usually following a straight path, as if we were cutting the object with a laser beam. The technique of drawing mid-plane contour curves is quite effective to define the nuances of certain shapes, such as in transportation design. It is very common to draw quite a few mid-plane contour curves on a single object, if the shape is particularly challenging. These curves are often drawn parallel or perpendicular to the main axis of an object.

Mid-ground (*see* foreground and background)

When drawing a perspective of a scene, the mid-ground relates to the objects or architectural features that are situated not too close or not too far from the viewer. Usually, objects placed at this range of depth help designers define a larger context of use and the atmosphere and personality of the space. When drawing a product, the mid-ground would relate to the other objects or elements that are surrounding the object, which we are drawing, to help us create a context of use.

Mid-tone

In rendering, the mid-tones would be the tonal values that would be situated in the center of a gray or colorscale range. They are used in conjunction with highlights and shadows.

Mullion

A mullion is a vertical element that divides a window. Mullions can be structural, to support the weight of a heavy window opening, or decorative. In the case of the latter, they are thinner, made with molding and situated in front of a window pane. The horizontal elements on a window are called transoms.

Mylar paper

Mylar paper is a type of paper, or film, that is used in certain types of renderings. It is a paper that is not coming from cellulose and offers great vibrancy and tonal qualities to a color rendering done with markers, pastels, and pencils. It can be purchased as a single- or double-sided paper, and it is usually a more costly substrate as compared to more traditional papers, such as vellum or marker paper. In a single-sided mylar paper, the usable side would be the matte side. In a double-sided mylar paper (and since this paper is translucent) designers would use the back for wet media (markers), leaving the front for dry media (pastels, pencils), thus avoiding smear strokes or clogging the felt tip of the markers.

Operational sequence boards (see shooting boards)

Orthographic view/representation

An orthographic view is a specific representation of one object, or a scene, where the different points that define each face it would be protected perpendicularly through the object into a virtual plane. If we imagine that an object is placed inside a clear box, the points and lines that define each of the six faces would be projected to each of the six faces of the cube, giving us the different orthographic views: front, left , right, top, and bottom. This technique is widely used by designers to place accurate dimensions on each of the views. In product design, the front view is usually chosen to be the one that best describes the object. In architecture, the orthographic representation of the front, left, or right views would be called an elevation.

Outline (see perimeter)

Palette

In drawing and rendering, a palette refers to the range of colors (or textures) that we have available to work with. When preparing a rendering for an interior or an object, we usually work with a set of colors or materials swatches that would have been previously defined, thus dictating the end result.

Parting line

A parting line can define either the transition between two materials in an object or the barely visible seam resulting in a shape that is made of two or more parts (usually coming out of a mold). Sometimes parting lines are disguised in an object and are barely visible, but other times the parting lines have a small radius on the edge. That edge would be often highlighted in the rendering process (see highlight).

Pattern

In the rendering process, a pattern is often referred to as a repetitive texture that is present on certain surfaces. That pattern can be 3D or it can be printed on a flat surface. Patterns can be geometric or can represent a figurative element, such as flowers, leaves, or animal prints.

Perimeter

A perimeter refers to the outermost line that defines an object. In perspective drawing, that line is quite useful to separate that object from the background, and it would usually be represented with a thicker line weight. If the object has a hole that cuts through its mass entirely, the resulting negative space would also be drawn with a thick line.

Perspective

Perspective is a representation of an object, or a scene, in space, as it relates to a particular position in space and a specific viewing height. All the elements that are represented in the perspective are drawn to represent depth in relation to the position of the eyes. In a perspective drawing, two parallel lines will converge at a point in the infinite.

Picture plane

The picture plane refers to the plane that captures the scene that we are drawing. If we imagine a person standing at a particular station point, the picture plane would be the representation of the canvas or piece of paper that we are holding vertically. The picture plane is where we draw the scene that we see. If we want to represent a dot in space, that point will be drawn as the intersection in between the picture plane and the imaginary line that connects our eyes to that particular spot in space.

Pixel

A pixel is the unit used to reference a single position in a digital screen, when describing a raster image—an image made of pixels. Each pixel carries information about its position and color. The larger the resolution of an image, the larger the amount of pixels it will carry to describe it.

Plain

A plain is a flat surface in an object or in a scene. Objects that are complex in shape can be simplified into a variety of planes. Each plane would receive a different tonal value in the rendering process, depending on the location of the light source set up for the scene.

Point of view (see station point)

Profile (see perimeter)

Reflection

A reflection would be shown on the floor directly under an object, if the surface the object is placed on is shiny. Some other times the object itself might be shiny or specular (think of a vehicle), and a reflection of the sky might be rendered on the hood or on the top half of the side. Reflections might pick up on the colors they are reflecting, but also will be blended with the color of the receiving surface. For example, a red car might pick up some sky tones on some surfaces. Consider what color you would pick to render the resulting reflections.

Rendering

For the artist and designer, a rendering refers to a sketch that has been developed further, by creating the lines that define its volume and by adding color, textural notes, and shading to define the different materials it is made of. A rendering typically would be drawn larger than a sketch, covering an entire page.

Shading, shading lines

In the process of rendering, an object, or a scene, would need to receive shading, or different tonal values (of gray or color), according to the light sources that we have. Shading would appear on the surfaces in the opposite direction of the light source. In the rendering process, the designer or artist will decide what type of shading will be most appropriate—whether that means using darker tones in color or using very thin parallel lines. This term is also referred to as hatching or crosshatching if the lines intersect each other, forming a tight grid.

Shooting boards

Shooting boards are a specific type of drawing where the designer or artist produces a series of frames, or cutters, to represent an action that needs to be performed in a specific set of steps: a scene that needs to be described in successive stages; how a user operates a product; or a motion that is carried by a product in sequential order. In a few frames the designer represents— visually—the motions that will describe a series of steps, using a minimum amount of information, usually with black pens or pencils and a limited tonal range.

Sketch

A sketch is a quick representation of an object, a scene, or any other motif, done with a drawing utensil over a 2D surface. It can be done by hand or using digital techniques. It is an effective way to quickly communicate a concept to other designers or to a client. It is often produced with a limited range of tools: a pad of paper, pencil or black pen, and some colors to give some contrast or give an accent to a particular area. A sketch is often accompanied with a series of quick callouts added on the side to explain certain features.

Station point

Refers to the specific point in space where we are standing to look at a view in perspective. That point unequivocally places a viewer in the scene, marking a unique distance from the floor to the eyes, and the distance from this point and each of the vanishing points present in the scene.

Storyboard (*see shooting boards*)

Stroke

In drawing and rendering, a stroke is the resulting line from using a drawing utensil over a drawing surface. Strokes can be well delineated with the help of a ruler or a drafting aid or can be free-handed resulting in a more gestural line. When rendering with markers over marker paper, the strokes need to be applied quickly and in parallel strokes, so that the resulting color will blend without leaving strikes across the area that we are filling out.

Texture

In a rendering or drawing, the texture of an object, or an interior, refers to the quality of the surface that is represented, and it can range from matte or coarse to shiny or specular. Designers would have to represent a particular surface quality with darker color tones or thin lines, and that is especially important when two or more adjacent materials are present.

Three-point perspective

A three-point perspective drawing considers the two vanishing points that we would have gathered in a two-point perspective, and all vertical lines would also converge into a third point in space. If we imagine that we are standing on top of a tower looking down, the vanishing point that results from converging all the vertical lines into a single point, it would be called a nadir. Likewise, if we are at the base of the tower looking up, the vertical lines above us would converge into a point called a zenith.

Thumbnails

Thumbnails are "thumb-sized" quick sketches that artists and designers often create during the process of concept ideation—usually before sketches or renderings. Drawing with thumbnails is an effective way to quickly explore different concepts without having to worry about specific details. Often, dozens of thumbnails can fit onto a single page. In the very early stages of the project, the goal is to produce as many thumbnails as possible and usually there is no color or shading involved.

Two-point perspective

In a two-point perspective drawing, we would situate objects in the space parallel or perpendicular to each other, and that would give us two different converging points or vanishing points, one on the right and one on the left. As a convention, all vertical lines would be kept vertical without converging into another point in space.

Underlay (*see* underline)

Underline

In the process of creating a rendering, designers and artists sometimes work with an underline, which is a preliminary drawing that they can place under the piece of paper they're working with to give them a base with which to work. Often, designers would produce a rudimentary layout showing just main perspective lines or a skeletal structure. Then, they work on top of that first layout on a new piece of paper. Sometimes, this technique gives them a much needed foundation (and freedom) to create believable perspective views. Other times, this term refers to the very loose lines that would first apply be applied to the page, often done with deliberate gestural strokes.

Vanishing point

The vanishing point is the point in space where two or more parallel lines converge. If the lines are on the ground or parallel to the ground, they will converge into a specific point in the horizon. Parallel lines that are situated in an incline will also converge into the vanishing point, although it will not be situated in the horizon line.

Vantage point (*see* station point)

Vignette (*see* frame)

Vellum paper

Vellum paper is often used to sketch and render. Its translucency offers the possibility of developing concepts in layers. It accepts marker, ink, and pencil tones well, and it comes in pads of different sizes or even in rolls.

Wireframe

A wireframe is a representation of a structure, or an object, exclusively using thin lines, as if the subject was made of thin wire. Sometimes this representation is showing hidden lines to give the designer the opportunity to see how the lines touch the floor or how they affect other surfaces or objects (*see* underline). Often these wireframe renditions are produced digitally and printed out to be used as underlays to help designers draw accurate perspective views.

CONTRIBUTOR DIRECTORY

Amrhein, Jacob
P.200, 201, 202, 203
Rhode Island School of Design (RISD) student, industrial design department. Color drawings of cleat designs.

Cogle, Laurie
P.60
The Art Institute of Pittsburgh, online division, student, interior design department. Renderings in perspective.

Connolley, Elizabeth
P. 135, 204
RISD student, industrial design department. Packaging sketches and furniture design renderings.

Fang, Emily
P.210, 211
RISD student, industrial design department. Shoe design and rendering produced for Drawing for Design class.

Harwood, Molly
P.183
RISD student, industrial design department. Point of Purchase Display Drawing.

Lopez, Gabriel
P.102, 103
RISD student, industrial design department. Visual design and concept design.

Morgan, Daniel
P.127
RISD student, industrial design department. Transitional running shoe.

Napurano, Joe
P.17, 20
Concept layout drawings by Napurano Akilez Design Consultants, Inc.

Ouchterlony, Elliott
P.9, 41, 42, 43, 44
RISD student, industrial design department. Tilt rotor shipping container crane.

Oh, Hanna
P.136, 208, 209
RISD student, industrial design department. Shoe design and packaging drawings produced for Drawing for Design.

Peer, Anthony
P.101
RISD student, industrial design department. Vending machine illustration.

Sager, John (Tate)
P.66
RISD student, industrial design department. Elevation of maple syrup bottle concept.

Snell, Benjamin
P.132
Brown University student. Exploded view of Timeless Clock.

Tawney, Kegan
P.207
RISD student, industrial design department. Photoshop sketches/drawings of product concepts.

Willemsen, Stephanie
P.131
RISD student. Industrial Design department. Exploded vintage alarm clock.

Yining Shao, Mary
P.74, 75
RISD student, industrial design department. Sneaker rendering.

ACKNOWLEDGMENTS

To all the mentors that I have had through my professional life, Andres Canovas, Joe Moya, Jay Crawford, Fred Blumlein, John Ciciora, Dr. Mitra Watts, Jan Jacobson, Leslie Fontana, Adam Smith, Soojung Ham and to the students that generously have contributed their examples for this book.

Also, thank you to all the students from the Istituto Europeo di Design, Pratt Institute, The Art Institute of Colorado, Parsons School of Design, The Art Institute of Pittsburgh Online Division and Rhode Island School of Design, because they pushed me with their questions to be a better at sketching.

And finally big thanks to Emily, John, Anne, and Cora from Rockport Publishers who helped make this publication a reality.

ABOUT THE AUTHOR

Jorge Paricio, M.I.D., Ph.D., was born in Madrid, Spain, but lives with his family outside Providence, Rhode Island. After completing his bachelor's degree in fine arts, in Madrid, with the highest GPA in the nation, he moved to New York City where he obtained a masters' degree in industrial design at Pratt Institute. Later, he obtained his Ph.D. in fine arts, also in Madrid. He has worked as a freelance designer for various product and exhibit design companies in Madrid, Arizona, Denver, New York, and Providence.

He has taught perspective drawing and rendering for industrial design and interior design at many institutions on both sides of the Atlantic, including the Istituto Europeo di Design, in Madrid; Pratt Institute and Parson's School of Design in New York; The Art Institute of Colorado, in Denver; The Art Institute of Pittsburgh, online division; and the Rhode Island School of Design, in Providence.

He maintains two websites dedicated to showing tips and tricks for industrial design students and interior design students: **www.idrender.com** and **www.renderinginteriors.com**. He also paints marine landscapes and accepts commissions to paint house portraits using watercolors. His work can be seen at **www.jparicio.com**.

INDEX